The Arts and Crafts of the Swat Valley

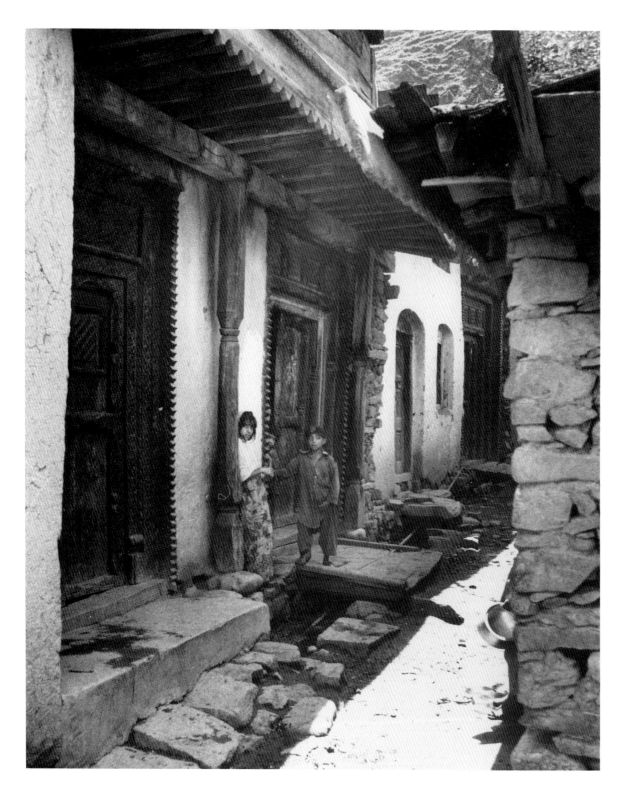

1. Sidestreet near the Great Mosque in Madyan.

Johannes Kalter

# The Arts and Crafts of the Swat Valley

## Living Traditions in the Hindu Kush

with contributions by

Joerg Drechsel
Viola Förster-Lühe
Jürgen Frembgen
Dietrich von der Lühe
Margareta Pavaloi

translated by
Sebastian Wormell

Thames and Hudson

First published in Great Britain in 1991 by
Thames and Hudson Ltd, London

First published in the United States of America in
1991 by Thames and Hudson Inc., 500 Fifth Avenue,
New York NY 10110

By arrangement with Edition Hansjörg Mayer, Stuttgart/London

Printed and bound in Germany by Staib & Mayer, Stuttgart

# Contents

In Memoriam Dietrich von der Lühe

# Foreword

The name Swat will not mean very much even to many of those who are well acquainted with the Islamic World. It is a narrow highlying valley in the mountainous region in northwestern Pakistan, at the point where the cultures of central Asia, China and the Indian subcontinent meet. Even in classical antiquity the region was famous for its fertile gardens and forests, one of the early centres of Gandhara culture, a goal of pilgrimage, and close to a side branch of the Silk Road. After the Pathan conquest of the Upper and Lower Swat – the uplands of Swat-Kohistan are still today largely inhabited by Dardic peoples – one of the most remarkable rural cultures in the Islamic World developed. The fertile soils made possible the development of specialized castes of craftsmen who were paid by the landowners for their work in produce and grants of land. The wooded mountains provided the most important raw material for the material culture of Swat – wood. In no other rural Islamic region is there such rich furniture or such lavishly carved wooden architectural elements. To a large extent the extraordinarily varied ornament has its roots in pre-Islamic traditions, and it is also influenced by Swats position between the various great cultural areas.

The Linden-Museum began collecting material from the region in the early 1970s following contacts between the museums then director, Friedrich Kussmaul, and Georg Gogel and his wife, Ute Gogel, of Malsburg. This collecting activity was intensified after the foundation of the Oriental Department of the museum with substantial support from Joerg Drechsel of Karlsruhe. By the end of the 1970s the collection had grown to such an extent that it inspired my friend the late Dietrich von der Lühe to write a dissertation on the material culture of Swat. Our main attention has been directed at the acquisition of architectural elements. Regrettably the traditional architecture, particularly of the mosques, has largely vanished from the villages of Swat (see Introduction).

For their assistance in the preparation of this publication I must thank the ladies of the Linden-Museum office, the Museum conservators and Maria Zerrnickel, to whom I am grateful for valuable suggestions. Margareta Pavaloi has read the manuscript and in collaboration with me has written a contribution. For other contributions I am grateful to my colleague Dr Jürgen Frembgen of the Museum für Völkerkunde in Munich, as well as Viola Förster-Löhe and Joerg Drechsel.

The photographs of objects in our collection, unless they are attributed to others, are by our photographer, Ursula Didoni. Mrs Lauber's painstaking efforts have made the best of what are sometimes rather flat field photographs. The field photographs are taken from the Dietrich von der Lühe Collection (now in the Linden Museum), by Viola Förster-Lühe and Txuku Iriarte.

Johannes Kalter

Stuttgart, May 1989

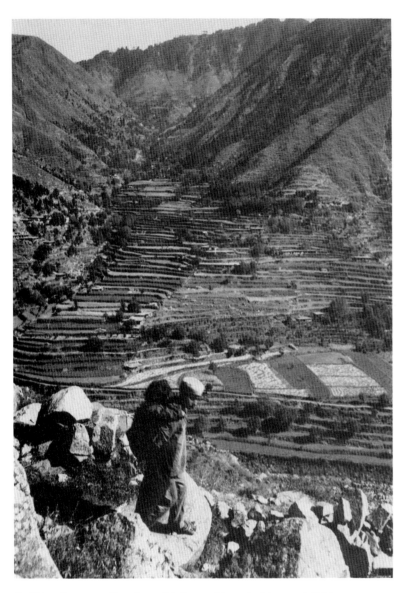

2. View down a valley above Madyan with typical terraced fields.

# Introduction

Until my first visit to Swat in 1978 I had associated mountain farmers with poverty. Their property seemed to me to be functional but meagre. The Swat visit fundamentally altered this view. Even though a change was already underway which has since altered the outer appearance of the culture the unusual richness of the furnishings was very evident.

What made the greatest impression on me – as it has on all visitors who have written about Swat – was the work of the woodworkers: carved architectural elements and furniture. These showed that until the Mongol attacks of the 13th century – if not until the Pashtun invasion in the 15th century – the Swat valley had been an area traversed by traders and pilgrims, close to a branch of the Silk Road, and that traditions from the old Gandhara empire, the Indus valley, central Asia, and the east Iranian region all intermingled there (see the section on history in the Appendix).

However, all this will not be appreciated by the cursory viewer – it requires careful research. If the carved wooden ornament of Swat is looked at through the eyes of a classical archaeologist, what is most noticeable is the survival of ancient classical traditions through Gandhara. The Islamic archaeologist or art historian sees connections with the eastern Islamic traditions in ornament between the 9th and 14th centuries AD, the woodcarvings of the Moghul empire, or, if he is familiar with them, with the stone relief ornament in the Chaukhandi graves in the Sindh region dated to 16th/17th centuries AD. These in their turn have forerunners which can be traced back to the 12th century. An observer less well versed in indology will see motifs which remind him of Quetta ceramics of the end of the 3rd millenium BC, others reminiscent of finds from Harappa and Mohenjo Daro (Indus culture c.2500 or 1800 BC), and will also be reminded of connections with the Gupta empire (320-535 BC). A student of central Asia will suppose that there are connections with the Bactrian cultures of the 3rd millennium, and recognize motifs from Sogdian wall paintings in Pendshikent (4th-6th centuries), as well as others from the popular art of the Pamir Kirgizes - and they are all correct. The history and geographical situation of Swat makes all these influences probable. The relative isolation of the region after the Pathan conquest of Lower and Upper Swat, the hierarchical society with its special woodworker caste which developed there, the quantity and relative durability of wood as a material, combined with the perseverence of the carvers who preserved their craft skills – and hence the stock of ornament - within the family, make the continued existence of patterns over the centuries plausible.

The foundation of the Swat State in the 1920s marked the beginning of a change in the social structure within which the material culture peculiar to Swat had developed. The final dissolution of the Swat State in 1969 and the absorption of the region into Pakistan as a district of the North-West Frontier Province hastened the process. There are various reasons for this. Transport has improved since the construction of an asphalt road running almost the whole length of the valley and the incorporation of Swat into the network of internal flights in Pakistan. Agriculture has changed from subsistence to market production, resulting in great streams of guest workers migrating from Swat to the Gulf States. Lastly, the region has been discovered by the Pakistani internal tourist industry and on a more modest scale from the second half of the 1970s by European tourism.

Looked at superficially this has resulted in a change in values. The old mosques with carved pillars and gateways were no longer renovated or replaced by new concrete structures in a standard Pakistani style. The old houses too fell into decay. People building today use concrete and bricks. In bridal processions people no longer carry carved beds, chests and chairs, but massproduced furniture – beside the veneered bed a chest of drawers with a mirror is now the showpiece. Clay cooking vessels and water pots are replaced by aluminium pots, which are lighter and easier to clean. The traditional silver jewellery in the woman's dowry has been ousted by coarse mass-produced gold jewellery. The silversmiths have become antique dealers. Anyone who still wants to see the typical neck ring of the married Swat woman has to go to some high mountain village off the road. In the same way the old costumes have almost vanished. People buying new clothes will choose either western dress or the standard Pakistani dress.

In such cases museum ethnologists often speak of the collapse of a culture and quite overlook the fact that the whole outer appearance of a culture can change without any fundamental change in the minds of the people, in their values and norms.

The code of honour of the Pathans, the Pashtunwali, still governs inheritance laws, blood feuds, as well as the sacredness of hospitality and the guarantee of shelter. Its central concept is the honour of the individual and his family. Honour and respect, and above all the protection of the honour of the women of the family, determine the rules of behaviour and set the pattern for daily life.

It is in this connection that the custom of 'purdah', the veiling of women, the physical division of the areas in which the men and women live in the house, and a consequent separation of men's and women's worlds to an extent found in almost no other Moslem society, should be seen. Even if the external appearance of these two worlds have changed radically, the rules by which life is organized in them have lost none of their importance. On the contrary, the isolation of the women's world has rather increased in importance in recent years with the revival Islamic values in Pakistan.

For this reason we have decided to supplement the description of the furniture and information about the historical, geographical, economic and social background, with descriptions of life in Swat from a woman's point of view (Viola Förster-Lühe) and from a man's point of view (Joerg Drechsel) which express the personal consternation and subjective impressions of the two observers. Only in this way could we hope to do justice to some extent to the complexity of the subject.

Johannes Kalter

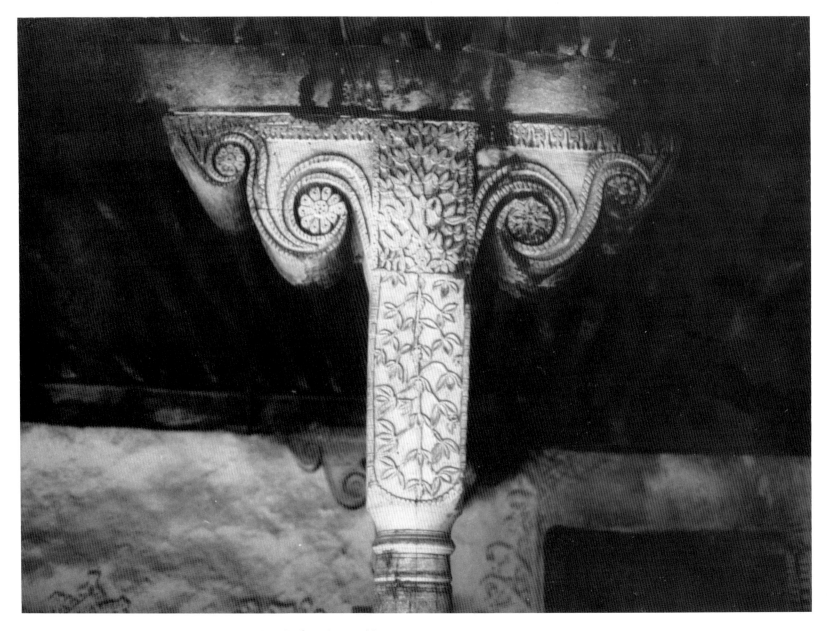

3. 'I want to turn wood back into a tree again'. Detail of a column with
   capital in the Great Mosque of Madyan decorated with a carved tree.

4. Capital with a tree motif in the centre, from a house. Linden-Museum.

# "I want to turn wood back into a tree again"
# – A material and the image of culture –

The quotation at the head of this chapter is from the mouth of a woodworker in Khawazakela and was recorded by my friend Dietrich von der Lühe. When I first heard it I was fascinated by it, although I could not have explained what it meant. But I took it to be indicative of the importance of woodworking in the cultures of the peoples of the Swat valley and my curiosity was aroused. This curiosity was amply rewarded.

Anyone who has been concerned with the peoples and cultures of the central areas of the Islamic world, from northwest Africa to north India, is not used to paying much attention to wooden objects. It is true that in the large urban centres, in princes' palaces, the grand houses of great merchants, mosques, caravan-sarais and saints' tombs, there are massive panelled doors with carved decoration, as well as carved and painted wooden roofs. In manufacturing centres in Syria such as Aleppo and Damascus furniture with intarsia work was produced – and still is today. But this is the representative art for public buildings or the houses of the urban upper class and furnishings for this class.

The wooden furnishings of the peasant population, whether in Morocco, the lands of the Arab world, Turkey or Iran, consist of a few carelessly knocked together chests, cradles of a uniform type found from Turkey to north China, mortars, funnels and stirring spoons with clumsy, usually geometric, incised or notched ornament. House furniture as we know it does not exist in their tradition. Beds are rare and there are no chairs – people sit and lie on mattresses on the ground or on bases built in to the houses. Instead of cupboards there are curtained wall niches.

I believe that this style of furnishing is not the result of a conscious decision but the necessary consequence of the scarcity of wood. The deforestation of the Mediterranean area and of

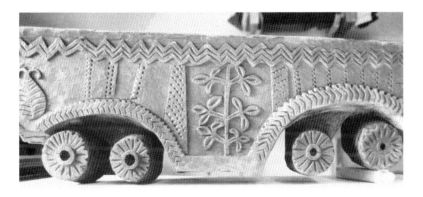

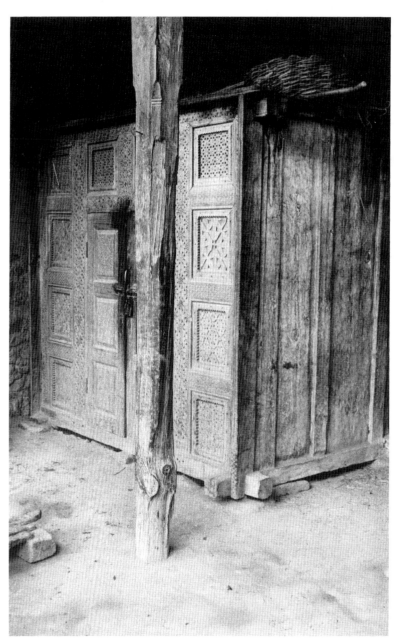

5. Walk-in chest, photographed in a house in Bajun on the border between Swat-Kohistan and Indus-Kohistan.

Anatolia and Iran had occurred in Antiquity. The situation in the wooded mountains of the Hindukush and Karakorum is quite different. Here it was not until the development of highways, which made possible the transportation of wood from the mountains to the plains, and the population pressures of the present century that the forests have been overexploited. This means that the high mountain areas of Afghanistan and Pakistan provide the natural prerequisites for the intensive utilization of wood as a raw material. Wooden architecture with varying degrees of elaboration is common to all the peoples of this region: the Pashai and Nuristani of the Afghan Hindukush, and the Kalash of Chitral in Pakistan.

If such a wealth of wood coincides with an economic and social development leading to the emergence of specialized craft professions, then outstanding achievements in the field of woodworking can be expected. This situation is found in Swat. The wood carvers in all the above-mentioned neighbouring regions practice their craft as a non-professional activity; in Swat it is their sole occupation.

7. Wooden livestock amulets and pair of bells. Animals – like people – have to be protected from diseases and misfortune. Unfortunately we do not know the meaning of these abstract geometric shapes. In combination with various types of neck ring, these amulets are often found as motifs carved on chests, on the backs of chairs, and on the doors of houses. Linden-Museum.

8. The simplest everyday objects and tools – a drumstick, a catapult, a spindle, a hammer or a plane – are decorated by the carvers with the same loving attention as the more prestigious furnishings. Linden-Museum.

9. This small selection of medicine spoons is impressive evidence that such items need not be boring: the individuality and creativity in the treatment of the handles is an object lesson for designers, and the beautifully formed handles are still suited to their practical function: they fit comfortably in the hand and ensure a secure grasp of the spoon. Private collection, Karlsruhe.

6. Large wooden ladles. The floral and geometric decoration emphasizes the beautiful shape of these simple objects. Linden-Museum.

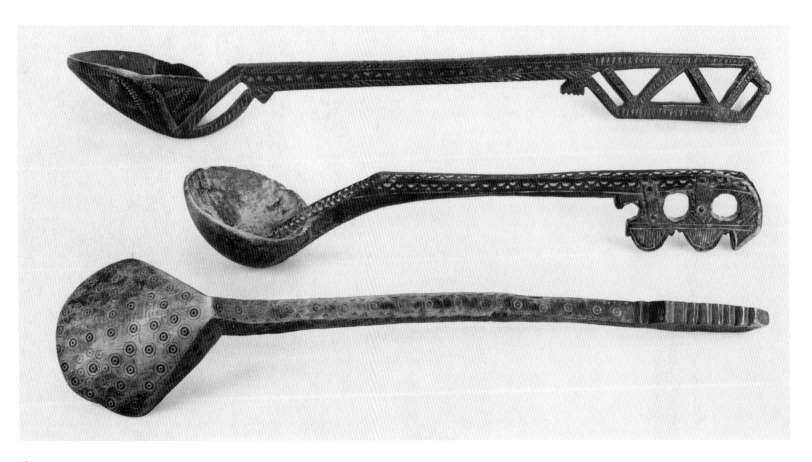

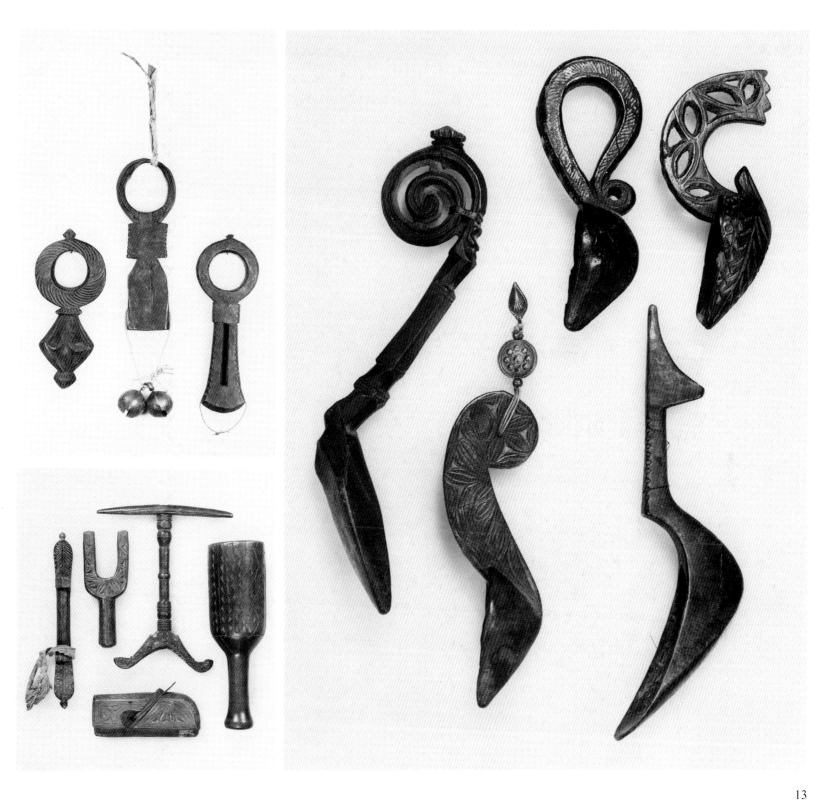

10. Mirror case with notched decoration composed of quatrefoil motifs and zigzag border. Linden-Museum.

11. The tool box of a respected and renowned woodcarver is, of course, richly carved. It serves both as his business card and as an indication of his status. Linden-Museum.

12. Turned utensils provide a striking contrast to the richly carved wooden objects. The bowls (one with a foot) and ladle are hardly decorated at all. The bare surfaces allow the shape of the vessel to stand out clearly, and it is sometimes emphasized by the sparing use of turned grooves.

When I arrived in Swat in the high summer of 1978 after a journey through the steppes and deserts of Iran and a lengthy stay in the steppes and oases of Afghanistan, my first impression was that the character of the material culture of the region was indeed marked by a skilful and imaginative handling of wood as a material. Despite all the differences between the cultures of the predominantly Pathanoccupied areas of the Lower and Upper Swat and the regions of Swat-Kohistan inhabited by Dardic groups, this impression was constantly reinforced during a journey through the whole region – from Barikot in the Lower Swat via Kalam in Swat-Kohistan to the sidevalleys of Ushu and Utrod.

Even the cursory visitor is struck by the great portals of the individual houses and mosques with their carved frames and more rarely with carved doors panels, and the carved eaves of the roofs of the houses of the well-to-do and of mosques.

Because the settlements are built on sloping sites it is possible to get a glimpse now and then of the inner courtyard of a house and see the rows of columns with their broadspreading, carved capitals. In Swat-Kohistan the traditional building style of the terrace houses was a sort of log-cabin.

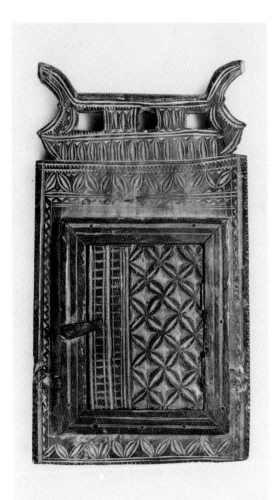

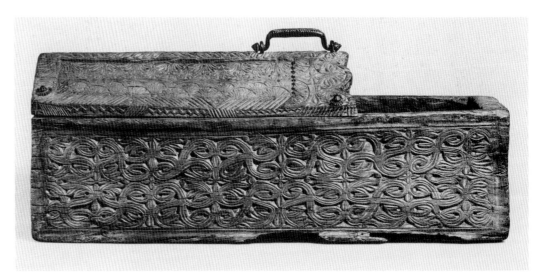

If one enters the "mardana", the guest room of a house, reserved for guests, and opening through its own forecourt, or the "hujra", the men's house of a quarter, or if Pakistani friends give one the chance of visiting the "zenana", the living area of the closer family, which is strictly protected because of the religious requirement that the women be screened from the public – a male guest can, of course, enter only when the women have retired to a closed room – one is surprised to find how much the sumptuous furnishings differ from the peasant households elsewhere in the Islamic world.

There are chests varying from those the size of a kitchen stool to storage chests more than the height of a man, shelved cupboards with the rear wall and feet set into the mud, low tables, stands of rectangular, triangular or polygonal shape for individual large clay vessels, high pot stands for several water storage vessels, wall shelves, tables, beds, chairs, stools, cradles, and lastly wooden "prayer boards" on four low feet or two transverse runners, or of a type resembling a miniature bed with a wooden surface. For their ritual prayers five times a day, Moslems require a ritually clean support. This can by a prayer rug, kelim or a woven mat. Swat is the only place in the Islamic world where prayer boards are used. After prayer the boards are propped against the wall to save space and to preserve their ritual purity.

As well as the furniture mentioned above small objects made by specialists, with carved ornament may also be found in Swat households. Carved winnowing fans; round, teardrop-shaped or rectangular livestock amulets, spoons, ladles, turned bowls, bowls with feet and plates, shoes with carved foot-supports, and children's toys. The delight in carved objects even extends the decoration of tools, such as the tubes of a smith's bellows, a cabinetmaker's plane, a wooden hammer or drumstick.

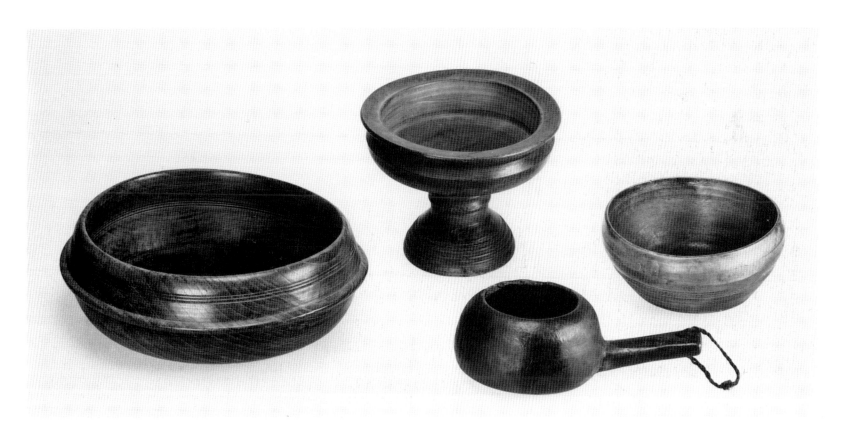

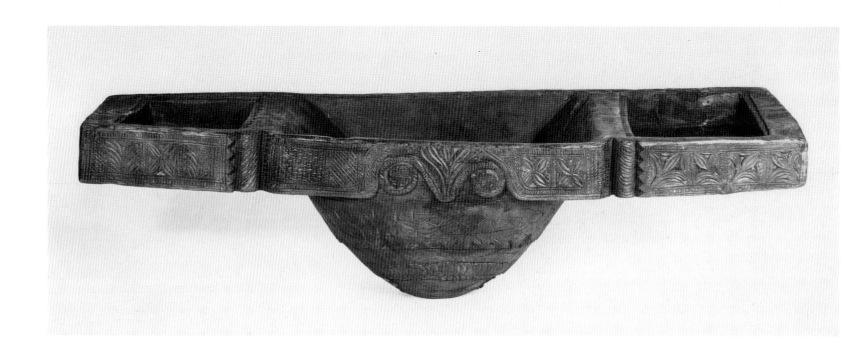

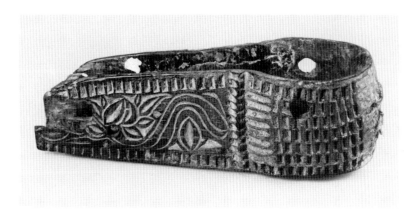

13. An opening to a mill, carved from a massive block of walnut. In the middle is a ram's horn motif combined with the representation of a tree.

14. An outlet from a mill decorated with a floral scroll and a chequerboard pattern. Both these parts were acquired in Madyan.  Linden-Museum.

15. Even a pair of bellows provides a surface which can be decorated with a foliage scroll. Linden-Museum.

The richly carved ornament on the tool box of a specialist woodworker bears witness to the skill of its owner.

In the cemeteries carved posts frequently mark the head and foot of graves, In Swat-Kohistan graves were frequently enclosed by ornamented wooden grave-borders.

The wooden architectural features of the mosques differ from those in ordinary houses only in the richness of their decoration and their size. Thus, for example, the columns are on average 3 m high and measure 80 × 80 cm with capitals up to 4.30 m wide. The specific furnishings of a mosque, like the koran-stands and mimbar, are carved. (I know of only one koran-stand made of iron, and in this the principles of construction and decoration follow wooden prototypes.) The mimbar where the preacher sits can be a sort of armchair or a high chair with three steps.

All the wooden objects mentioned above are made by craftsmen who are known in Swat at "tarkarn" and who, like other respected groups of craftsmen, trace their origins back to King David. Dietrich von der Lühe translates the term as "Schreiner" (cabinetmaker). In fact their work covers a wider range, including the crafts we would call carpentry, joinery and furniture making, turnery and carving; but their achievements as carvers are certainly the most extraordinary.

Before describing in more detail the form and construction of the individual products and attempting to place the ornamentation in the context of the various traditions, it seems useful to give a short summary of the social structure in the region.

## Social structure

In von der Lühe's words: "Since the foundation of the the the 'Swat State' (see the chapter on History in the Appendix) and the rule of the 'Wali', the social order has been in transitional from a particular feudal system to agrarian capitalism. A caste system derived from birthright (descent) which determined the distribution of land and labour, is being destroyed by the large landowners. The majority of the people are freed from ties to the land and feudal obligations, and have to sell themselves as labour to the new (and old) land owners for wages according to the laws of supply and demand."

One of the essential prerequisites for the emergence of the specific social system in the Pathansettled part of the Swat valley is what is called the "wesh" system", a regulation which provides for the redistribution of rights to farmland at particular intervals, thus ensuring that ideally there is no such thing as a landless Pathan.

The following description is taken from the dissertation by D. von der Lühe and represents the state of research in the early 1980s. In places it has been slightly abridged or expanded.

"In about 1530 Sheikh Mali establishes the system of a periodic redistribution of farmland to ensure a just portion of land to the various Yusufzai clans. 'Wesh' continued in the Swat valley, mainly because of its isolation, until well into the 19th century, and survived in a few regions until the 'Wali' abolished it.

The redistributions do not affect the area of the thirteen hereditary units, the 'tapa', but the subdivisions, 'watans', which correspond to the number of the main branches of the subclan. The 'watans' are of relatively equal quality, better land is balanced by a greater area. The right of a clan to a 'watan' is called 'daftar– the individual's right to use it is 'brakka'. This right of use is hereditary and can be acquired by members of the same subclan. The land left to non-Pakhtuns, e.g. to mullahs or 'saints' for their services as mediators, is called 'siri' or 'tsirai' and is excluded from the redistributions. These occur every five to ten years. The dependent part of the population – Pathans who have lost their portion of land and with it their status as 'Pakhtuns', all non-Pakhtuns – remain tied to the land. The 'Pakhtuns' and with them their personal servants and a few contract craftsmen move to another village which belongs to the newly alloted 'watan'."

One consequence of this movement of the landowners with the craftsmen is that carved architectural elements, for example, which judging by their distinctive style of carving and repertory of ornament must be the work of a single craftsman, may be found in various locations. Therefore, if the place where a piece of carving was acquired is not known, it is impossible to categorize it as a particular local style. Consequently in the following pages the discussion will be of the style of a whole cultural region. When I talk of the Swat style I mean works that come from the area inhabited or ruled by Pathans between the Malakand Agency and Madyan.

"To possess a portion of the 'watan' does not just mean material possession for a member of the descent group, it also determines his 'Pakhtun' status and his political role. So a distinction must be made here between the term 'Pathan', which includes every member of a descent group, both those who possess a portion of land and their dependents, and 'Pakhtun', which indicates social status, the membership of a very particular social group. Only a man who has a 'brakka' is a 'Pakhtun', only he has a place and a vote in the 'jirga'.

The 'jirga' may be described as a kind of council assembly which has the power to make resolutions but not to execute them. Every owner of a portion of land is equal in the 'jirga' and can summon it and speak in it. The assembly decides, administers justice e.g. in frequent disputes over land, but does not see to the implementation of law. Those affected have to deal with that themselves. It also undertakes the land redistribution when it occurs."

Because of the institution of the "jirga" the social structure of the Swat-Pathans has been called acephalous and anarchic. Acephalous societies are defined as those without any institutionalized central political authority, i.e. also without any generally recognized leader or ruler. In any case, this description reflects the ideal model of the society of the Swat-Pathans rather than the reality. In fact there are always individuals among the "Pakhtuns" or "Saints" who rise to become powerful "Khans" or leaders through their acquisition of land, personal services and/or their charisma. To understand the society it is important to bear in mind that this prominent position is attached to the individual and is not hereditary.

"One prerequisite for such a rise to power is what are regarded in Pathan society as the individual, personal qualities of 'ghairatman' and 'tura'. The former is the ideal character of the 'good' Pathan whose behaviour sets standards for others and who is of value to the community' (Steul, W., Heidelberg 1977, p.202); the latter is the aggressive will to succeed. Barth speaks of 'a person's willingness to lead' (Barth, F., London 1959, p.73). The other prerequisite is economic wealth, control over sources of income and the aggressive preparedness to hold on to these or increase them, for the position of a 'Khan' as leader is always under threat and must be defended in a constant struggle for followers against other 'Khans', or rival 'Pakhtuns' from the same descent group.

These struggles take a variety of forms from the permanent

holding of banquets for the followers to a permanent small war between the rival 'Khans' in which the 'Pakhtuns' are involved.

The 'pakhtuns' do not usually work the land themselves. They lease it out for a share of the harvest. The various forms of leasehold have survived to the present day, although all the land is now in private ownership and since the coup d'etat have grown increasingly close together. There are four different forms of leasehold:

1. 'ijaragar'. The land is leased for a particular length of time and a particular sum, which is usually paid in kind and depends on the quality of the land. The tenant provides his own seed, team of oxen and equipment, and himself determines how the land is used. He bears all the risks because his rent is not related to the yield of the harvest.
2. 'brakkakhor'. Here too the tenant provides seed, team and equipment, but usually not the fertilizer; but he pays with a proportion of the harvest: on the valley slopes this amounts to between two fifths and two thirds, and at the bottom of the valley up to three quarters.
3. 'dehqan'. A piece of land is assigned by the landowner to an agricultural worker. Four fifths of the harvest must be handed over. The landowner provides seed, team and equipment.
4. 'faqir'. A piece of land is assigned to a dependent of the landowner. The right to keep back the yield of the harvest is paid for in work or services and/or 'ghee'.

In all leasing agreements during the most labour intensive time, e.g. rice transplantation or harvest, the landowner assigns all his dependents, as well as strangers such as the nomadic 'Gujars', to help the tenants. Their wages too are mostly paid for in portions of the harvest.

The craftsmen or those with professions are also integrated into this system. Originally tied to the 'daftar' they produce all the necessary tools both for the 'pakhuns' and the tenants, or perform services for which they are paid with portions of the harvest. Today they are usually tied to one or more landowners by contracts and are paid either out of the portions of the harvest that go to the land owner or by a leasehold agreement ('faqir'). Especially in the larger centres along the main road some have managed in recent years to free themselves from the traditional ties and make their products independently for the market.

'Pakhtuns', the various forms of 'Saints', the various sorts of tenants, the craftsmen and the professionals together form a hierarchy in the Swat valley which Barth is bold enough to call a caste system. He not only compares it with the Indian Jajmani system, but also traces its historical foundation to that system (Ahmed, A., London 1967, p.50), but recognizes that there are serious differences in the lack of a religious foundation and the permeable nature of the barriers between the levels of the hierarchy." In my view it is somewhat problematic to use the term "caste" outside the Hindu context. I would prefer the term "status group". The word used by the people themselves is "qoum" meaning lineage, sect, people, nation, family. Although this word is used in Swat today only to describe a social stratification on the basis of function, its original meaning denotes the different ethnic origins of the various social groups. Besides the indigenous population, which is represented by the remaining Kohistani groups and most of the tenants and craftsmen, and the "Gujars" and herdsmen, there also seem to be descendants of the Dilazak and Swati in some tenant groups. The "paracha" group of the mule drivers claim Bengali origins. The leather workers are recent immigrants from the Punjab. The barbers class themselves as a separate barber caste to be found all over Pakistan and north India. A person is born into his "qoum".

"In the figurative sense of a feudal ruling class the word 'caste' is most applicable to the 'pakhtuns'. Their group identity is derived from birthright and a portion of land and compels them to a deliberate political and social action to protect group interests, the aim of which is the maintenance of their position of power." Citing Barth, von der Lühe lists 23 "qoum" groups in Swat.

| Function | Pakhtu name for the "qoum" |
|---|---|
| Descendent of the Prophet | "Sayyid" |
| Saints of various levels, | "Sahibzada" |
| landowners and arbitrators | "Mian" |
| in conflicts | "Akhundzada" |
| Landowners and warriors | "Pakhtun" |
| Mullah | "Mullah" |
| Shopkeeper | "Dukandar" |
| Muledriver | "Paracha" |
| Tenant farmer | "Zamidar" |
| Goldsmith and silversmith | "Zaerger" |
| Tailor | "Sarkhamar" |
| Woodworker (cabinetmaker) | "Tarkarn" |
| Smith | "Inger" |
| Potter | "Kulal" |
| Oil presser | "Tili" |
| Cotton comber | "Landap" |
| Weaver | "Jola" |
| Leather worker | "Mochi" |
| Agricultural worker | "Dehqan" |
| Herdsman | "Gujar" |
| Ferryman | "Jalawan" |
| Musician and dancer | "Daem" |
| Washerman | "Dobi" |
| Barber | "Nai" |
| Rope and sievemaker, dancer | "Kashkol" |

"These lists, which also define a social hierarchy corresponding to the status of the individual 'qoum', show the degree of the division of labour in the agrarian society of Swat.

Only a few occupations can be combined with others. Thus a 'mullah' is expected to support himself as a tenant farmer or shopkeeper, woodworking can be combined with blacksmith's work, but the further down the hierarchy one is, the more difficult such a combination becomes. Thus it is impossible to combine oilpressing and tenant farming, tailoring and shopkeeping, or leatherwork and ropemaking. Also 'qoum' and occupation do not always have to correspond. Up to a certain point the occupation is matter of free choice, and a change in 'qoum' status so that it reflects the actual profession only occurs some generations later.

What are exchanged are mostly services. Each group serves the others reciprocally, while services are provided for the 'pakhtuns' and the various landowning 'saints' on a more onesided basis. The landowner is at the centre around which the production and reciprocal exchanges turn.

Such a production and exchange system is autarkic because within its boundaries all requirements can be satisfied. For such a system to work the reciprocal services which each participant is required to provide must be clearly established and strictly demarcated." For our purposes it is important to make clear that the landowner's relationship to the craftsmen is clearly that of a client. The landowner creates the economic setting required for the work of the craftsmen, who provide the products that he needs to a quality which enhances his prestige.

"Now that the 'wesh' has been abolished and land can be sold, and there is the slow development of a modern infrastructure through administration, road and telephone links, the beginnings of electrification etc., and above all an increasing use of money, all social relations are in the process of dissolution. Professional groups are emerging freed from the old connections to the land or landowners. Traditional trades are given new tasks. The muledrivers ('paracha'), for instance, become truck or minibus drivers controlling the transport of goods and people. Besides landless 'Pakhtuns' it is the members of the craft 'qoum' who crowd into the new professional groups. But only relatively few of them succeed in 'rising' in this way. Most sink to become daywage earners as agricultural labourers or ancillary workers for the the large landowners. Thus as the boundaries of the 'qoum' system become increasingly porous, they are relaced by the modern barriers of social status based mainly on income.

Also in such a money economy the handmade product loses its specific or work-intensive quality, and is replaced by the mass-produced factory goods in the bazaars which they cannot compete with."

The objects in the collection published here were made in a period when the social structure described here was still largely intact. Von der Lühe's investigations – together with other reports known to me and my own observations – indicate that until very recently there were basically no differences between the furnishing of households of different social classes. The difference was only in the number of objects whose production was connected with great expense. A landowner or shopkeeper had more and larger chests than a weaver or agricultural worker; beds comprising a wooden frame with leather webbing were found in all classes, but the de luxe versions with carved headboard were found only among the well-to-do members of the upper class, simple stools with square wooden frames are found more frequently than chairs with backs – which are usually carved. Wooden pillars were used as supporting elements in the houses of agricultural workers and those of landowners – though in the former case they are roughly hewn, and in the latter they have carved ornament. To that extent this publication does not give a truly representative picture of a culture but presents only the peaks of its achievement.

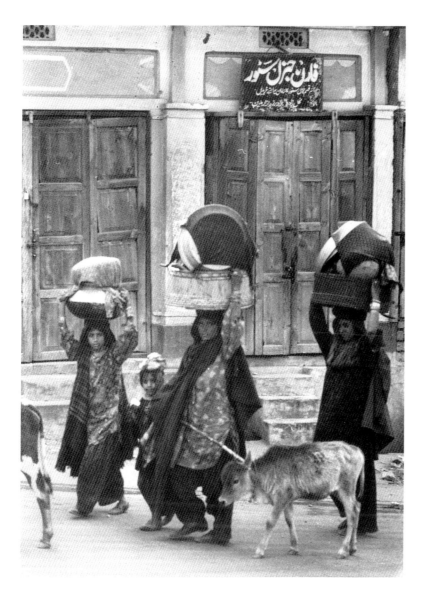

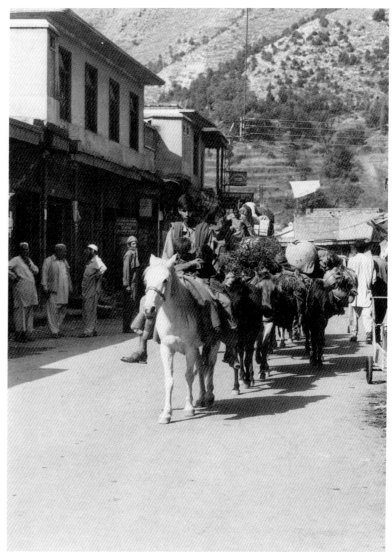

17. The main street in Madyan.

16. Gujar women and girls in the main street of Madyan.

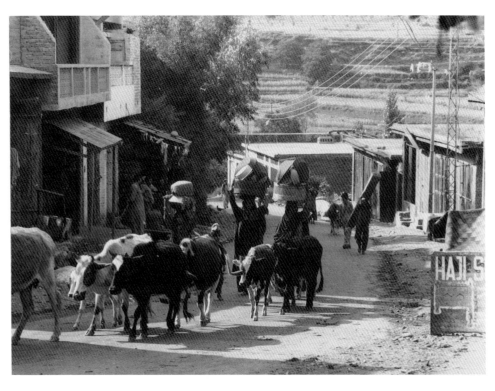

18. Gujars on their migration to new pastures passing through the main street of Madyan.

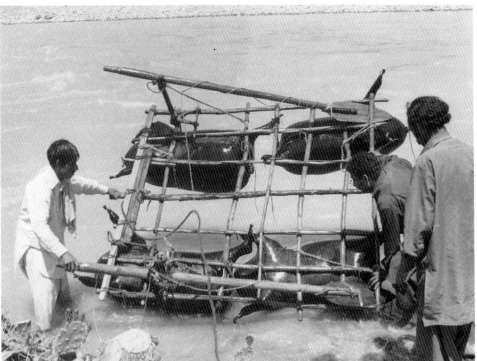

19. Raft supported by inflated animal skins near Mingora. This method of crossing rivers is mentioned in ancient sources.

# The House ('kor')

Dietrich von der Lühe

### Building type

The houses are mostly rectangular and are massed together in the villages so that there is hardly any surface that is not built over apart from the narrow streets (which sometimes widen to form areas like squares), the small forecourts at the entrances to some of the houses (most of which are in fact roofed), and inner courtyards.

A house consists of a number of enclosed rooms and roofed and open courtyard areas ("gholai"). The enclosed rooms are situated in the part of the site furthest from the entrance to the street or on walls which do not adjoin the street. The size and location of the roofed and open courtyards can vary. The open courtyard may be anywhere between the wall(s) separating it from the street and the enclosed rooms. But there is almost always a roofed courtyard connecting the entrance gateway and the enclosed rooms. Only one roofed space, which is always used as a guest room, may be situated directly beside the entrance gateway.

The whole of this ensemble of enclosed rooms, covered and open courtyard, guest room (if it is present), as well as a veranda-like canopy over the outer wall to the street, forms a unit: the house or homestead, called a "kor".

A "kor" may have a length and width of more than 25 m. Its area can vary between 100 and 500 sq m.

At the bottom of the valley only one-storey houses are found. On the slopes the rooms can straddle two terraces to form a single building. In these cases the roof area of the rooms on the lower terrace functions as a courtyard in front of the rooms of the upper terrace. All buildings have flat roofs.

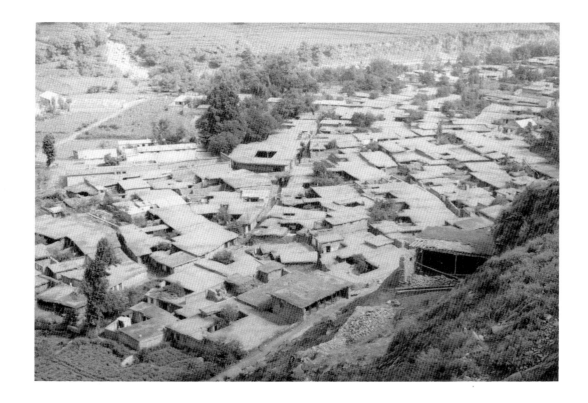

20. View over the roofs of Khwazakhela.

23

## Building methods

The building material used is determined mainly by the geology of the immediate vicinity. Smooth stones from the river bed or rough stones, depending on the location of the village and even the site of the building within the village, are used undressed.

Mud mixed with chopped straw is used as mortar, flooring and roofing. Where plenty of mud is to be found in the area the outer walls and some or all of the inner walls are plastered with it.

The supporting or weightbearing elements for the roof and the wall supports or horizontal halftimbering are of cedarwood.

Another building material is brushwood or wattle, plastered with mud and used for the non-loadbearing walls or the roof.

Because of the danger of earthquakes the roof construction is relatively light. The roof covers the whole area of the house, except for the open courtyard, with no changes in level.

The ceiling is supported on long beams, usually spanning the narrow side of the building, which rest on the walls about two metres apart. Their weight is also partly borne by cedarwood pillars placed in rows under the beams between two and three metres apart, thus articulating the large space in the roofed-in courtyard. They are richly carved and have capitals.

## Dwellings and living conditions

Almost all houses have only one entrance, even when they adjoin a street on two sides. It consists of a solid wooden gateway which is often richly carved. Where a guestroom is situated in the front of the house towards the street, it has its own entrance; a direct connection between the guestroom and the rest of the building is not customary.

Behind the entrance door the "zenana" begins. Often there is a wall directly behind the entrance door which serves not only to preserve the completely enclosed interior of the house from prying eyes, but also as a bullet-screen in case of sudden attacks.

The enclosed rooms of the house only have doors to the covered or open inner courtyard and occasional small ventilation windows opening to the courtyard. There are never windows to the street; except for the entrance gateway the house is completely enclosed by a blank wall.

The only other way out is over the wide roofs. These can be reached from the courtyards by means of simple ladders or tree trunks in which notches have been cut as steps. Normally only women and children have access to the roofs, because it is possible to see into the neighbouring houses from them.

At the centre of each house is the courtyard, or "gholai",

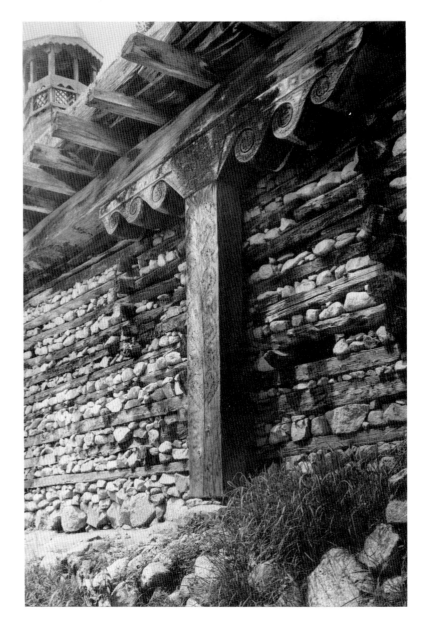

21. The outer wall of the mosque of Bahrein demonstrates the building method in the region: alternating courses of layered rough stones and massive wooden beams. The size of the pillar and the corresponding extent of the capitals are typical of mosques in Swat-Kohistan. In the region of Swat settled by Pathans they are considerably more modest.

22. House between Madyan and Khwazakhela built in the traditional manner.

23. View down a street in Madyan. Winter provisions and fuel are stored on the roof.

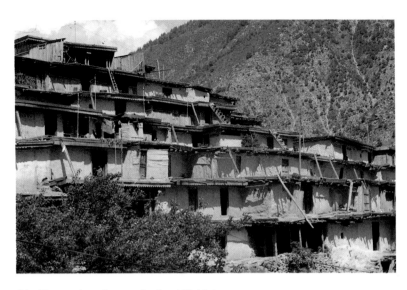

24. Terraced settlement in Swat-Kohistan.

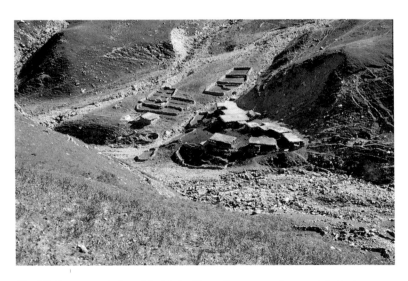

25. High pasture below Mankial with cattle pens and mountain huts.

which is partly covered and is divided by rows of pillars. This is the living area for the women, girls and children of the families, which often number as many as twenty members. It is where the baby's cradle is hung, where the open fireplaces and cooking places are situated, where the richly carved wooden stands or clay benches for waterpots are placed. It is the sleeping area for the greater part of the year, the place where the tools for the household, for handiwork and for farming are stored, and where the head of the family practises his craft. If there is a milch cow and a few animals such as sheep, goats and chickens, they too are kept in the "gholai".

There is always at least one enclosed and roofed room. It is connected with the "gholai" by a door which again is usually richly carved. Nowhere have I been able to find more than four such rooms. They are used as storerooms for grain, and the clothes chests, ammunition and jewellery are kept in them. In winter people sleep in these rooms and in summer they are occasionally used by married couples.

In the Swat house grown-up sons and very close male relatives may enter the house – after all, some of them work as assistants to the father, if he practises his trade there – but not only do they spend all their "free time" in the "hujra" like the father, they also sleep there until they are married. No stranger may enter this area.

Some houses, mainly those of the upper social classes, have a semipublic area, the "guest room", called "betak", in the front section facing the street, or more rarely a "veranda" open to the street. They are situated either in front of or next to the entrance gateway and are places where business negotiations can be conducted, guests and strangers can be received and entertained – though always only by the master of the house or his sons.

The sealed off interior of the Swat house fulfils the requirements of the "purdah" system which demands the isolation of women and girls from public life, and at the same time satisfies its inhabitants' need for defence, acting as a single building and even more so in combination with its neighbouring buildings with its narrow entrances approaches, its strong windowless walls, the fewness and strength of its entrances, and the wide open complexes of flat roofs, it forms an easily defensible fortress.

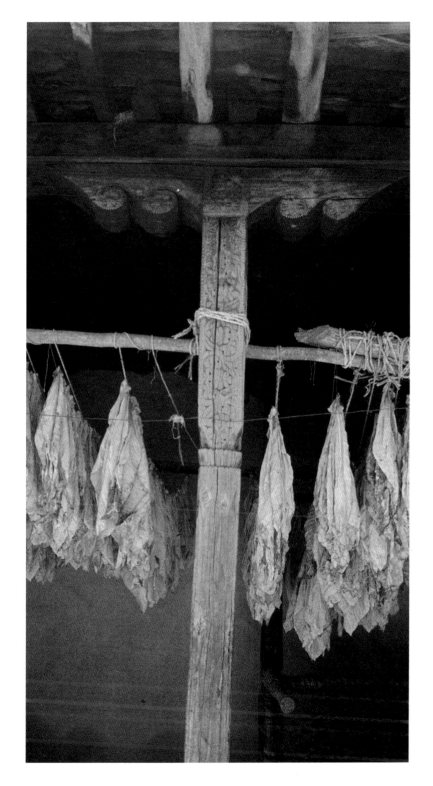

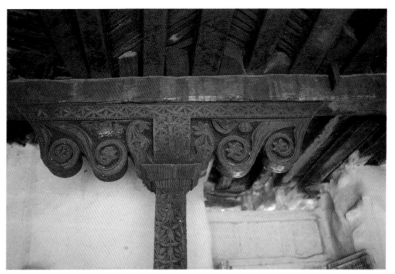

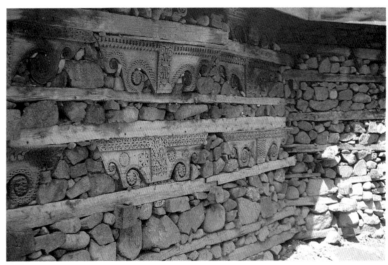

26. Bunches of tobacco leaves hung out to dry in a house in Khwazakhela.

27. The structure of a house seen from below.

28. Façade of a dwelling diagonally opposite the Great Mosque of Bahrain. The size of the reused capitals suggests that they come from a mosque built in the last century.

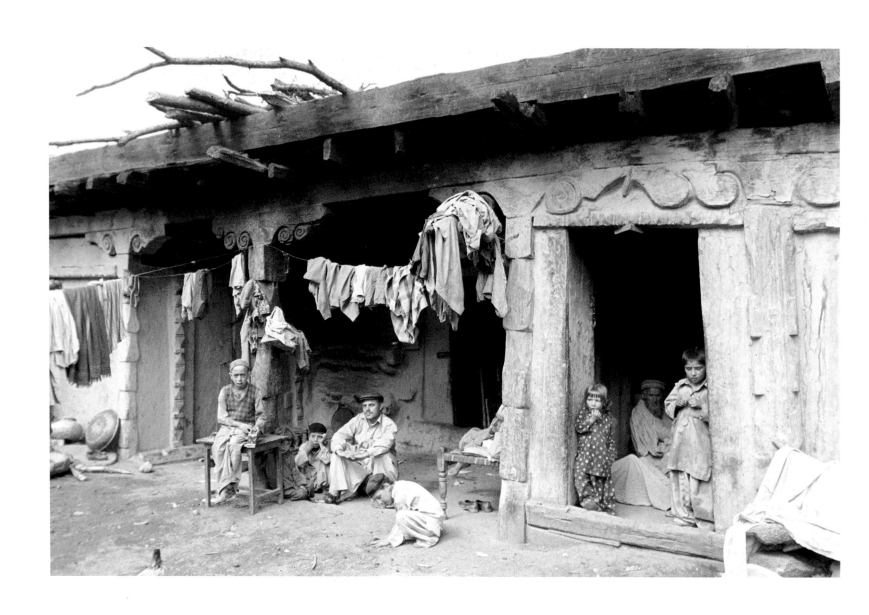

29. Mardana – terrace of a house in Swat-Kohistan.

30. Landscape in Swat-Kohistan, a day's walk up from Madyan. In the foreground is a cemetery with the wooden borders to the graves usual in Kohistan.

Pages 30/31:

31. Rice fields ready for planting near Shin.

32. Rice threshing and irrigated rice fields just outside Khwazakhela.

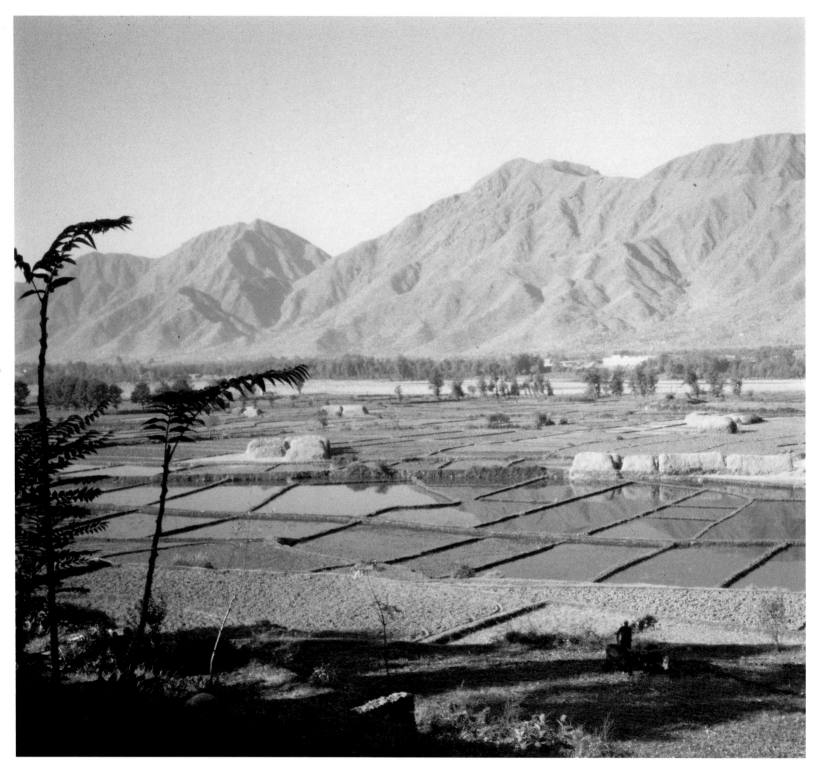

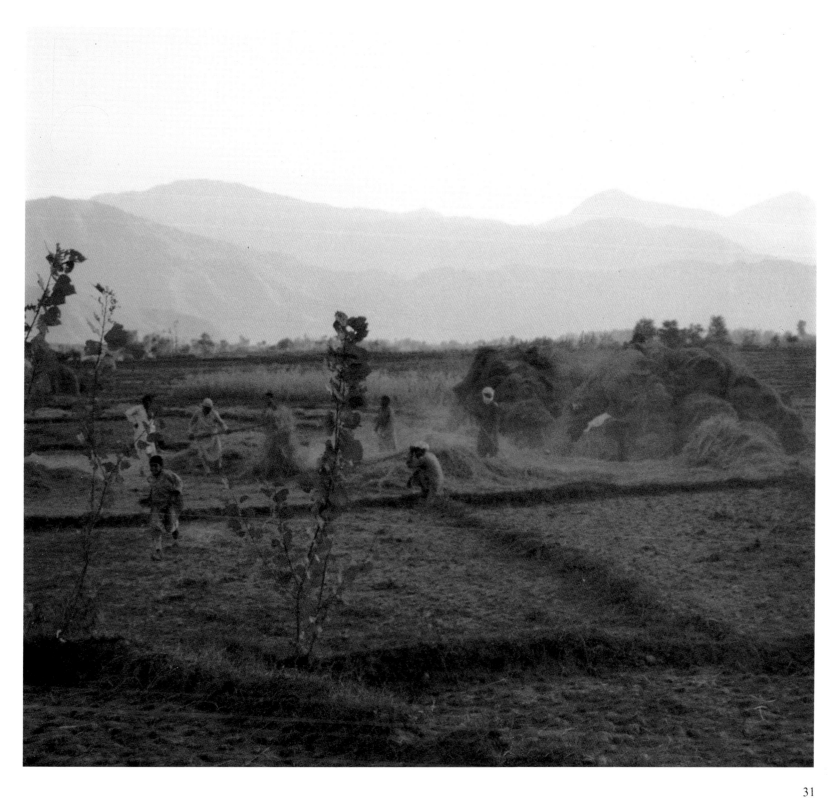

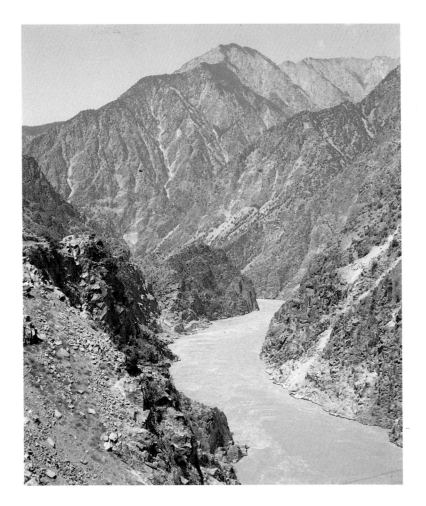

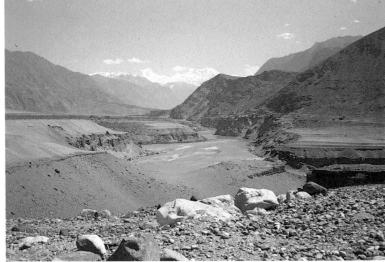

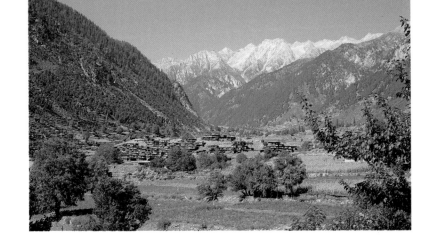

33.–35. The contrast between the barren mountain landscape with Indus glacier or a view of the Indus valley, and the photograph of a village on the upper Panjkora clearly illustrates the exceptional situation of the high mountain oasis of Swat with its valleys, compared to the inhospitable mountain deserts of the neighbouring regions.

36. A Gujar family on its migration to the valley. These nomadic herdsmen traditionally use mules for the transport of their household goods; only in very recent times have camels also been used. But considerable burdens are also carried on the head.

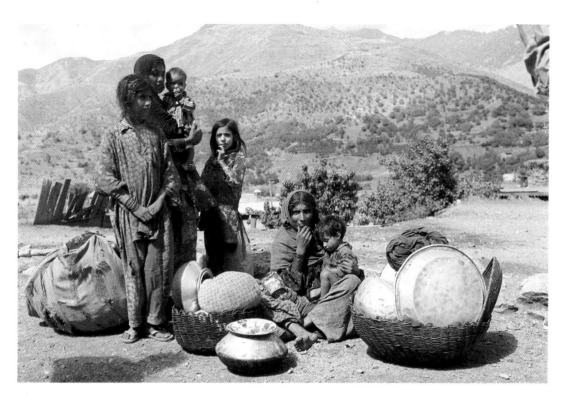

37. Gujar woman in Madyan.

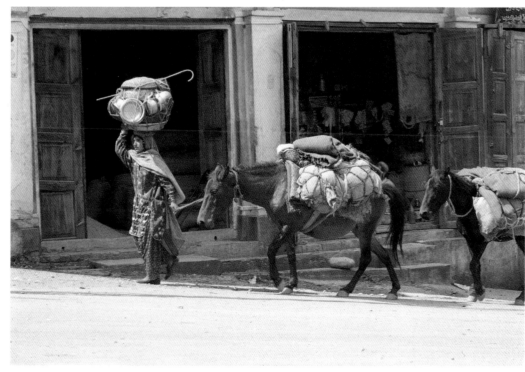

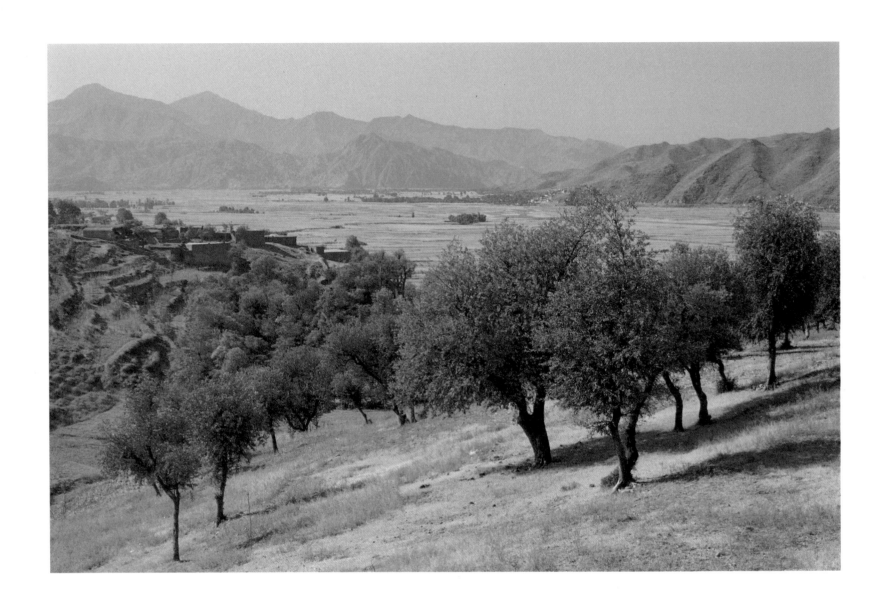

38. View across the wide valley to the heights between Mingora and
    Khwazakhela.

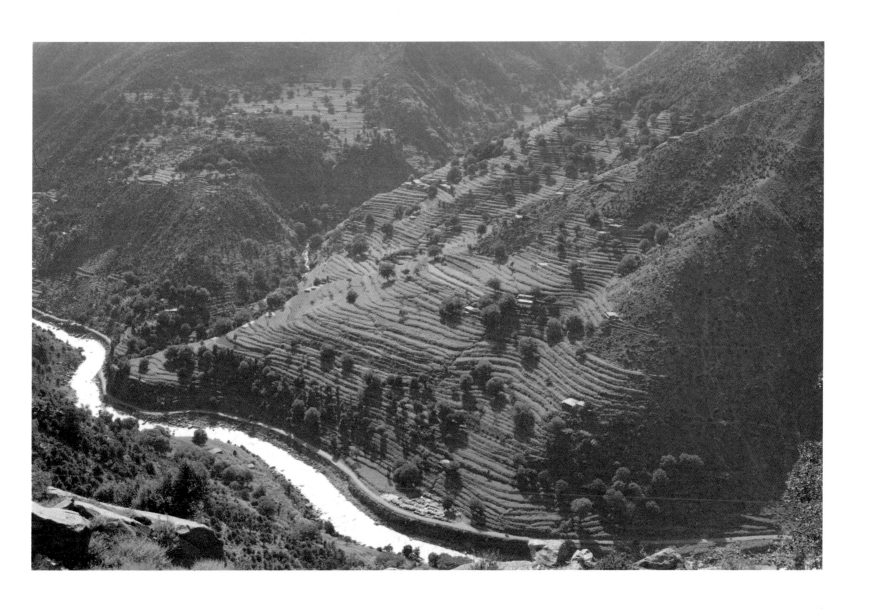

39. Valley above Madyan. Only by means of terracing can soil erosion on the steep slopes be avoided. It is also necessary for irrigation.

Page 36:
40. High meadows in Swat-Kohistan. Here the Gujars pasture the herds of cattle belonging to the landowners from the valleys.

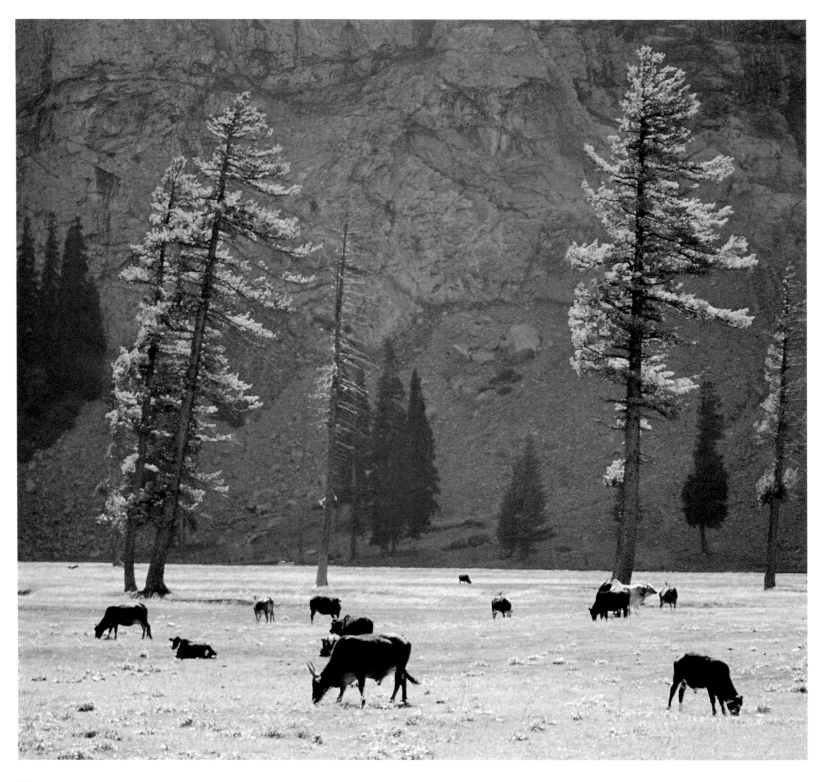

# The Lives of Men and of Women in Swat: Hujra and Zenana

Margareta Pavaloi and Johannes Kalter

The roles of women and men in other cultures, their relationship to each other and the institution of marriage have always held a particular interest. This is not surprising since these subjects not only have to do with basic emotions, they also raise particular problems in our own culture. Yet it is precisely the emotionalism inherent in these matters, our own understanding of ourselves (as men or women) and of what is normal, natural or desirable, which forms an enormous barrier to our understanding of a different set of emotions, a different set of norms. To overcome this personal and emotional barrier by intellectual means we must see that our own standpoint and behaviour patterns are relative, and recognize that our norms and ideals are not self-evident, universally valid principles but culturally and historically influenced phenomena. The understanding of another culture, and with it of another set of norms, depends not on personal reactions, and shared emotions and values, but on intellectual relativism and distancing.

How seldom this is successfully accomplished is evident from the numerous – often contradictory – reports about marriage and relations between women and men in other cultures, which veer between glorification and disapproval, depending on the time in which they were written and the personal standpoint of the writers.

This dilemma between emotional, personal reactions on one hand and intellectual standards on the other becomes particularly acute when one is confronted with conditions like those pertaining in Swat. The spatial separation of men and women – the men's life is mainly passed in the "hujra", the women's in the "zenana" – and institutions such as the code of honour and "purdah" (the seclusion of women) seem particularly extreme.

How can we possibly understand the code of honour, "purdah" and the specific relationship of men and women in Swat?

Certainly not by looking at these matters in isolation; they must be seen in the context of social and economic conditions, of the values and ideals of the people of Swat, taking into account the whole cultural world in which men and women move, in which they marry and seek to realize their goals and ambitions.

It may help our understanding to consider how we might describe to a member of another culture the coexistence within our own society of love matches, the total rejection of all marriage, good marriages, socially desirable marriages among

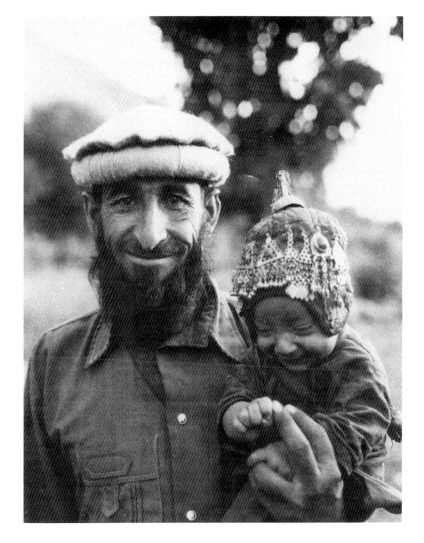

41.  Kohistani. The woollen caps are the last remnant of Dardic male costume. The pieces of jewellery on the child's cap have a significance as amulets and come from the village craft centres of the Swat region.

43.  Zenana. The zenana is the living area of the house reserved for the women and the closest male relatives.

42.  Hujra, Lower Swat. The hujra is the traditional meeting place for the men and also serves as a guest house.

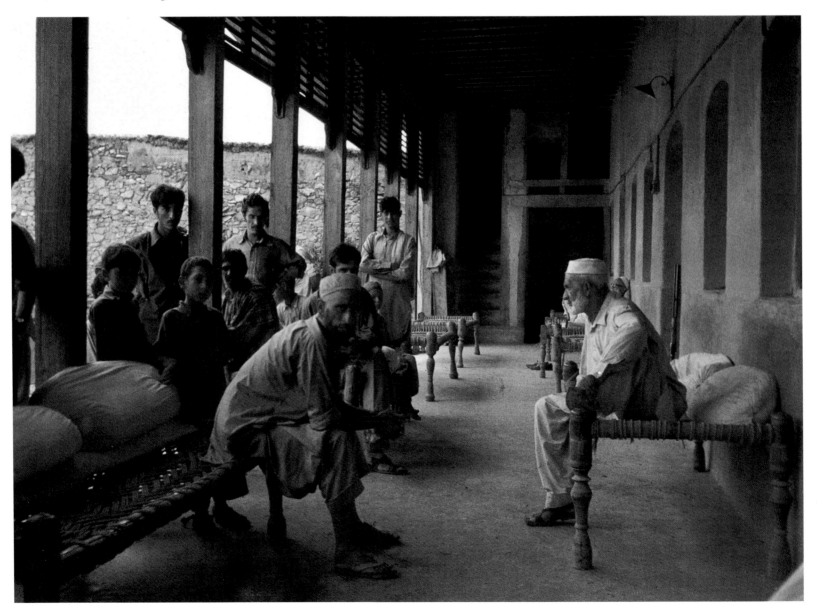

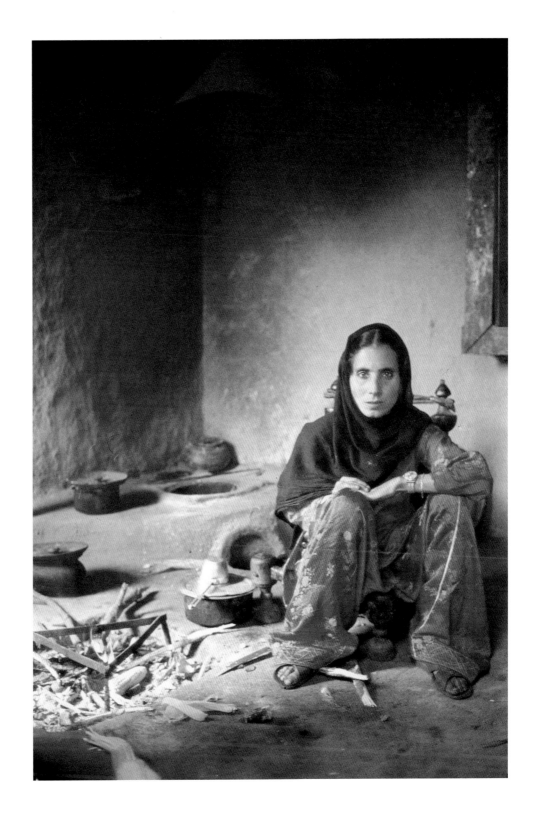

industrialists and the aristocracy, the "new men" and radical feminism, and what generalizations we would draw from this.

The self-image and sense of their own value, the public or private recognition of men and women in Swat, are bound up with their socially determined roles and their expectations of fulfilling them.

The technical term "patrilinear segmentary lineage" describes the social (kinship) model of the Yusufzai-Pathans. It means that all Yusufzai can trace their ancestry back in the male line to a common ancestor, Yusuf, the founder of the whole clan. All the segments (i.e. all the kinship groups) of a male line feel that they are equal to each other, and all men have the same rights to the family-owned land. Genealogy and inheritance rights therefore depend on the male line. Despite this egalitarian ideology there are disagreements, as the stronger individuals and families seek to dominate the weaker families and dispute the ownership of their land.

The ownership of land has been the prerequisite for the status of "Pakhtun" since the Yusufzai settled in Swat in the 16th century. Only the possession of land enables a man to be fully accepted in the circle of influential men, to be a member of the class that dominates politically. Only then is a man able – and indeed expected – to fulfil completely the dictates of the code of honour of the "Pashtunwali". To lose his land means to lose his honour as a "Pakhtun". This means that the families make every effort to secure their land in any circumstances. In the present situation with overpopulation and shortage of land the competition for land is fierce.

This competition also occurs between fathers and sons, and among the sons themselves. The fathers draw their authority and position from their ownership of land, and at the same time they use it to deny their sons the possibility of acquiring authority, status and above all independence.

The relationship of the sons to each other, to their father and to their male relatives in the male line is determined by latent rivalry and concealed aggression. Their interaction is strictly formal, in contrast to their behaviour towards their mother's relatives to whom they feel affection. Nevertheless if it comes to it they cannot rely on the support of these maternal relatives. In the segmental system sketched out above allies are found only in the father's camp. A boy will thus have his emotional relationship with his maternal uncle (his mother's brother) and a more ambivalent and hence distant and formal relationship with his father. Nevertheless, it is his father who remains his model.

His strongest rival is his cousin, the son of his father's brother, since he has a claim to the land of their common grandfather. He is also often at the same time a relative by marriage, since – for the reasons given above, though with little success –

preference is given to marriages with one's father's brother's daughter. A man's greatest rival is also his most dependable ally if a conflict arises. Alliances are made within the patrilineal kinship and are constantly changing since the men are continually involved in struggles and rivalries for influence and honour.

The premise for these continually shifting alliances lies in this type of kinship structure which has the possibility of splitting into very small interest groups and yet also of creating large coalitions when the need arises. This is best summed up in the formula: I against my brothers, my brothers and I against our cousins, and my brothers, my cousins and I against the rest of the world.

These guidelines founded on the kinship structure combined with a particular ethos (the code of honour, the Pashtunwali) and economic basis (here ownership of land), result in an extremely complicated network of rights, duties and moral norms determining a persons's decisions and actions.

The guidelines arising from the social structure (traditional law) probably exercise a considerably greater influence over the individual than external controls (civil law, Islam, religious law) ever could. There are often conflicts in which the rights and norms which have developed from the social structure quite often prevail.

The stress imposed on the men by their involvement in external alliances and internal rivalries is intensified still further by the striving to attain the ideal of an autonomous and autarkic family, the ideal of the free, individualistic, selfdetermining Yusufzai who is bound only by honour. It is obvious that this ideal goes against the necessities of reality. The safeguarding and defence of personal honour, family pride and low esteem for everyone else form the main basis for behaviour and identity.

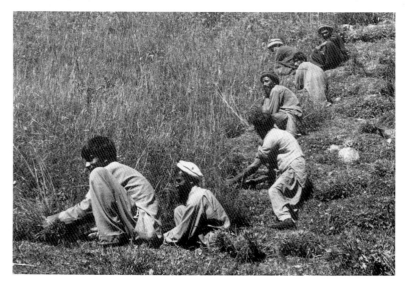

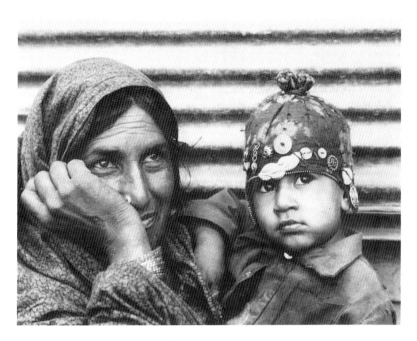

45. Torwali woman on a visit in Madyan. Torwali are members of the largest Dardic linguistic group in Swat-Kohistan.

46. Group photograph in the zenana.

44. Grain harvest in Kohistan. Work in the fields is done by the men.

They apply not only to men but also to women. In the eyes of the women any man who is not a member of their own family is not worth much. Consequently every marriage agreement is strained because it basically amounts to forming a connection with a person who cannot possibly be regarded as one's equal. Both the man and the woman are prepared to defend their personal honour and that of their family.

All this makes marriages a tricky business since they expose contradiction between the reality of interdependence between families resulting from a marriage, and the ideal of autonomy.

How sensitive the reactions to this can be is demonstrated by the fact that the bride's family are most unwilling to let her go and the arrival of the bridal procession at the bridegroom's house often results in a conflict. When war drums are sounded at weddings this is more than a mere custom. Even if marriage and home life are shielded by the walls of a "purdah" household, they are still far from making a congenial home. The marriage partners do not know each other, they have never seen one another before, so it remains to be seen how and if they react to each other.

The marriage begins as a "relationship with the enemy". At the celebration only the guests participate. The bride sits motionless in the courtyard of her new home hoping that her husband will be pleased with her and that he will treat her with the respect due

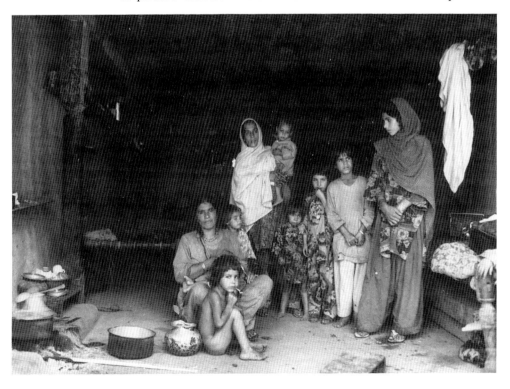

47. and 48.  Bridal procession near Ramet.  The bride is brought in a
decorated litter from her parents' house to the house of her
future husband.  The children's cradle is used as the litter.
Her household goods are carried with her to display her wealth
and enhance the reputation of the family.

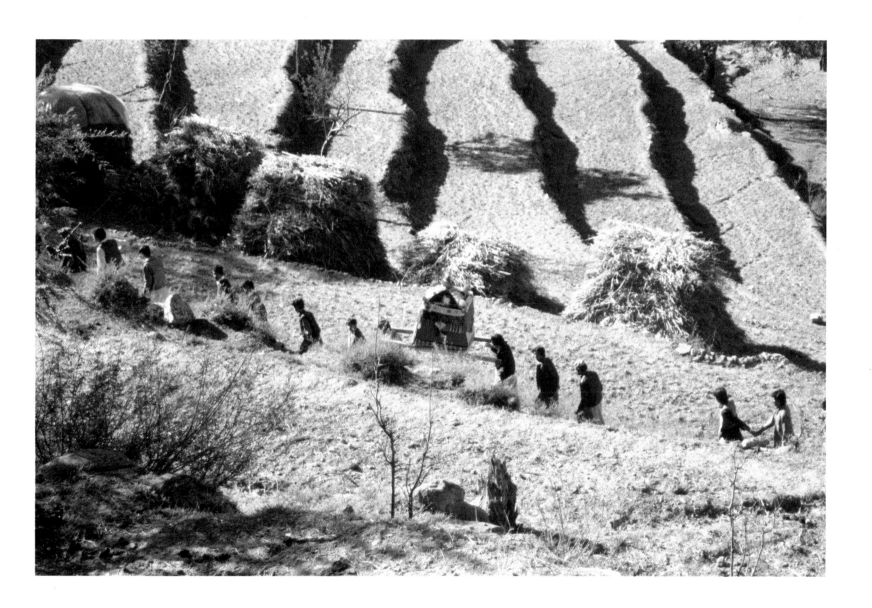

to her, for in her own eyes she comes from a good family and her family pride and personal sense of honour are as pronounced as a man's. She will also have taken to heart the advice her mother has impressed on her: for a successful marriage she must control and dominate her husband.

The bridegroom, who also takes no part in the festivities, waits apart in the hujra. The marriage is shaming to him, it puts a sudden end to his ideal of freedom and independence – for ever, since divorce is forbidden. At the same time he hopes that his bride will be gentle and placid. This is a wise hope, since women are not brought up to be obedient and submissive, or to be loving and loyal to their husbands. On the contrary they are taught to fulfill their own ambitions and goals in marriage. These traditionally involve having their husbands and households fully under their control, forming bonds with their sons, and finally establishing themselves as "matriarchs" of a proud and successful line.

While marriage has little attraction to the man, since it adds domestic worries to the stress he already experiences from the outside, to the woman it is a means of attaining position and influence. It is for this reason that the early stages of a marriage are marked by tensions as each partner attempts to assert his or her position.

The women are not afraid of conflicts, since their personal pride and ambitions are much stronger than any fear of violent clashes. Women do not shy away from provoking their husbands, insulting them or – if it comes to it – striking them back. The situation usually becomes rather less tense after the birth of the first son because the wife has guaranteed the continuity of the male line and thus gained respect and position.

A husband cannot avoid domestic conflicts, because his reputation and honour depend on the behaviour of his wife and how well she keeps her house under control, women are aware of their power and their ability to ruin the reputation of their husbands and are therefore feared by the husbands. They try to control this ability – purdah is a means of doing this, since the husband hopes in this way to exclude any improper behaviour on his wife's part. It is no coincidence that the masculine ideology paints a picture of a woman who is incapable, weak and in need of protection, nor that outside the house a man will avoid making any mention of his wife or asking after anyone's wife, since the question touches on of the most sensitive spots in a man's honour.

If a husband does not manage to arrive at a modus vivendi with his wife, if he is no match for her, the wife is free to behave as she chooses. It will not taken amiss by anyone since it is entirely her husband's problem if he cannot assert himself. His wife indeed expects him to assert himself, but if he cannot

manage this in matters outside his house he can expect neither sympathy nor consolation from her.

Even if the couple like and respect each other and admire each other's will to assert his or her claims, they – and particularly the husband – will not show this either in public or private. They are too much afraid of revealing any sign of weakness in this way.

If a man in a unsuccessful marriage attempts to improve his situation by marrying a second wife (assuming he has sufficient financial resources), he usually only manages to make his position worse. Even if she cannot stand her husband, the first wife will regard this step as massive injury to her honour, and will do her utmost to repair this damage. "You can tell an idiot by his second wife" is a Pashtun proverb on the subject of second marriage.

Purdah does not make the wife fearful or submissive, her children and her relatives are emotionally tied to her, and remain her natural allies.

Compared with the possibilities a man has of achieving his aim in "public life", power and influence, the wife's chances of becoming mistress in her house are many times better.

The only area in which men can express their feelings, affection, magnanimity and solicitousness is within the framework of hospitality. In a society characterized by permanent rivalries and the pressure for self-assertion, friends are rare. In fact only a complete stranger can become a friend – the stranger who becomes a friend is a frequently recurring topos in the dreams of the Pathan man, but it seldom becomes a reality, unlike the woman's aim of making her house into her domain.

It should be clear that these social conditions and norms which affect the roles of men and women do not exclude individual factors. Men and women move in the field of conflict between the ideal of the autonomous family, the marriage problem with the resulting relationship between two families, the demands of the code of honour and Pakhtun status. Both men and women employ the large number of "manoeuvres" which this field opens up. Society and the role of women or the role of men are not theoretical topics of conversation, society is not an abstract quantity separated from the private sphere. Influence is not only exerted through participation in public life, and identity cannot be changed and chosen depending on the requirements of a particular set of circumstances.

Although the spheres in which men and women live may be separated from each other spatially, they are dependent on each other and social continuity is only safeguarded by careful balancing of their interests.

A husband may refuse to speak about his domestic sphere in public, but he cannot ignore it. The wife by her behaviour at home can directly determine what her husband's word is worth

in the village. This description of the areas of conflict does not mean that every person is always involved in every possible disagreement. But the possible conflicts and their influence on the behaviour of the individual, and the social norms and values become apparent in conflicts, because in such cases people relate more readily to these than they do in their daily life. One can seek a conflict – if one expects to gain respect and influence through such competition – or one can avoid it. If it becomes inevitable, one will attempt to limit the consequences.

Each is responsible for the results of his action and is obliged to show a high degree of self-control and courtesy in his relations to his fellows, for example, not injuring the honour of another out of thoughtlessness.

In this connection honour – a key word which recurs again and again in the Pathan society of Swat – is to be understood as a social concept. Honour as a central concept is the (implicit) epitome of all the social norms and values and is part of the selfimage of men and women in Swat. This means that instead of a long explanation a simple sentence will do: "It is a matter of honour."

On one hand injuries to honour are a permanent source of conflict, on the other honour is an effective guideline for correct conduct. To respect and defend one's honour and the honour of one's family, sisters and wife is not a matter of expressing a one's own psychological disposition but of doing "what is correct".

The aspects of life described above apply only to a particular class of the population of Swat, the landowning Yusufzai. Conditions for the individual professional groups, who form the clientle of the Yusufzai, are different. For example, the wife and daughters of a barber have different rules.

Swat is not shielded from change. The traditional client relationships are dissolving. Groups who previously were not entitled or required to observe the Pashtunwali and purdah now do so for reasons of prestige. On the other hand many find that purdah has become a financial problem: women have to work for economic reasons. The reactions to changes vary greatly. It is not surprising that some attempt to counter the pressure for change and reduce the trends towards dissolution by a particularly strict observance of the traditional way of life. We do not know exactly how men and women cope with loss of status, for example, and what it means for them to have to bow to different circumstances.

The authors of the following essays are not ethnologists, they bring together impressions gained during extended journeys in Swat (in Joerg Drechsel's case over the last twenty years, in Viola Förster von der Lühe's since 1978). During their numerous visits they were both based mainly in the village of Madyan, an important settlement situated roughly in the centre of the area of the old "Swat State" with the largest bazaar in Swat after Mingora.

Because of its position on a main road and its function as a centre, the cultural and social change in Madyan was already more farreaching than in more remote regions. The following reports must be read against this background.

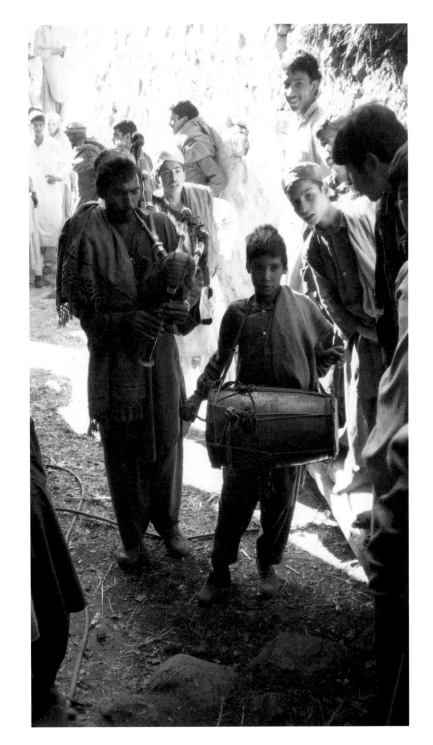

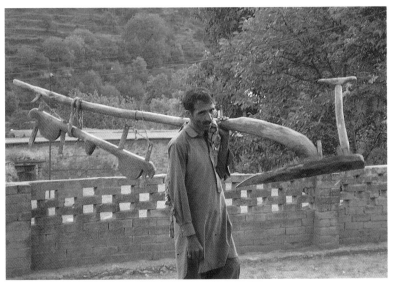

50. Bridal litter with escort in Madyan.

49. Drummer leading a bridal procession in Serlat.

51. Man in Madyan with wooden hook plough and yoke.

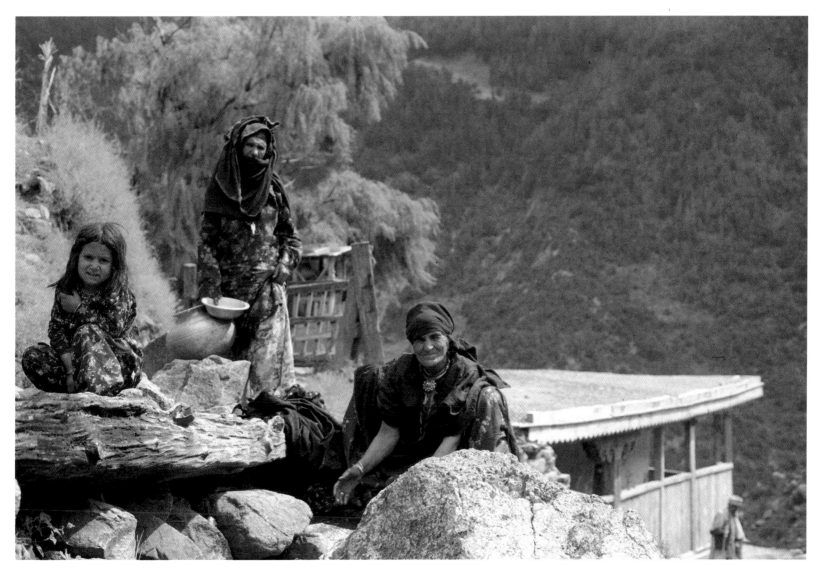

52.  Women on the roof of a terrace house typical of the upland in the
     Chail valley near Madyan.

# The Life of the Men: in the "Mardana"

Joerg Drechsel

## Problems of understanding

I was not the only one to experience the time twenty years ago as a time of new departures. Some people made long journeys, driven by curiosity and the search for something different, in my case as far as the remote valleys of Karakorum. In my eagerness for strange experiences I believed then that I understood a lot – more than I do today.

The mountains, roads and villages of Swat became part of everyday life and lost any exotic quality. But curiosity about life in all its variety remained, curiosity about the men's life among the Pathans.

One's direct impressions and one's reading, conversations and reflections, form parts of a jigsaw which is – inevitably – full of cracks. If one has not grown up in a way of life one must attempt to understand boundaries that are always new. Only to a limited extent can one comprehend feelings, and only partially share joy and sorrow, for every culture creates its own specific feelings, its own joy and its own sorrow. Much, perhaps most of it is outside one's own sensibility and therefore outside one's understanding. What can only be partially understood can only be partially judged or condemned. If this is true of the men's world, then it is also true to a much greater extent of the world of women, which a stranger is hardly aware of at all. I respect the fact that this remote mountain oasis has a world of its own with birth and death, happiness and unhappiness and all the problems that people make for themselves.

Sufi, my friend and guide, as well as being a waiter at the Swat Hotel in Madyan, came to me years ago, pushed back his hat, fixed me with his eyes and said "Sir, people without problems are animals."

## The way into the mountains

The road from the Malakand Pass follows the topography, ascending the broad valley in sight of the river most of the way, hemmed in by mountain ranges which cast shadows which shorten or lengthen, showing the time of day like a sundial. It passes through the valley as if through a treelined avenue past stupas, monuments of the accumulated history from the first four centuries of our era when Buddhism flourished.

It passes through Mingora, the small capital of Swat, with its continually growing industrial districts which enable the new technological age to penetrate into even the most remote mountain valleys.

All houses cling to the slope, terraced like the maize fields around.

Between the road and the river are flooded rice fields in which the mountains are reflected, detached and linked by irrigation channels, groups of farmsteads, the villages. The overlapping mud roofs are interrupted only by the dark caves, the openings to the courtyards, and reveal nothing of the life within.

On the road the pickups, minibuses and painted buses vie with each other to be the first to give a lift to the the next passenger waiting at the roadside. They overtake brightly painted lorries which carry all the necessities of life up the valley and transport wood and potatoes down from the mountains. Motor transport by resricted donkeys and mules to the impassible side valleys, just as electric light has restricted the use of lanterns, and television and video conversations and singing. Everywhere, in the bazaars and fields, there are men, at work, at rest, young and old – it seems to be a land without women.

Madyan is situated where the oasis narrows to become a high mountain valley at the foot of the snow-covered summit of Swat-Kohistan. This was where I lived when I stayed in Swat.

## Arrival

On arrival time seems to have stood still: it is always as if we last met only yesterday.

Friends come up to one smiling with an "asalamaleikum" on their lips and with open arms, we embrace, three times if we are good friends. Then there are always the same questions: "How are you? How is your family? How are your parents? How is your work? How is your health? Is everybody well?" And once again: "How are you?"

After this you are taken to a "hujra", or more recently to a hotel. Tea is ordered and drunk, little is said and there are pauses in the conversation which would embarrass Europeans.

We do not have much to say to each other – "please" and "thank you", banal everyday phrases. There is no cameraderie, yet there is a wordless communication, a sort of exchange of feelings and respect. After a certain time one is left alone. Food is served later by one of the younger men, a sign of particular respect.

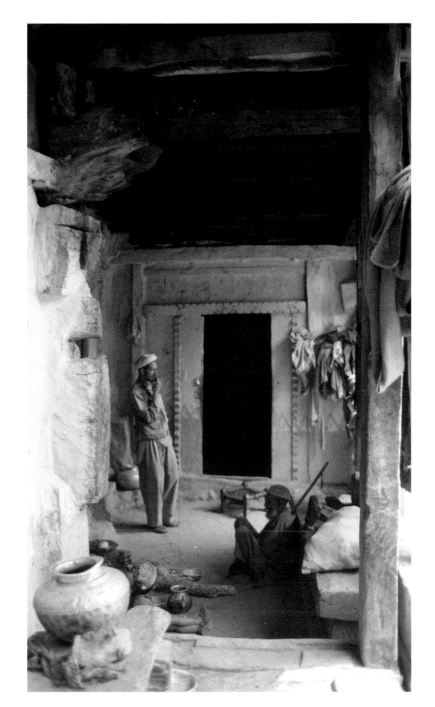

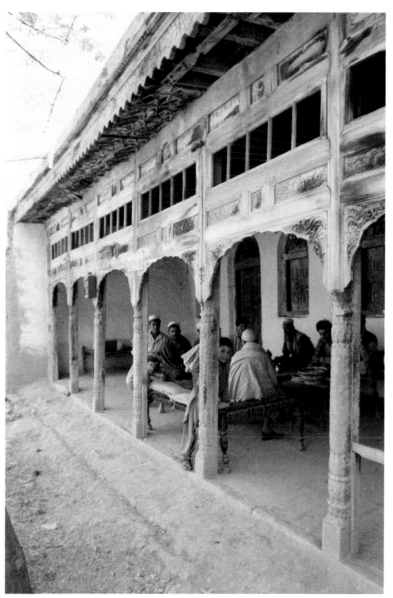

53. Men beneath the terrace antechamber of a house in Swat-Kohistan. The massive wooden wall posts to the left in the foreground are typical of building methods.

54. Hujra at Khwazakhela. The arcaded façade has been influenced by urban architecture of the Moghul period.

## Pathan hospitality

Most of the inhabitants of Swat belong to the Yusufzai, one of the Pashtun clans, like the Mohmend, Shinwari, Afridi, Khatak, Durrani and others, who inhabit the mountain region of northwest Pakistan. The sense of belonging to a clan is so strong that not even a Friesian or a Bavarian would understand it. But all the clans have one thing in common: they live according to the Pashtunwali, the Pashtuns' rigid code of honour. One of the pillars of these unwritten but iron laws is "melmastia" or hospitality.

In all Islamic countries there is hospitality, but nowhere is it as comprehensive and generous as among the Pashtuns. It means not only food, drink and shelter, but also protection – to the point of laying down one's own life to protect one's guest.

## The mens' life

From youth to old age the male Pashtun lives exclusively in the "mardana", the world of men. The world of the "zenana", of the women behind the walls and gateways remains closed to him, yet it is a deeply familiar world for it is where he spent the formative years of his early childhood in the care of his mother.

At the age of four, the time of his earliest possible childhood memories, he is circumcised. This ceremony, which is celebrated like a little wedding, introduces him to the world of men.

From then on he lives both in the world of the "mardana" and the world of the zenana, but as he approaches puberty he becomes gradually embedded more and more into the "mardana".

As a young man he sleeps mainly in the "hujra", and besides his parents' house he is also permitted to visit the houses of his father's brothers. Unlike his sisters he has attended school for a few years at least, and then has usually learnt his father's trade. Up to five times a day he visits the mosque with the other men, where he learnt the Koran as an adolescent, works in the bazaar or in the fields, depending on his trade, and spends his free time in the "hujra" or in the tea house.

At the age of 18 to 20 he is married; while still a child he will have been promised to the parents of his bride. The wedding is celebrated lavishly, often swallowing up savings made by the family over years, but makes very little change in his life. It is true that he can now discover the joys of matrimony and will be teased by his friends with jokes about his sexual potency, but he still lives with his wife in his parents' house, he is still bound up in the hierarchy of his extended family. All decisions are taken by the oldest in the family, and his wife must follow the directions of his mother. His children are born, and his power grows gradually as one generation gives way to another. He becomes the provider and looks after his parents in their old age. He pays due respect to his elders and begins to make the decisions. Thus he assumes the role of his father in the sequence of generations in the extended family, a life in which the decisions and needs of the individual are secondary to those of the group.

He is seldom at home. His social life takes place in the company of the men. There he follows the basic principles of Pashtun society: honour, masculine courage, and the aversion of shame. Life in accordance with these principles is at the centre of his awareness. Only by strict adherence to them can he gain the respect of the others, and on this respect depends his happiness as an individual.

"Women, family and money mean nothing to me in comparison with my wounded honour," a friend said to me after an opponent had taken away his pistol. "I will restore my honour, otherwise I would rather be dead."

It is not until he is an old man, when his sons have taken over his work, that he once again spends more time in the house. He watches over the women and grandchildren, and allows himself to be looked after. Only occasionally does he visit the mosque or the "hujra". He has come full circle and returned to the security of childhood.

## Men and women

Women are not seen outside the house. And even on my visits to the beautiful shady courtyards with their richly carved pillars when the master of the house would show me many things, I still never got to see the women. They were usually sitting in one of the closed rooms at the back, or sometimes just in a corner of the courtyard hidden behind a cloth.

Not only are the women practically invisible, they are also not a topic of conversation in male society. At most they are spoken of in negotiations over future marriage contracts, at the birth of children, and if adultery is suspected, which can be anything from a forbidden glance to an indiscretion. The Pashtun man is a patriarch, the "owner" of the women of the family. When a marriage is arranged the bridegroom's family pays the bride's family for the loss of human labour. If one meets a veiled woman in the street one does not look at her. Who would want to get involved in a property dispute! The same power which men have over women is exercised by the older women over the younger ones and the children.

We live in a world undergoing the process of emancipation. The dismantling of patriarchal structures is our objective. We stand for freedom and equality in a society of supposedly

responsible individuals.

But can this be translated into another world with different values and feelings? I don't know the answer.

And what is the reality behind the walls of the "zenana"?

## Conversation with Jaffer Sha about domestic life exemplified by his father-in-law's house at Shagram near Madyan

Q: This is the house of your father-in-law: how many people are actually living in this house?

JS: In total eleven people.

Q: How many generations or families are actually living under this one roof?

JS: One family in one home. This was the house of my father-in-law's father. It has been inherited by him and he lives here in a joint family of eleven people. Some of them are working: the owner himself is a agriculturalist with a little land, and he works on that. His eldest son has a job in a private firm, and is the main source of income, I would say. The rest of the children are at school.

Q: So there are two families living here: the children of the owner and the children of his eldest son ?

JS: Yes. Two families living together. The house comprises two rooms, one room for each family specially for sleeping.

Q: Is that the traditional arrangement, that the eldest son usually stays with his parents, or do all the sons stay with their parents?

JS: It all depends on the social and econonmic conditions of the family. For example, most of the men here migrate to Karachi, especially the eldest sons, and their wives stay living with the fathers…

Q: That means they see their wives only once a year?

JS: Yes, in that case. It also depends. Sometimes the eldest son and all the sons separate, and live in separate houses. But again it is a problem to make a new house, because of economic conditions. So it depends. It is traditionally the eldest son who lives with his parents to help them, especially financially.

Q: Traditionally the main source of income was agriculture?

JS: Yes, traditionally. Take this family as a typical example. The father of the owner was the biggest farmer of the area. I would call him the landlord. He lost it for various reasons – mainly gambling – and now there is very, very little land left. He rents it out, because he has to be in the house to look after the children and so on. And the farm is quite far away. So traditionally he was from a big farming family, but now the

system has been changed a little bit. He was also in the army of the ex-Walli of Swat and is retired.

Q: But how much is the annual income from farming for an average farming family here?

JS: In Shagram the the landholdings are very small, so the people are very poor. I would quote as an example that more than fifty per cent of the the people have migrated to Karachi to work, and have settled there. The average income here is five to six thousand rupees per year.

Q: Which is not really enough for a joint family to live on now.

JS: So they are forced to do other jobs in business or service, or something like that.

Q: Now, I'm here with you inside the courtyard of the house. It's very unusual for an outsider to be able to come inside the house and it's very kind of you to show it to me …

JS: You are welcome.

Q: Could you just explain how the social system of purdah works here, keeping the womenfolk and the men separated?

JS: I would say that we consider it as a religious duty – but to some extent it part of the Pathan system here, and I would say the Pathan tradition has predominated over the religious aspect. The reasons may be historical. I don't know what they all are. But the purdah system here does not mean exactly the same thing as it does in Islam. During the Prophet's time I would say it was not so strict as it is now – as you can see here in this society. Here the ladies are supposed to live inside the houses. They are not allowed to come out and talk with men who are not very close relatives, for example, sons, sonsinlaw, nephews or cousins of their husbands – those kinds of relatives. Besides that, the ladies cannot be seen by a man who is not from this community and is not a relative. So they are kept inside the house, and they care for the children and cooking and washing clothes, cleaning the house – things like that.

Q: The women mostly live together with the other women of the house. I mean, that is their main social contact.

JS: Yes, that is the main social contact. There are some other contacts. For example, if three or four house are close together in a village they can talk together with other ladies in neighbouring houses in their free time, when there are no men present. Outside in the marriage parties, or funerals or on such occasions especially in the festivals, for example, when the ladies go and their relatives are there, they have special contact with each other, and it is the main occasion when they can have it… And another means of contact I would say was fetching drinking water. It was the tradition that a village had a spring or some place where they could fetch water – in Pashtu we call it a "godar" – a place where

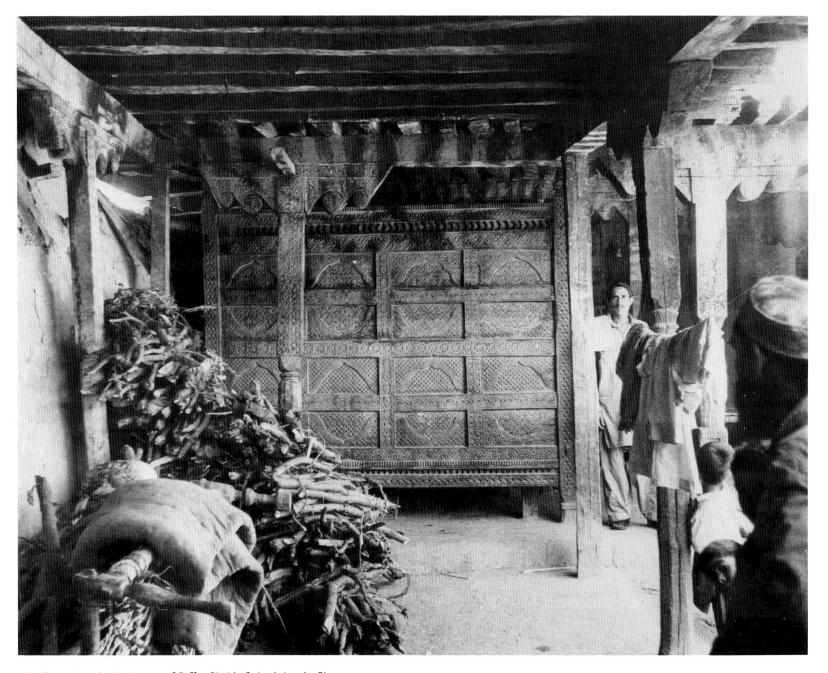

55. Corn chest in the house of Jaffer Shah's fatherinlaw in Shagram.

56. Pathan.

57. Kohistani. The old man has dyed his beard with henna.

the whole village fetched water (it could be spring water or river water), and it was there that there was most social contact between the young ladies. They would go there especially in the afternoons, and maybe they would have a chance to discuss with each other. But now the system has changed – people call it "development" – and now every house has running water. For example, in this village now there is a pipeline in every house, and so the possibility of making such contacts has been destroyed.

Q: So if you have guests who don't belong to the family, what is the arrangement for entertaining them, if you can't bring them to your house.

JS: Once there are a few houses together a "hujra" is built. In former times there were two or three "hujras", big "hujras", in a village, where the people used to entertain guests of the village when they came. Only the ladies could cook the meals but they were served by menfolk. Now the tradition is changing a little bit, and everybody tries to make what we call a "betak" near the house. When guests come, they go there, and their meals are prepared by the women inside the house but served outside in a separate house for the guests.

Q: So that means the "betak" is something like a small "hujra" for entertaining male guests?

JS: Yes. I would say that about fifteen years back the tradition was quite different from now. There were a lot of "hujras". I mean, in a big village there was "hujra" for the village. Sometimes it was a common "hujra" and everybody contributed money or something like that to build and maintain it. Now the system has been changed a little. Everybody tries to make a better "hujra" and entertain his guests personally. But the old tradition still exists also, and some of the big "hujras" still exist, and people still use them. But now it depends on the relation between the owner of "hujra" and the villagers.

Q: What about the religious life in a village like this? Is it mainly the concern of the men? The women, as far as I know, don't go to the mosque, only the men.

JS: Yes, in fact in Islam there is a provision that they can go to the mosque if they like, but I would say that in the whole of Pathan society I cannot quote a single example of the ladies going to the mosque for prayers. They perform their prayers inside the house, and for prayers they have a special "takht aposh" made of wood. They perform their religious duties there. Also we consider the womenfolk to be much more religious than the men, especially in keeping the fast in "ramzan" very strictly. Now we can see that some of the younger men don't bother too much about fasting, but among women it is one hundred per cent.

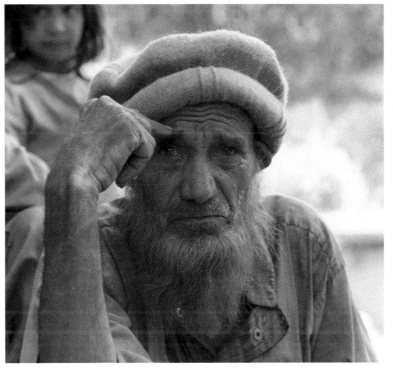

Q: Since we have come back to the subject of women, one thing that interests me is how much respect the women enjoy within the house. I mean their social life with the outside world is very limited, which means that in order to fulfill their emotional life they must have something in their indoor life. For me, as a stranger, this is not visible. I would very much like to know how much respect they have.

JS: I would say that this is a male-dominated society. Women have no social contact with the outside world. The only thing is that there is a tradition that the elders are respected. For example, the mothers, are respected by the children in a very good way. Decisions about the marriages of their children – boys and girls – are made by wife and husband together. But on the whole the men don't think that their contribution to decision making is as valuable as their own. Also the women make demands of their menfolk which depend on socio-economic conditions, but they do not overstep the limit.

Q: You use the word respect a lot. Do you think respect is the most important emotion.

JS: Yes. You have respect and you respect others. This is very common even in the case of females. In fact it is much higher, because we consider an insult to ladies to be something we could sacrifice ourselves for. It is a common tradition over here. So in Pathan society if any lady is insulted the people mind it. When their own family is concerned obviously they will mind it. I would say that in another society – in the city, for example – the divorce rate is too high. But in this society it is considered a very bad thing for a man to divorce his wife. So this may be another thing which makes her think that she has some respect or some value.

Q: In my own society people consider love a very important emotion. Which is more import in Pathan society, love or respect?

JS: Respect. Once you are married it is very seldom that you would separate. You are forced – or you want – to stay in the marriage for your whole life, with your children.

Jaffer sha is one of the few men in Maydan with a degree; he works for a Swiss development-aid project in the mountains of Kohistan.

## The "hujra"  (Dietrich von der Lühe)

The focus of the social life of the men in Swat is the "hujra".

It is rarely empty: any one who does not need to work sits there, smokes, drinks tea, discusses, negotiates a leasehold agreement, gossips about the neighbours. Those who are not in the fields or at home eat there in hierarchical order of precedence. It is where guests who come to visit the village are received and entertained, where music is performed or stories are told in the evenings, where the unmarried men and sons sleep.

The "hujra" is indistinguishable from the houses both in its building materials and its construction. However, its particular social functions do affect its shape and interior arrangement.

It may be situated in the middle of the "kandai" or on its edge, high ground is preferred because it allows an unobstructed view out.

The building itself is always a long rectangle in which at least two and no more than four rooms are placed side by side. One room, usually larger than the others, has a fireplace. In winter this is used as a centre for the social functions of the "hujra". The other rooms are used in winter for sleeping and in summer as storerooms. All rooms only have doors and windows facing the veranda.

The veranda is formed by the roof extending far beyond the house. It is often supported on two rows of pillars with carved capitals like those in the roofed "gholai" of the farmstead. Here the veranda cannot be be regarded as part of the courtyard because it is only ever built directly in front of the enclosed rooms, which are usually on a higher level and are reached up steps. However, like the roofed "gholai", the veranda is the main meeting place in the summer. Beds and low chairs are placed there. For this reason the veranda usually covers an area the same size as the rectangular roofed area of the rooms.

Cooking places and household equipment are not found there since the "hujra" is provided with food by the houses.

Many "hujras" are not completely surrounded by walls. Their long sides with the verandas open onto a small square shaded by trees. When the outer supports of the veranda are given an artistically carved wooden railing or are hidden behind carved wooden blinds their appearance between the bare masonry of the farmsteads makes clear the special function of the "hujra".

58. Hujra at Khwazakhela.
The form and furnishing of the hujra is a measure of the prestige of the men of the village. As in mosques the carved architectural elements are donated by the richest landowners.

## The Mosque ("jumaat")   (Dietrich von der Lühe)

Every quarter has its mosque, called "jumaat" in Swat. The assembly of the faithful of the district appoints one of their number as an "imam" who is in charge of the "mullah".

The mosque is built and maintained by funds and services provided by all families according to their wealth and social status.

The mosque in Swat consists of a rectangular walled area entered through a wooden gateway which is usually richly carved. As in the houses the walls enclose a covered courtyard area divided by richly decorated pillars, leaving an uncovered area in the centre. Just beneath the roof beyond the entrance is a channel of running water or a fountain for ritual ablutions.

On the western or "qibla" side of the courtyard the pillars supporting the roof are particularly large and richly carved, or there may be two or three rows of them. They emphasize the direction of Mecca. In the adjacent wall is the "mihrab" in the form of a decorated wall niche emphasized by a pointed arch above it.

To the right of it there is always the "mimbar", the richly carved wooden 'armchair' from which religious instruction is given. In another niche, often surrounded with mud plasterwork, stands a wooden bookstand ("rehel") on which the Koran is kept. The open area and part of the covered area is used for prayer. They may only be trodden barefoot and are always strewn with fresh hay or straw.

Most mosques also have an additional enclosed room on the west wall of which is another "mihrab". Here there are fireplaces too. This room serves as a winter mosque.

The open courtyard does not have to be always in the middle of the mosque. Often it is shifted to one of the walls. But there is always the "pillared hall" of the "qibla", in Swat a verandalike covered open room supported by pillars, on the west side in front of the "mihrab".

With the exception of the western one these "pillared halls" are used not only as a sacred space during the religious ceremonies, but also as meeting places and rest areas where men converse or sleep during the day.

From the outside the mosques are hardly distinguishable from the houses. Only the particularly richly decorated wooden boards along the outer eaves, and the finial-like wooden posts indicate its function.

Because the condition and furnishing of the mosques are outward symbols of orthodoxy, many of the old mosques have been modernized. Concrete supports and coarse concrete ornament have replaced the traditional wooden constructions.

59. The Great Mosque in Madyan.
   View of the courtyard of the Great Mosque of Madyan. In the
   foreground are the washing facilities, for the faithful to perform their
   ritual ablutions. The floor is here covered with grass instead of the
   carpets which are usual elsewhere.

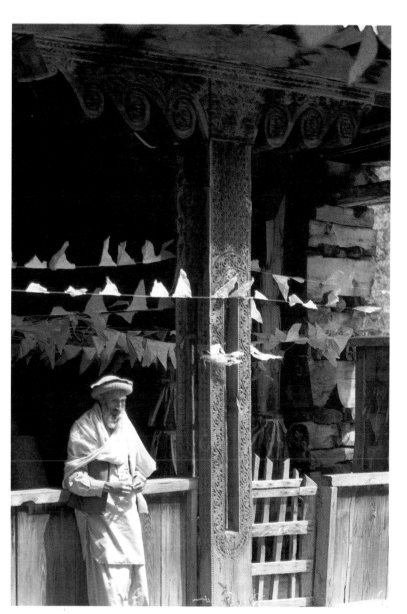

60. View through a window of the Great Mosque of Madyan towards the main entry to the winter prayer hall.

61. View into the mosque of Kalam.

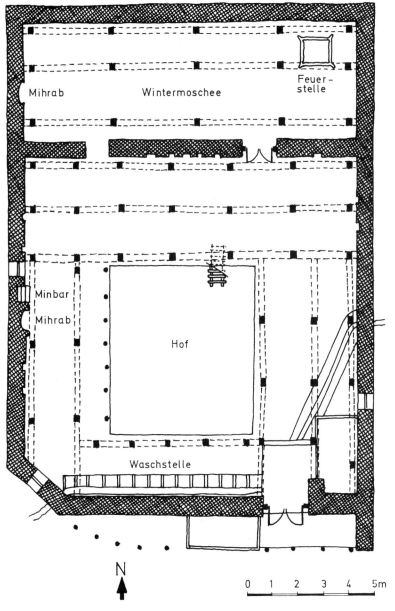

Mihrab  Wintermoschee  Feuer-
stelle

Minbar

Mihrab

Hof

Waschstelle

N

0 1 2 3 4 5m

62. Plan of the Great Mosque of Madyan.

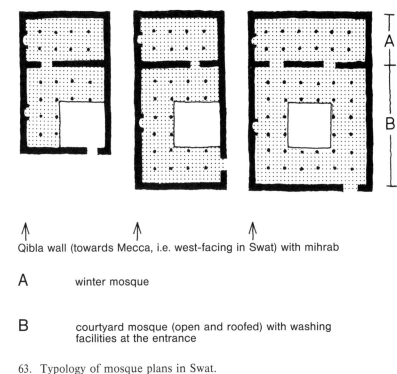

A

B

↑        ↑        ↑
Qibla wall (towards Mecca, i.e. west-facing in Swat) with mihrab

A          winter mosque

B          courtyard mosque (open and roofed) with washing
                  facilities at the entrance

63. Typology of mosque plans in Swat.

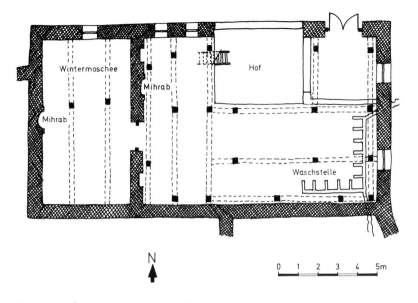

64. Plan of the mosque in Jukhtai.

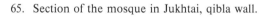

65. Section of the mosque in Jukhtai, qibla wall.

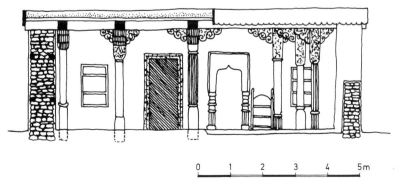

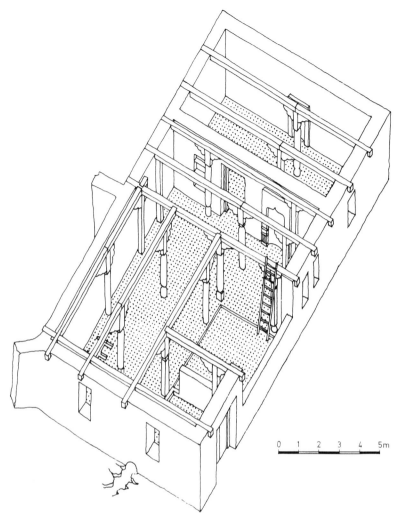

66. Isometric drawing of the mosque in Jukhtai. All drawings and plans are by Dietrich von der Lühe.

Page 60:
67. Mihrab with carved decoration in relief and paintwork. The scale of the ornament suggests that this was made in Swat-Kohistan. Linden-Museum.

68. Koran stand with incised foliage decoration and notched ornaments. The shape of the feet with the small niche and the lozenge decoration is inspired by the prayer wall of a mosque. Linden-Museum.

69. Mud plaster decoration with mountain and horn motifs framing the niches in which Korans are kept. Great Mosque, Madyan.

70. Stepped mimbar with palmette and acanthus ornament. The geometric decoration is reminiscent of tile patterns. Upper Swat. Linden-Museum.

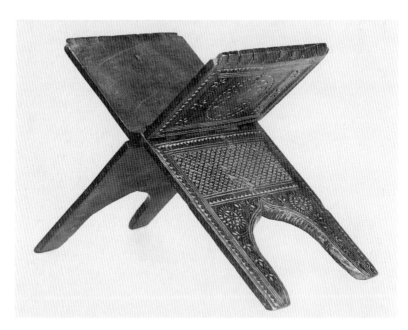

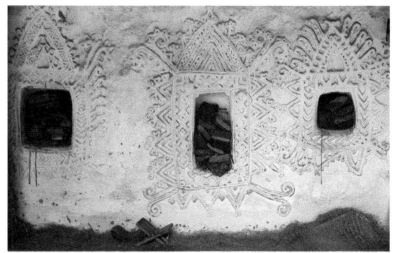

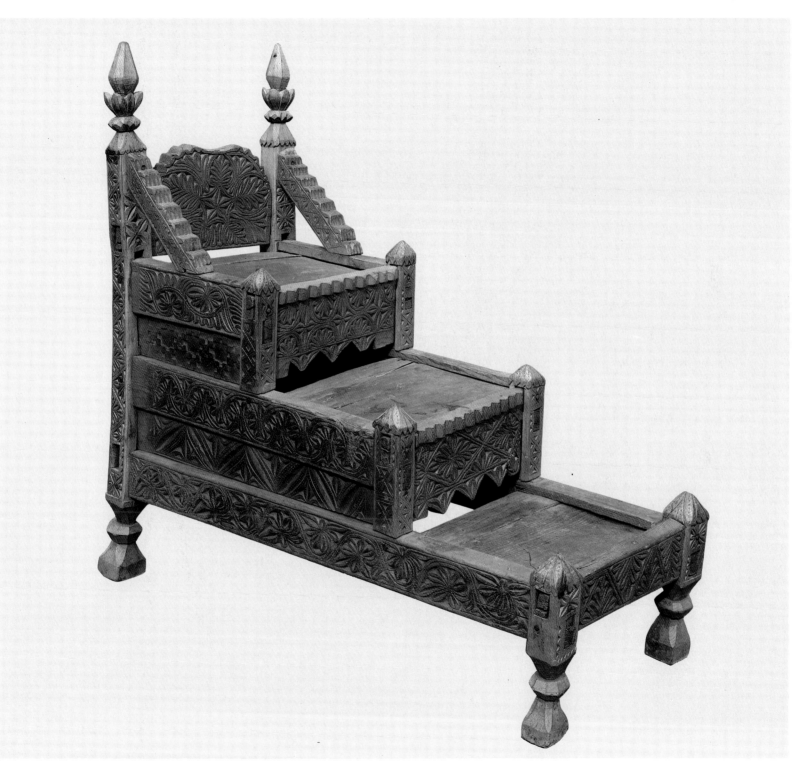

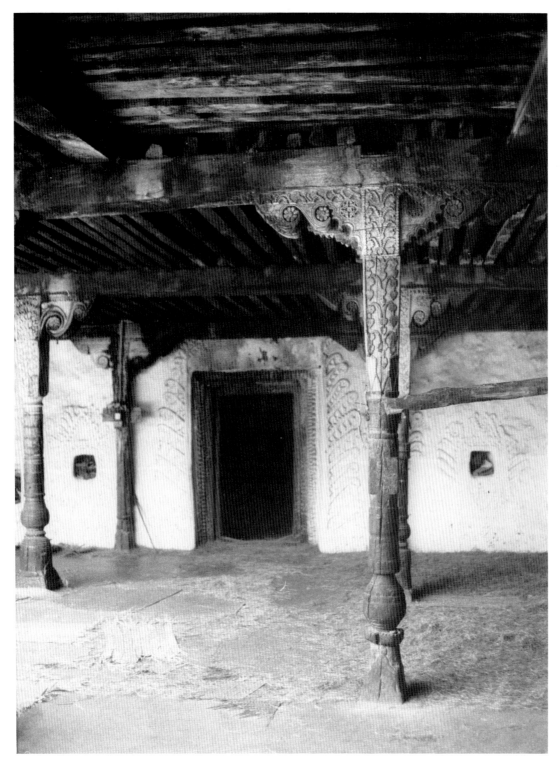

71. The Great Mosque at Madyan, entrance to the winter prayer hall.

72. View into the covered colonnade and the courtyard of the Great Mosque at Madyan.

73. Man praying in the mosque at Bahrein, Swat-Kohistan.

74. Interior of the mosque at Arin. In the background is the qibla wall with the mihrab and the stepped mimbar beside it.

75. Exterior of the mosque at Arin. Arin is in Torwali territory, Swat-Kohistan. The mosques in Kohistan used to be constructed entirely of wood.

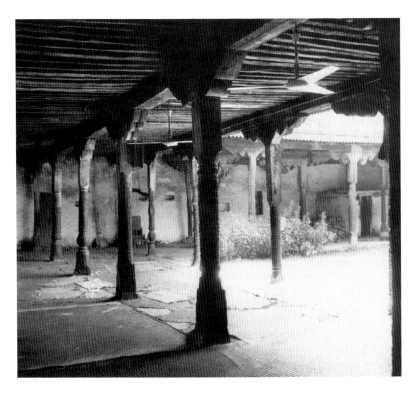
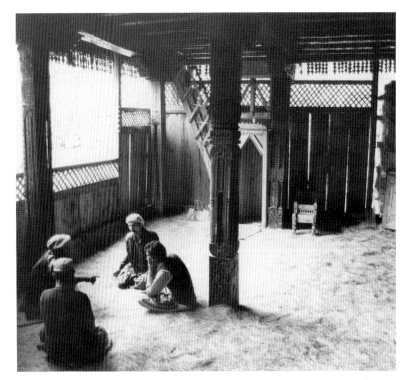

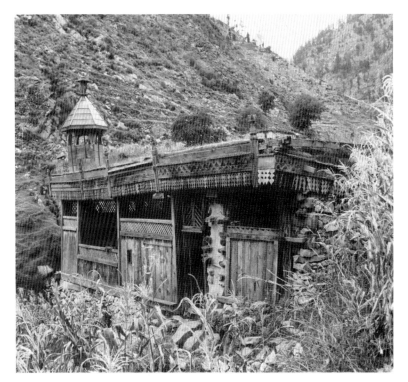

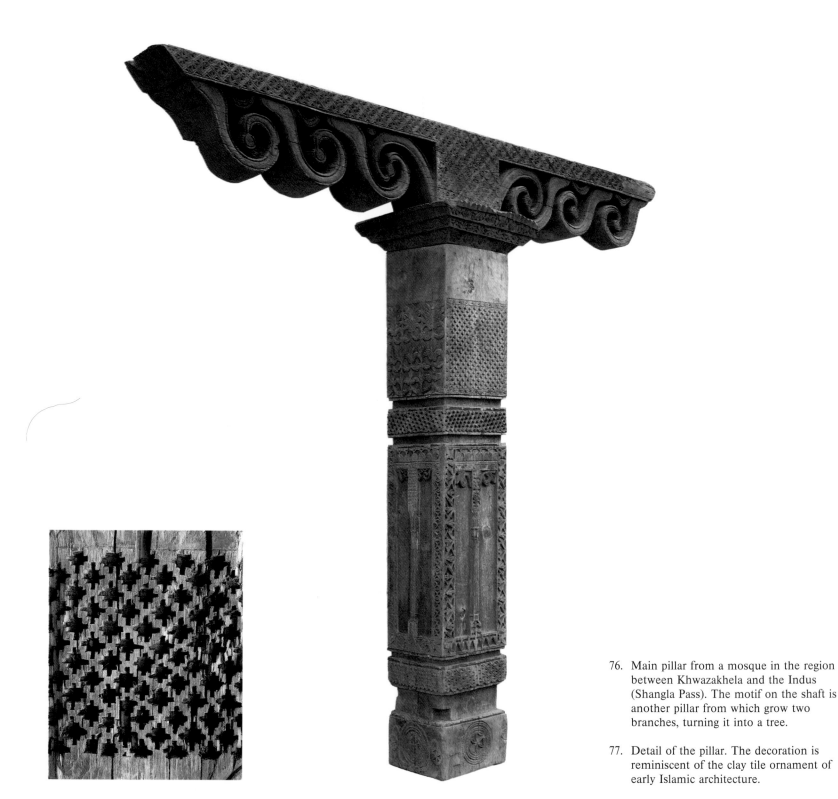

76. Main pillar from a mosque in the region between Khwazakhela and the Indus (Shangla Pass). The motif on the shaft is another pillar from which grow two branches, turning it into a tree.

77. Detail of the pillar. The decoration is reminiscent of the clay tile ornament of early Islamic architecture.

64

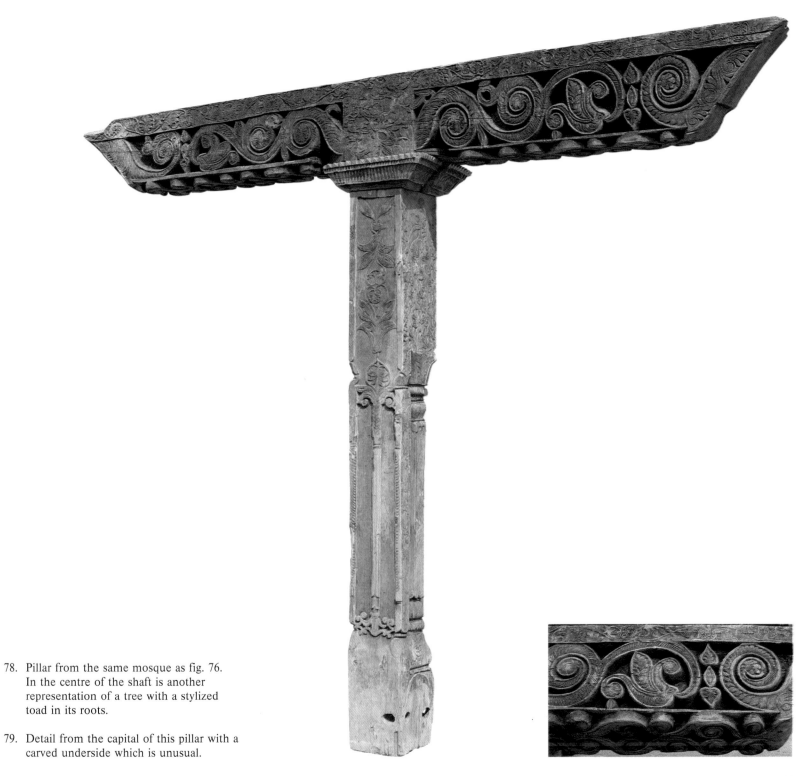

78. Pillar from the same mosque as fig. 76. In the centre of the shaft is another representation of a tree with a stylized toad in its roots.

79. Detail from the capital of this pillar with a carved underside which is unusual.

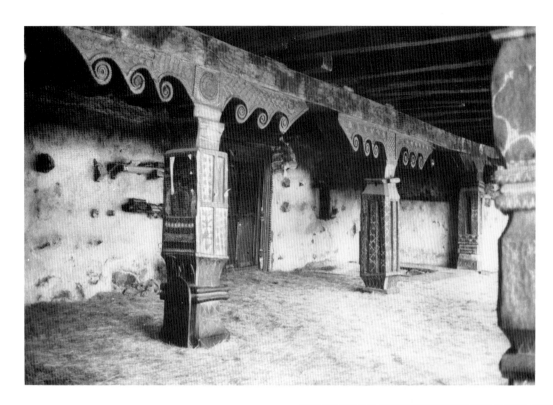

80. Interior of a mosque between the villages of Thal and Lamotai in Alai-Kohistan (the region between Swat and Dir).

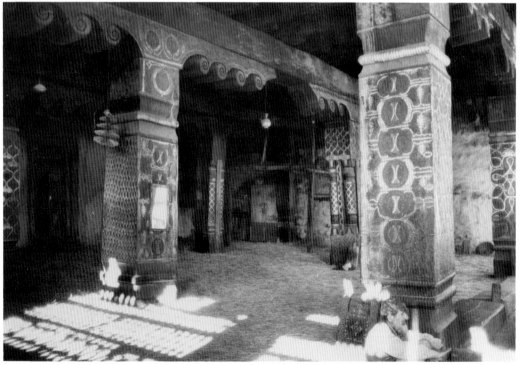

81. Prayer hall of a mosque in Dir-Kohistan.

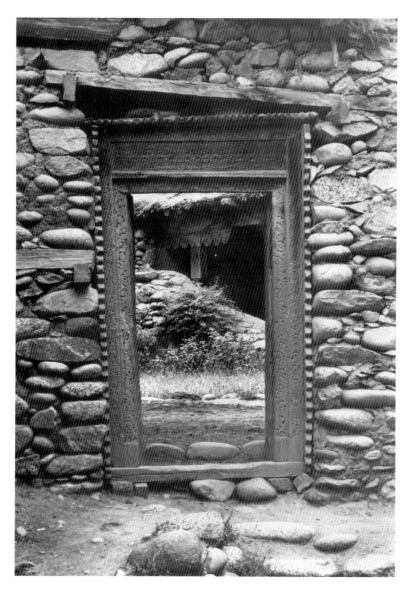

82. Entrance to a mosque.

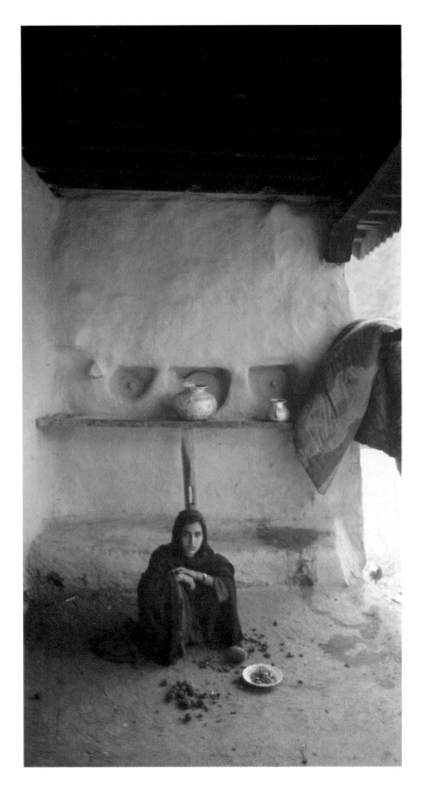

# The Life of the Women – in the Zenana

Viola Förster-Lühe

"A woman's place is in the home or in the grave"
Pashtun proverb

**"Chaadar" and "Chardivaari"**

"Wrap her up in blankets and shut her up in the house." This was the official pronouncement of the Pakistan dictator Zia 'ul Haq and his military regime concerning the question of women's rights. During that time (1977-88) with the help of the Shariah courts, where orthodox Islamic law was dispensed, unbelievably discriminatory laws were passed, ranging from the enforced wearing of the veil to the stoning of prostitutes and adultresses. An illustration of this discrimination is that a woman who has been raped has to produce four male (!) witnesses of the crime, otherwise she can be condemned for prohibited sexual intercourse (zina), especially if the rape has resulted in pregnancy. The sentencing of women to beatings with sticks, floggings or forced labour were the order of the day. Again and again Pakistani women turned to foreign women's organizations and media with reports of contraventions of international human rights conventions, torture, rape, maltreatment. Towards the end of the military dictatorship the protests of the Pakistani women's movement against discriminatory laws and their implementation became increasingly aggressive. Although they knew that public demonstrations were ended with police truncheons and arrests, the women could restrain themselves no more.

The women's movement has not reached Swat. There the "ancestral law" of the Pashtuns still rules unchallenged, with its patriarchal structures of power, the Pashtunwali code of honour with a rigid interpretion of the purdah system.

The rules of purdah, the Pashtunwali and the Pakistani-Islamic administration of justice then current, together keep the women of Swat within very narrow limits. They live in purdah. In Pakistan (and in other Islamic countries) this term embraces the principle of the exclusion of women from public life and their confinement in the house by a complex system of regulations, rules, requirements and prohibitions; the visible manifestation of this is the veil in its various forms and assignment exclusively to the domestic sphere, the "zenana", the women's section of the house. "Fundamentally purdah is much more than this. It is the symbol of the exclusion of woman from public life with all its difficulties, from work and earning money, from the sexual confusion of her

own feelings; it is at once a limitation and a protection."
[Charlotte Lehn, "Kabul. Die Afghanin" in Margarete Driesch, Frauen jenseits der Ozeane, Heidelberg, 1927.]

This description of the function of purdah was written in the 1920s but it accords with the arguments of today's traditionalist, orthodox defenders of a purdah society as part of "reislamicization". The basic concepts are seclusion and segregation. The specific form of purdah varies depending on economic conditions and ethnic traditions. In Swat the latter are summed up in the Pashtunwali, the Pashtun code of honour.

As a consequence of social change the Pashtunwali is now no longer the only law of Pathan society, but the attitude towards women remains untouched by this. The Pathan man still finds his identity by keeping the Pashtunwali. The worst thing that can happen to him is the loss of his honour. A "begherata", a man without honour, is a man who has lost his land, who is weak and lazy, who has no control or command over his womenfolk and his household. For the Pathans this is worse than death. Linked with this concept of honour is the ownership of land as an indicator of a man's status: the more land he has the greater his reputation is. If women were to inherit land, the male members of the family would lose both land and status. Unlike the Pashtunwali Islamic religious law makes provision for women's inheritance rights: they can inherit a third of the property. In this respect the Pashtunwali stands above Islamic law in Swat.

The strict control of the women is achieved by the most rigid observance of the rules of purdah. Women must be kept in seclusion so that they cannot get into situations which could injure masculine honour. Islam is not in itself sexist and allows women an active role, but it takes the view that if this role is not controlled by rules it can destroy Islamic values and rules. Women do not have this destructive power if they remain shut up. So segregation and seclusion are a prophylactic means of nipping in the bud any misfortune (which in Pashtun terms means injury to one's honour) which women could threaten.

Enclosed in her husband's house the woman helps to preserve his honour, for her behaviour is an expression of his power and control over his house (= his women). It does not follow from this that women have power over men. No woman will "negligently" put her husband's honour at stake. Her fear of punishment is too great. The men in Swat told me that women used simply to have their noses cut off for infringements of the rules.

In the public life of Swat women are not visible, not present. If they do appear it is wearing the "burqua" which covers them from head to foot and has a small grating allowing them to see their surroundings.

Women are not spoken about either. In the tradition of the

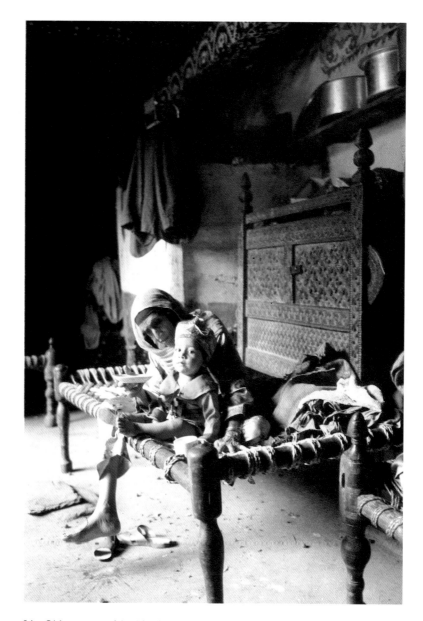

84. Old woman with child in the house of Taj Mahal, Madyan.

83. Woman cracking walnuts on the veranda of a house in Swat-Kohistan.

Pashtuns to ask a man directly about his wife is unthinkable. "How is your house, how are things there?" is the only possible circumlocution. European women who tactlessly ask outside the house about the wife's name, her state of health or domestic goingson are regarded as grossly ill-mannered. Outside the house women are unpersons.

In the same way questions about women's rights are greeted by men with a mild astonishment and incomprehension. In Swat such questions are absurd per se. "They have no rights." After insistent questioning it is admitted after some consideration that they might have one right: "the right to eat, to work, to look after the children."

Women in Swat do not yet even have one of the basic human rights, to be able to move about freely. From the age of puberty a woman is literally shut up in the house and can leave it only with the permission of her father or her husband, and only on special occasions and under particular conditions.

According to the Pashtun ideal a woman should leave her house only twice in her life: the first ison her marriage, when in an enclosed litter (the "dohli") she moves to her husband's house, and the other is when, shrouded in cloths she is taken to the cemetery. Until this last journey all other outings are exceptions requiring authorization from her husband or a very close male relative.

The range of possibilities for a woman's everyday activity in Swat is strictly prescribed by the rules of purdah. Permission may be granted for outings – wearing the veil – to attend weddings, visit the sick, take part in funeral ceremonies of close relatives in the immediate neighbourhood, usually accompanied by her husband or a close male relative. Unaccompanied outings require additional permission and do not usually occur. In this way participation at important events in women's already severely restricted social life is linked with the presence of men. During our last visit we saw how an entire female household was not allowed to take part in a wedding celebration because no male escort could be found as demanded by the rules of purdah. Consequently they were denied the opportunity of being with other women, chatting, dancing, making merry, exchanging news getting to know potential daughters-in-law. The women were angry and wept; we were enraged and disconcerted – but the men of the household were in Peshawar and had not given any of their relatives the task of accompanying the women.

Visits to neighbours are occasionally allowed. But the only occasions when this raises no problems is if they are close relatives (brother, uncle etc.). Women can visit the houses of women who are distantly related or unrelated if it can be guaranteed that the men will be absent. There is no provision for a spontaneous visit to a neighbour.

Women have the right to vote, but they can only exercise it when their husbands allows and has arranged the necessary outing. Thus at the last election – the first free one – the women in Swat were not able to take part in any election meetings and thereby form their own opinions. In any case a Pashtun man cannot imagine that they might vote differently from their husbands. Their vote is used to promote his interests. "Of course the women of my village receive permission to go to the polling station; after all, our party must win," a local political leader told us.

If a woman has no rights, she does at least have a value – an economic value. Besides her unpaid labour in the house and in the fields, there is also the "bride-price" that must be paid in the North-West Frontier, where, in contrast to the practice in the other provinces of Pakistan, a woman is sold by her family. The brideprice is paid in land and/or cash. The average payment is about 7000 DM. Many men in Swat remain unmarried or go to work in the Gulf States to earn the brideprice. From economic necessity and so as not to disturb the social structure Swat families have been forced to marry their girls for a lower price. But in any case the birth of daughter is very welcome in Swat since it increases the family property.

In order to get to other houses – dressed of course in the "burqua" in accordance with the rules – women must take the connecting paths over the roofs, if there are any, so that this activity can take place in the most unobtrusive manner and encounters with strange men in the narrow village streets are avoided. Where this is impossible then if men come towards them, the women must obey the rules of purdah and stand still and turn their faces to the wall until they have passed.

In the summer months the women in the villages sometimes receive permission to meet together on the roofs to enjoy the cool of the evening after the hot, stifling days and chat with each other, on condition that the men are in the "hujra", the men's meeting house. This is particularly important for the girls who are still unmarried. They are not allowed to see any man before they are married, otherwise they could be accused of immoral behaviour which would damage the honour of the whole family.

Shopping in the bazaar for the household and the personal needs of the women is always done by the men. In this way the men also govern their personal tastes.

Women cannot leave the house without permission for any reason. If water, wood or provisions run out, they always have to wait until these things are brought to them. It does not matter whether they are hungry or freezing. These strict rules can have dangerous or fatal consequences. "Going alone" is forbidden even in extremely dangerous situations which could result in death. The only declared exception is in a state of war. For example, any

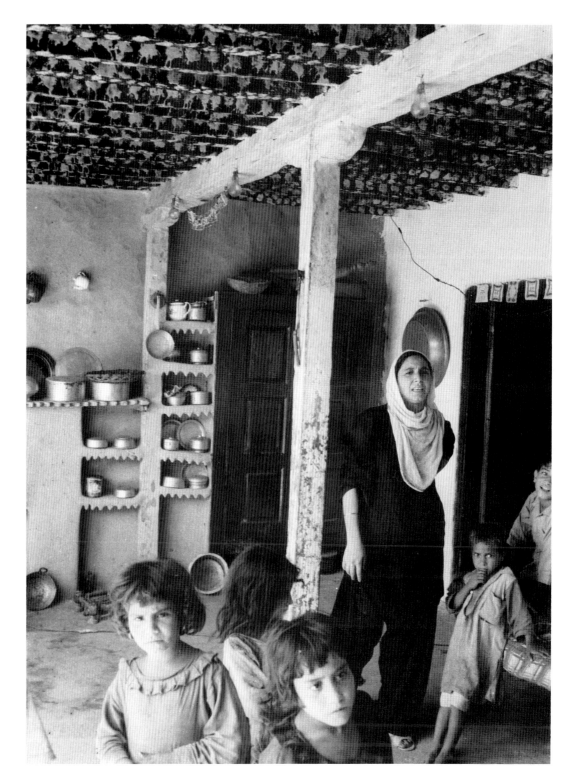

85. Woman in the courtyard of a farmstead in Khwazakhela.
The functional wallshelves in the kitchen area are plastered with mud and regularly whitewashed.

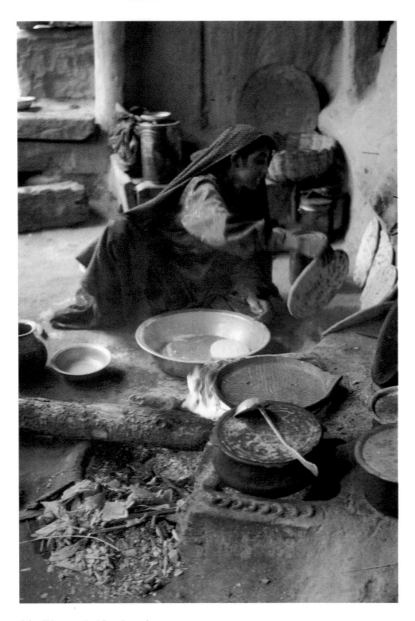

86. Woman baking bread.

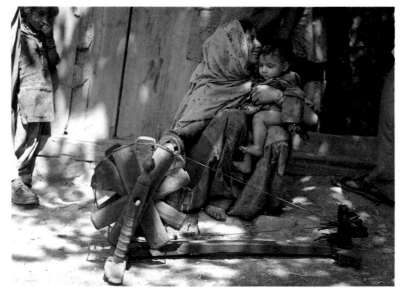

87. Woman spinning.

88. Woman at a board loom.

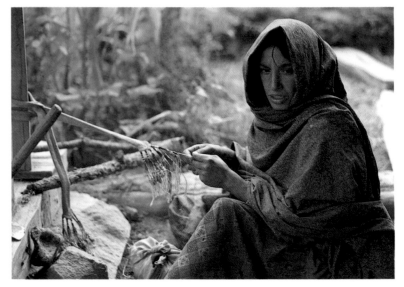

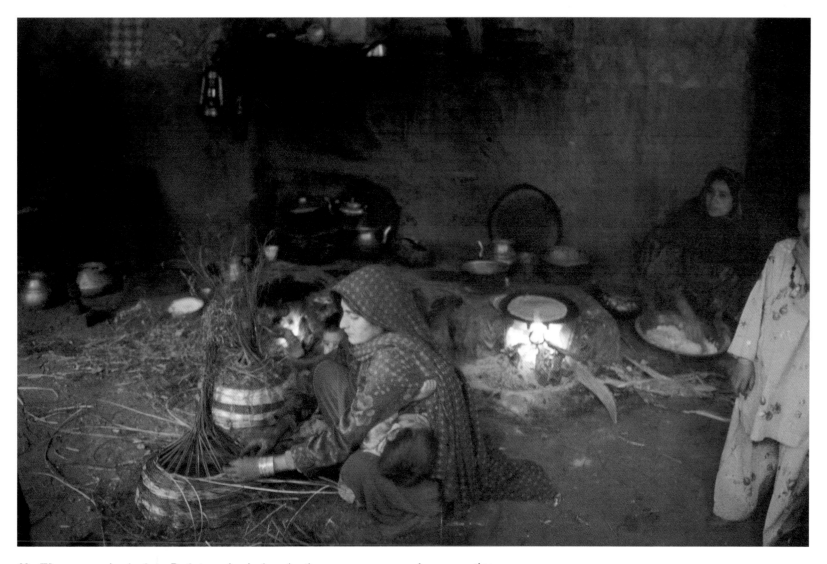

89. Woman weaving baskets. Basketweaving is done by the women as a secondary occupation.

90. Women and children on the roof of a house in Shinku in a valley (Chail valley), Madyan. The building technique using woven brushwood with wooden corner posts was once widespread but in recent times it has ceased to be customary in Swat.

consultation with a doctor, no matter how urgent, can take place only in the presence of the husband or a close male relative. Women are forced to wait for this escort. If this is not available or can be found only after some time, they will in extreme cases die helpless at home – ultimately as a result of the rules of purdah. Pains, fears must all be borne by the women. Since no male stranger may enter the house, the doctor too is denied access. An exception is made for births which endanger life. After a diagnosis by proxy a doctor prescribes an injection which is then administered by his assistent, who is usually a member of the village community, unlike the doctors who mostly come from the town.

Otherwise there is a set of rules governing which man is allowed to enter the interior of a house. The brother, nephew, wife's cousin, sister's cousin and the husband(s) of the sisters of her father. Any men who are not members of this inner family are received and entertained in the men's meeting rooms of the village or of the house. The only men who are excepted are those who are already very old, about 60 (this is the average age of death of men in Swat). Infringements are not permitted – they damage the honour of the man, the family and the group, and can lead to quarrels which last for years. If necessary this injury to the family's honour is avenged by force of arms in order to repair the damage done.

The structure of the houses and settlements is arranged so that the rules of purdah can be followed. In Swat – mainly in the villages on the road – the accessible roofs have large wooden screens erected around the openings to the courtyards in order to prevent any male strangers from looking in. Tall screens have been installed on the main road to obstruct the view of houses near the thoroughfare and the rest of the village, particularly in terraced villages on slopes adjacent to the road.

Within the house women can move freely everywhere except the men's anteroom. If the family is well off, the women live in a correspondingly grand house. In this case the inner courtyard, the central area of the house and the only openair space available for women, is usually large (c.60 sq m), light and airy, with a tree. The total area of most houses is smaller than that. They are narrow, dark, damp in the cold season, stuffy and full of smoke which does not easily escape. The inner courtyard is normally no bigger than 9 sq m.

Stuck in these confined living spaces year in year out without much exercise or light, the women are naturally prone to illness. This is intensified by continual pregnancies and inadequate nutrition. The average life expectancy of a woman is 50 years, ten years shorter than a man's.

The women's narrow, restricted housing allows little variety in daily life. Taking a household which has a typical structure

situated in a village near the main town of Madyan, I shall describe a normal day in the life of the women of Swat. The income of this household enable the rules of purdah to be fully observed. The women do not need to do any additional work in the fields.

Living with their mother are two sons with their wives and a total of seven children including two girls aged eight and nine. One son works in the fields, the other is an employee in the bazaar earning the necessary cash and helps in the fields after finishing work. The house has a tiny inner courtyard, the single interior room is divided in two by a curtain (in other houses there is a wooden partition), so that each family can have a partially separate area to itself.

The women's day begins around 5.30 with the call of the muezzin, ablutions and prayers. Then one of the married women prepares tea for the men and bakes chapati, the round flat maize bread. The other wife together with the mother deals with washing and dressing the children.

When the men have left the house the women have their breakfast with their children. The men never eat their meals with the women. The women first serve the men, then they eat what is left over with the children. After breakfast one of the wives sweeps the floor, the other tidies the house. The mother is busy looking after the youngest children.

The main task of the two eldest girls, who are still allowed to leave the house, is to fetch water form the nearby water point for cooking, washing and cleaning the house.

The women spend the whole morning preparing the midday meal. The vegetables are cleaned, peeled and chopped, the curry is mixed in the mortar. Wood is chopped, the fire carefully tended since firewood is scarce and expensive.

The normal meal consists of a vegetable dish with chapatis or dal, a sort of lentil with spinach and potatoes in a curry sauce. This very unbalanced diet encourages illnesses resulting from malnutrition, one of the principal problems in Swat. At the moment attempts are being made to cultivate and introduce other varieties of vegetables to make up for the shortcomings. The girls often take the men their food in the fields or at their workplace in the nearby village.

In many households – including this one – it has been the custom for years to buy food at the hot food stall or from street vendors in the bazaar. Often there is not enough money for the

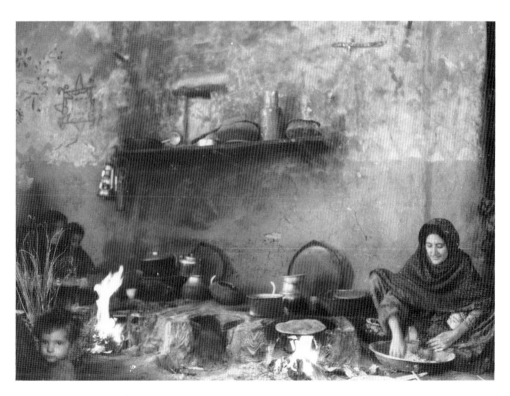

91. 'Kitchen range' of a house in Ariani, Swat-Kohistan, just outside Kalam.

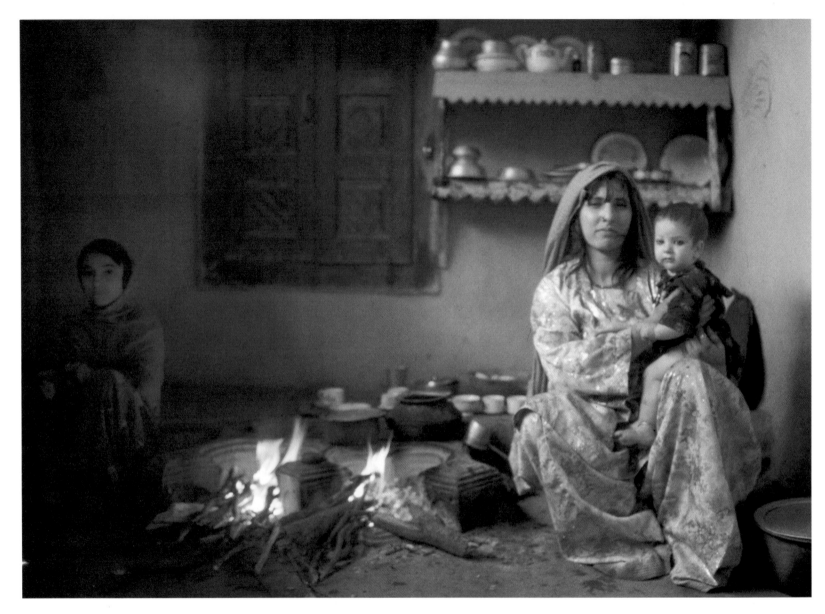

92. Woman with child in Madyan.

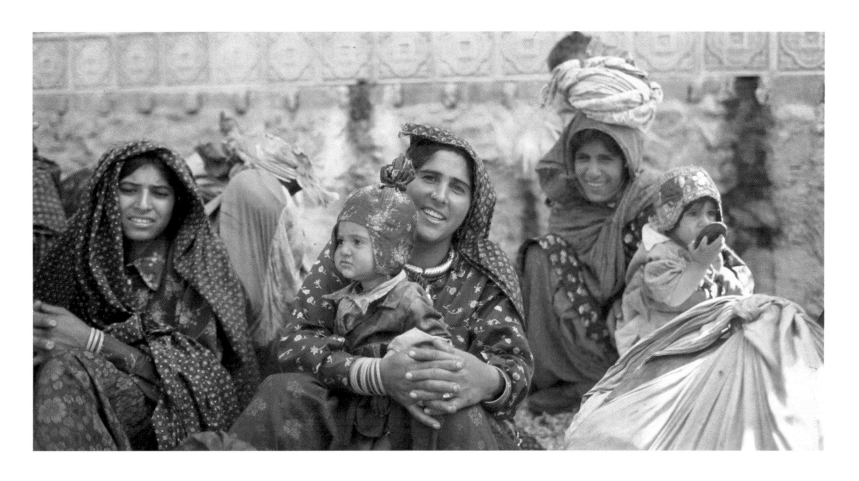

93. Torwali women on a visit in Madyan.

94. Woman winnowing in the Chail valley.

expensive firewood, or there is no wood available because of the overexploitation of the Himalayan forests.

In the afternoon the washing is done, mending is done for the whole family, the children are taken care of, and towards evening the remains of the midday meal are warmed up and chapatis are freshly baked. The call of the muezzin marks the end of the busy day.

Additional work occurs in the spring when it is usual in Swat to repaint the interior of the house, relay the mud floor, decorate the walls and beams with (floral) patterns. Elaborate mud decorations are usually created around windows and niches.

At the time of the two harvests the yields are stored in the house. The women then do the winnowing of grain, the stripping of the maize cobs and the shelling of the walnuts.

In families with low incomes the women are forced to undertake badly paid supplementary work at home. For a pittance they embroider cushion covers and cloths, usually with old motifs, and these are then sold in the bazaar.

How porous the purdah system is depends on the financial situation of the family. The possibility of leaving the house is directly linked with the poverty of the woman and the family, and the poorer the family the less the rules of purdah can and must be observed. The further the family lives below the minimum existence, the more activities outside the house the woman can pursue. In the country as a whole women can be found in many different areas of work.

In Swat women may only work in the fields. Every man in Swat endeavours to stop his wife working as soon as his financial situation permits. The necessity of releasing women from their enclosed world does not enhance a man's honour. The women find that work in the fields means a hard additional burden, since the domestic tasks also have to be done.

Women only gain freedom of movement when they are widowed. Widows used to be looked after by close relatives. Increasing impoverishment has made this more and more difficult. Since the Islamic "zakat" system (social security system) provides insufficient maintenance and consequently there is no protection from total poverty, widows are allowed to move about freely to ensure their livelihood.

In Madyan the widow Batsha Zarin has the right to move about freely – without observing the outward regulations of purdah. She receives about 40 rupees (4 DM) from the community's "zakat" fund, and has no relatives in the town who are responsible for her.

She married at fifteen and has two daughters and three sons. When she was thirty her husband, who worked in a butcher's shop in the bazaar, died. Not of anything in particular, she said, he was just very weak. He left her nothing, the house they lived in belonged to the miller. In return for her work in the mill – which the miller uses when he needs it, which is frequently – he waives her rent. Her sons, who are working as a butcher, an assistant chef in a hotel and in the teashop, bring in only a few rupees. One son has left home with his family, a wife and two children, because the living space was impossibly small. Nine adults and five children were living in a house measuring about 20 sq m. The housework is done by the daughters and daughters-inlaw. Batsha Zarin is allowed to deal with all activities outside the house, enter any house, go shopping in the bazaar, to do the necessary women's work outside the house for families which had no young daughters, fetching water and washing dishes and doing the laundry. She works in the fields and in the houses when the harvest is brought in, helps with the winnowing and takes the corn for the women to the bazaar to be sold. For her work she is given a few rupees, or else clothes or food depending on the particular arrangement.

She serves an important social function. Since she can go everywhere she canbring news to the women, carry news to other houses, tell stories from the world which the other women do not know.

The atmosphere in the houses of the enclosed women depends above all on the relationships between the women. A clear hierarchy – with the oldest woman at the head – and a division of labour define the framework in which they move. I got to know the whole range of possible ways of behaving: tense, quarrelsome, happy and balanced. I know women who are always ill, whose company I find depressing, but I also know physically healthy, selfassured women. As yet there has been no study of the psychological and physical effects of seclusion in the extreme form it is practised in Swat.

For more than ten years I have had an insight into life in Swat. In this time I have made contacts in various houses and have got to know many women and their households.

I experienced the selfassured Taj Mahal, full of vitality, always pregnant, purposefully directing and dominating not only her children but also her motherinlaw. She expects to hear news about life outside, is receptive, curious, wants to know all about our life. She naturally decided what I was going to do. I must eat, photograph everything I could, and stay there for hours. She does not allow any contradiction. She always stands at the centre of things, she shows me how you make chapatis, prepare a midday meal, enjoys being photographed doing her household chores, shows me her wedding jewellery, her wedding dress, her dowry. Together with the other women she keeps the house clean. It is decorated with colourful plates on a wall shelf and a carved board for spoons. The dark wooden beams of the ceiling are painted with a colourful floral pattern, the walls are decorated

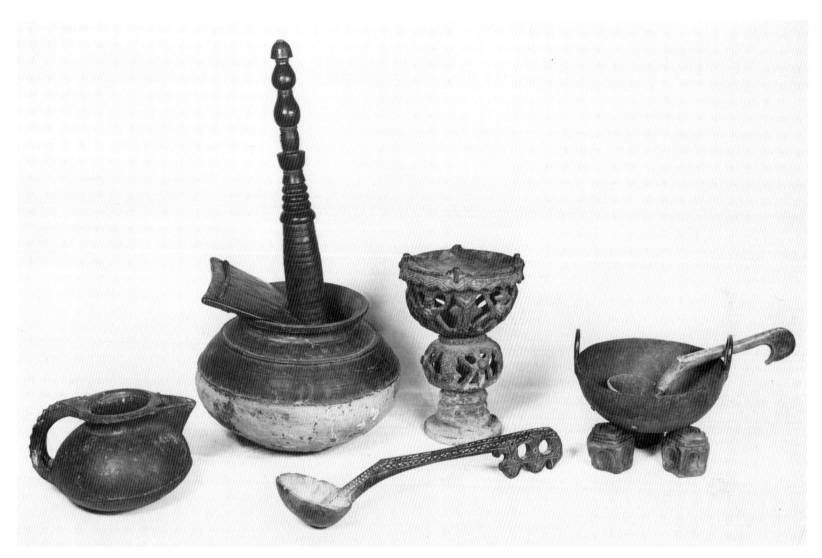

95. Milk jug, butter pot (with turned beater), charcoal brazier, bowls for melted butter (ghee), hearthstones and a large carved wooden ladle are items of household equipment used in Swat. The decoration of the charcoal brazier is an attractive translation of carved wooden ornament into clay.
Linden-Museum.

Pages 80/81: 96. and 97.
Bread cloths. Women still embroider bread cloths and cushions today, whereas modern textiles have largely replaced other traditional embroidery. In these embroidered cloths the women express their artistic creativity and craft skills. One often has the feeling that they embroider their world onto the bread cloth a little. The rectangular surface is usually articulated by a centrally placed motif and emphasis on four (or eight) corners. Tree motifs are often placed in the corners.
Private collection, Karlsruhe.

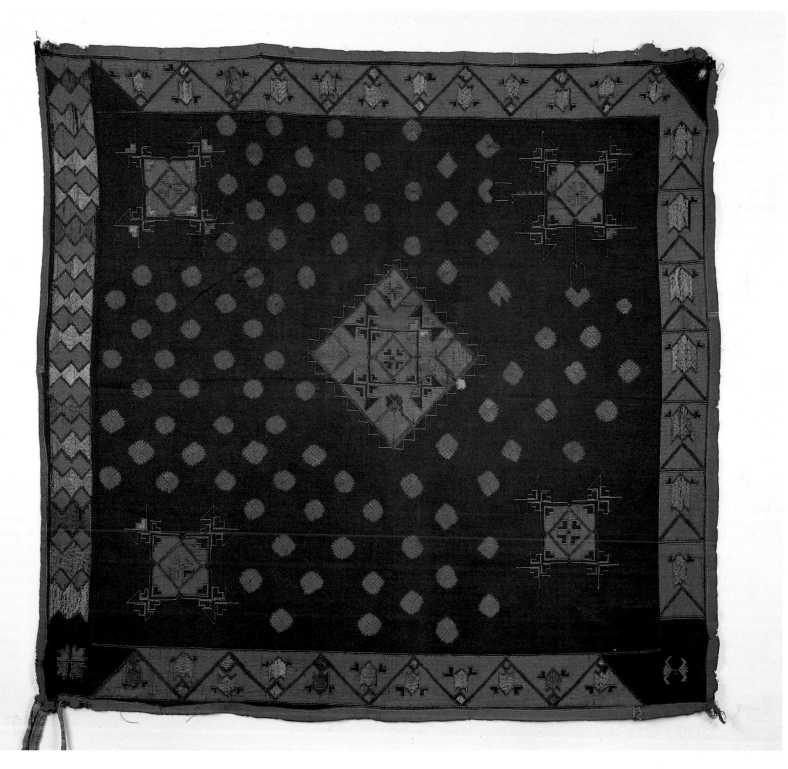

98. Peasant woman from one of the surrounding mountain villages in traditional costume, Madyan.

99. and 100.  Short embroidered woman's shirt and matching loose trousers with drawstring waist and embroidered cuffs. Linden-Museum.

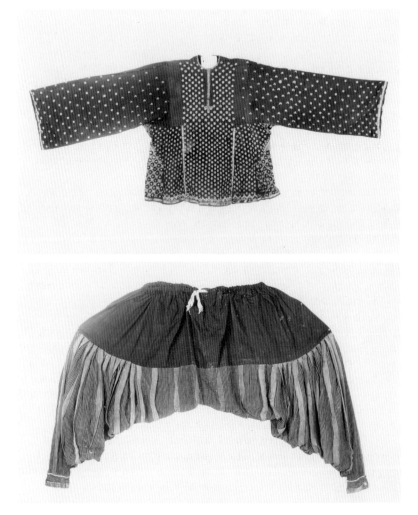

with incised drawings of flowers. The house is small (c. 50 sq m) and divided in two by a wooden partition. It has a tiny inner courtyard without much light and, since the husband's income is small, it has to be shared with another family. The two families comprise a total of 21 persons extending over three generations.

I enjoy being at home with Taj Mahal, but I am aware of the cramped conditions and the gloom and cannot imagine being shut in there. But it is imbued with her vitality I do not find the atmosphere as oppressive as in other houses.

Again and again I hear the same argument about the life the women in Swat must lead: "In the house they are guarded and protected against all troubles, from themselves, from others, from the Pashtun men and the confusions of social change. They do not have to deal with the changing world. We look after them and treat them with respect. It is true that they are shut in and have no rights, but they do enjoy respect." The men always use this empty formula when they speak about the women, but none of them could tell me what it meant.

If it cannot be denied that the purdah system is protective, providing social and psychological protection within the extended family and emotional security, stable relationships at the domestic level (which in this society is very necessary and desirable), but this still does not justify a structure which in my experience holds women in contempt.

Women are shut up in the house, barred from public life. The husband and the male members of the family have unrestricted power over women and can treat them like slaves.

Because of the large number of children and the lower rate of deaths at birth, the land which in earlier generations easily fed the whole family (making it unnecessary to earn cash to pay for additional purchases), is divided between an average of five grownup sons. In an increasing financial crisis this is leading to empoverishment. Nowadays there are only a few families or village groups in which half the sons have not left to earn money in the cities on the Gulf States.

Such socio-economic changes, together with the efforts of Benazir Bhutto, the new head of government, could bring with them long-term changes in Swat. Benazir Bhutto's first act was to free all women sentenced under Shariah law. She wants to use all the powers at her command to bring back and implement in all areas of activity the hardwon equal rights for women established in the constitution (though not of course in practice) under the regime of her father, rights which were removed under Zia 'ul Haq. Even the new government will not be able to abolish the discriminatory laws immediately. Benazir Bhutto has to show the religious fundamentalists that by making women equal to men she is not doing away with the traditional religious values.

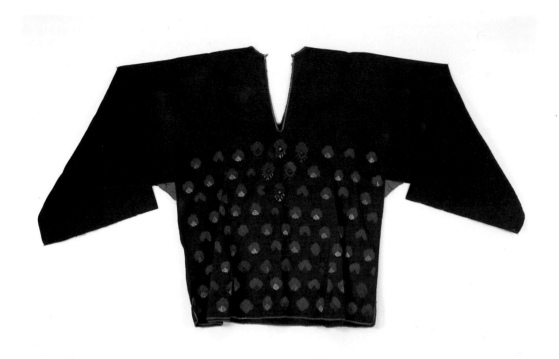

101.—104. Women's shirts, silk embroidery on cotton, some with glassbead edging or silver trimmings. Linden-Museum.

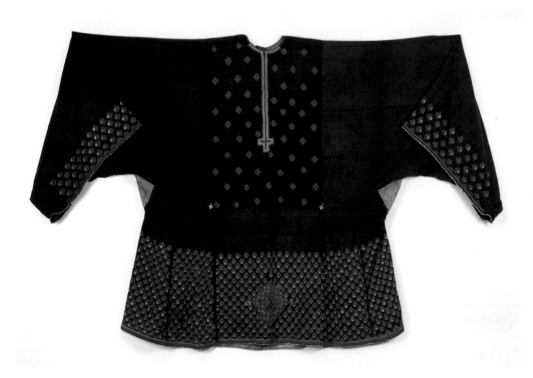

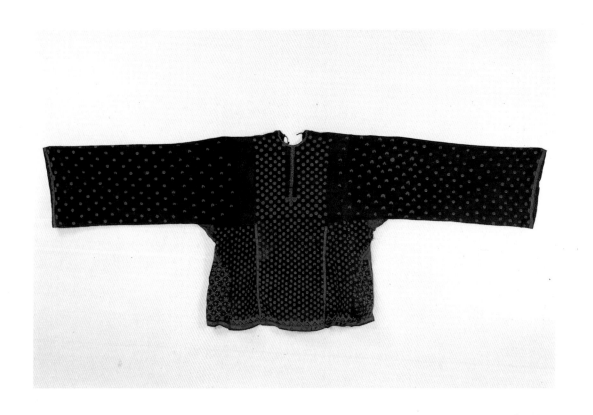

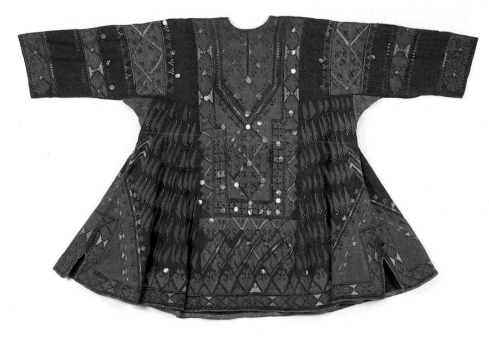

101.–104. Women's shirts, silk embroidery on cotton, some with glassbead edging or silver trimmings. Linden-Museum.

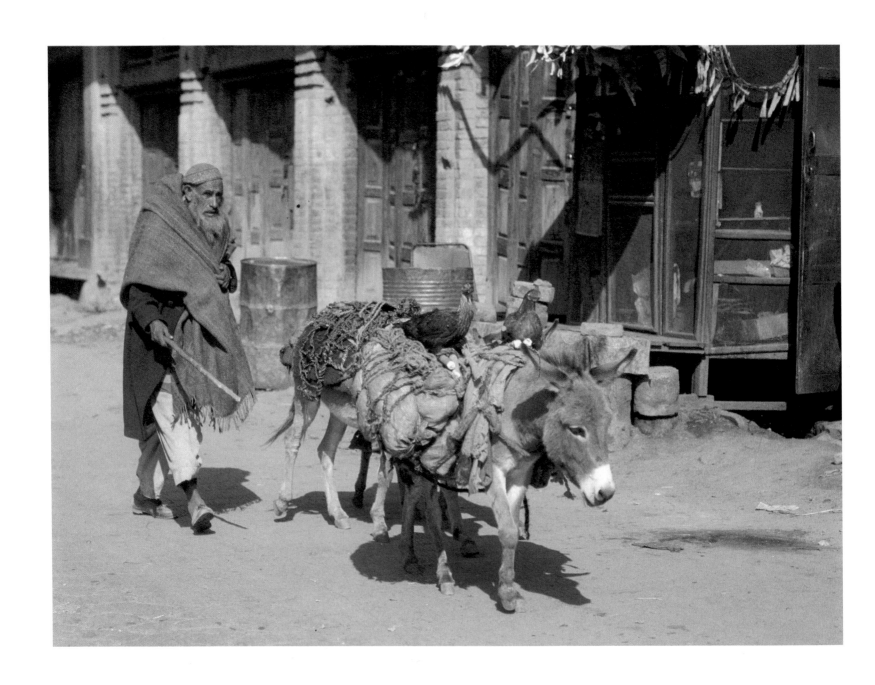

105. Old man wearing the characteristic Swat rug with its brightly coloured
selvedge in red and green. The main street, Madyan.

106.  Grocer's shop in the main street of Madyan.

107.  Street barber in Madyan.

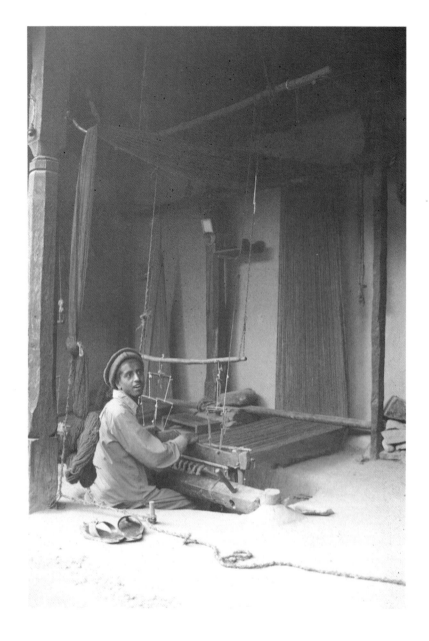

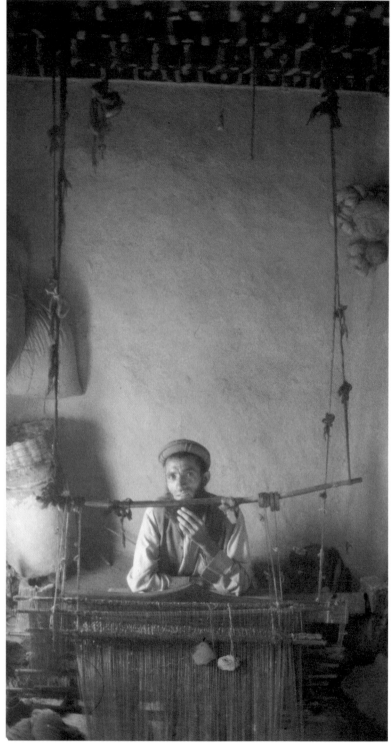

108. and 109.   Weavers at treddle looms making rugs, Madyan.

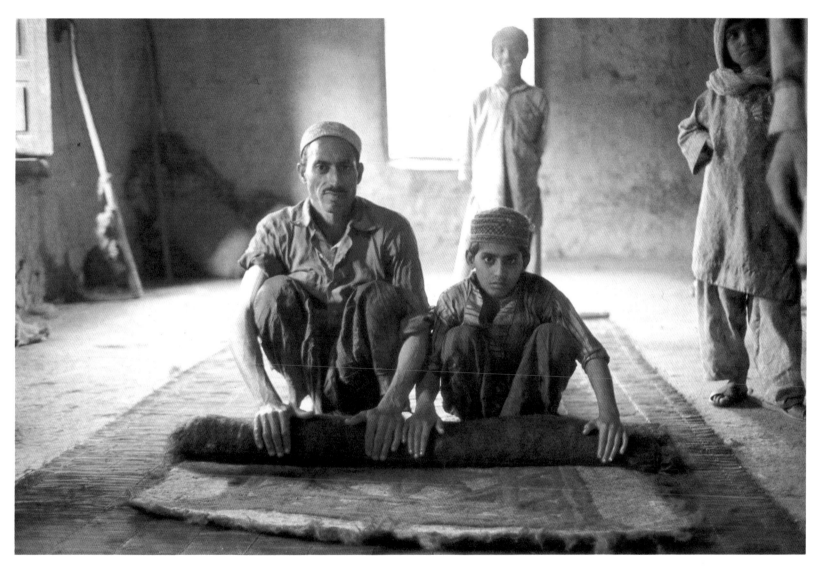

110.  Father and son fulling felt, Madyan.

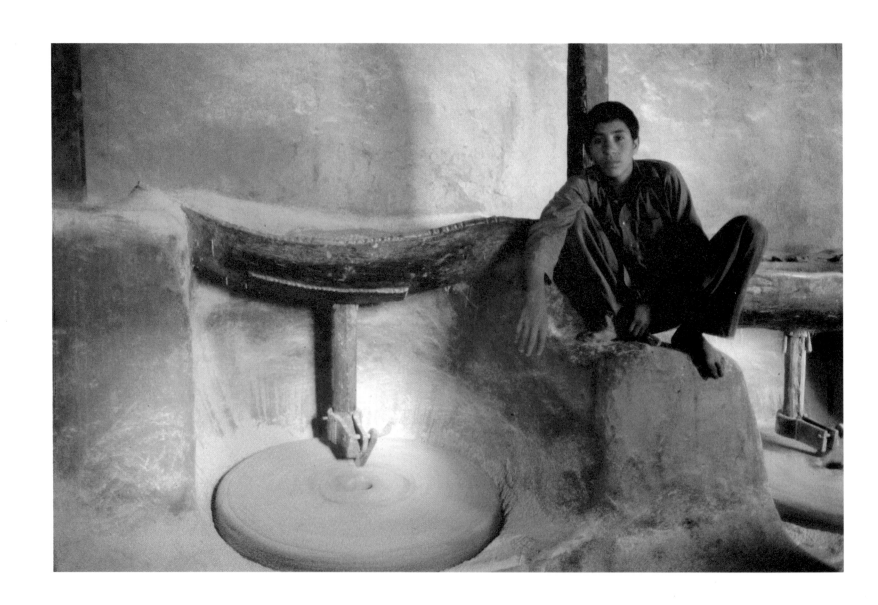

111.  In a mill at Madyan.

90

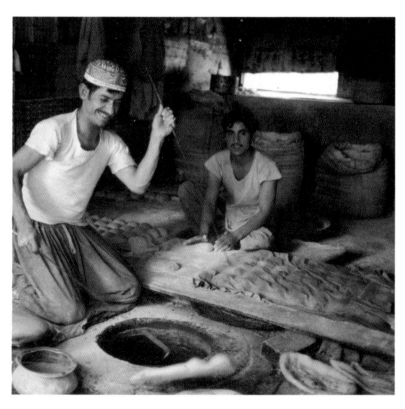

112. Bakery in Madyan.

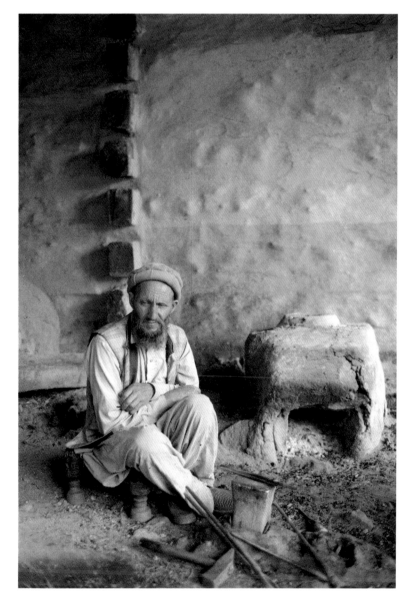

113. Master smith in Swat-Kohistan.

114. Trader in Madyan selling aphrodisiacs (ginseng and claws) as well as jewellery.

115. Blacksmith in Khwazakhela.

116. Potter's workshop in Shin.

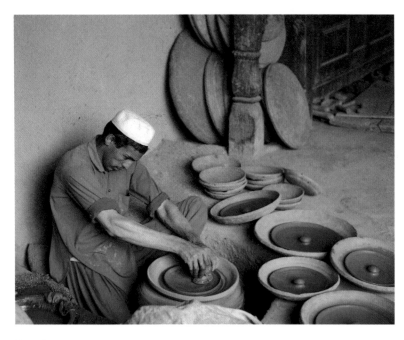

117. Potter in Shin making lids.

118. Ceramics from Swat: bowl with foot, dish with incised decoration, pot with turnedin rim and incised decoration, and narrownecked bottle shaped like a calabash. Linden-Museum.

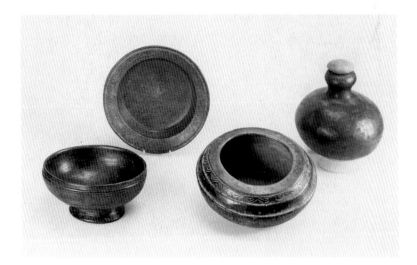

119. Lower part of a waterpipe with impressed and incised decoration. Linden-Museum.

120. Bread pan with incised geometric rosette decoration. Linden-Museum.

121. Shoulder pot with outlet, traces of paintwork, used as a water vessel. Linden-Museum.

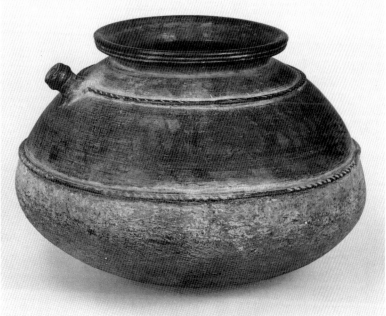

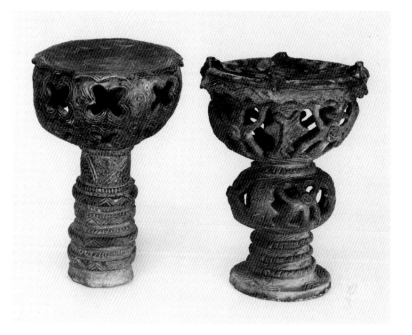

122. Charcoal braziers with openwork decoration some of which is reminiscent of wooden ornament. Linden-Museum.

123. Pine spill holders with perforated or attached handles and incised decoration. Linden-Museum.

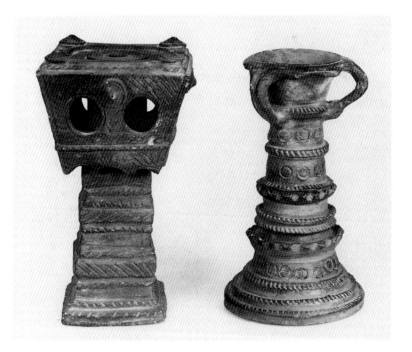

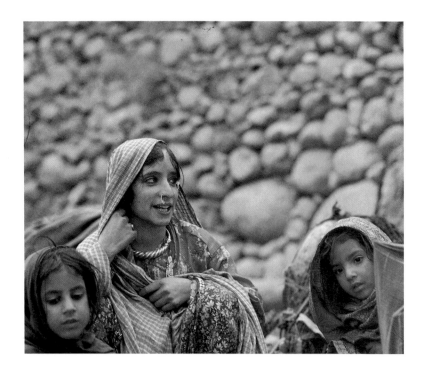

124. Gujar woman in a camp at Madyan with a heavy twisted silver neck ring.

125. Peasant women from Swat-Kohistan with traditional jewellery on a visit in Madyan.

126. Silversmith in Madyan.

127. Sultan Zarin, jeweller in Khwazakhela. Imported old jewellery from the plain has since largely supplanted the traditional silver jewellery of the region. Many silversmiths have abandoned their profession and now sell old silver jewellery to tourists and imported jewellery to the inhabitants of the region.

128. Woman in the summer camp on the high pasture in the Mankial valley.

129. Woman on the high pasture at Tape below the Mankial.

130. Woman in Shinku in the valley of Madyan (Chail valley). Swat has produced few characteristic forms of jewellery, and today they are worn only in remote mountain regions. The most important piece of jewellery of a married woman is the neck ring which can be seen in all the pictures.

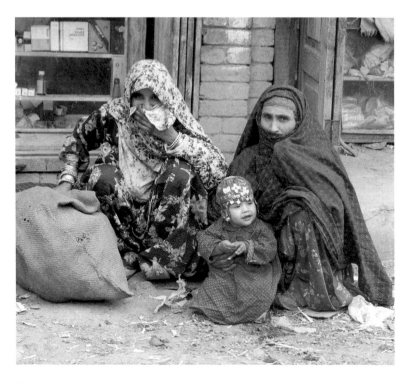

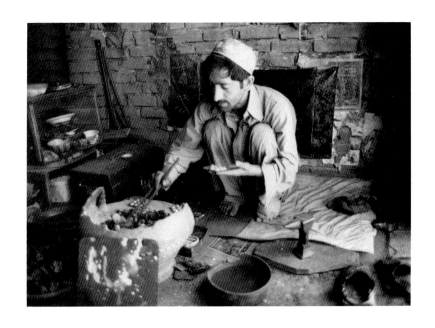

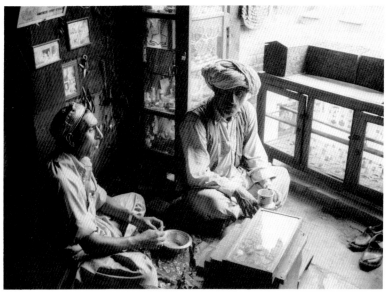

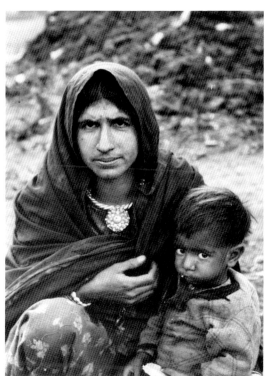

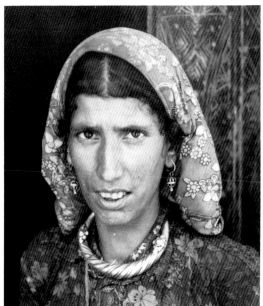

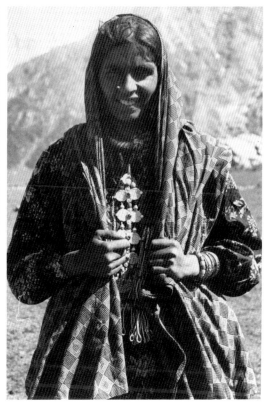

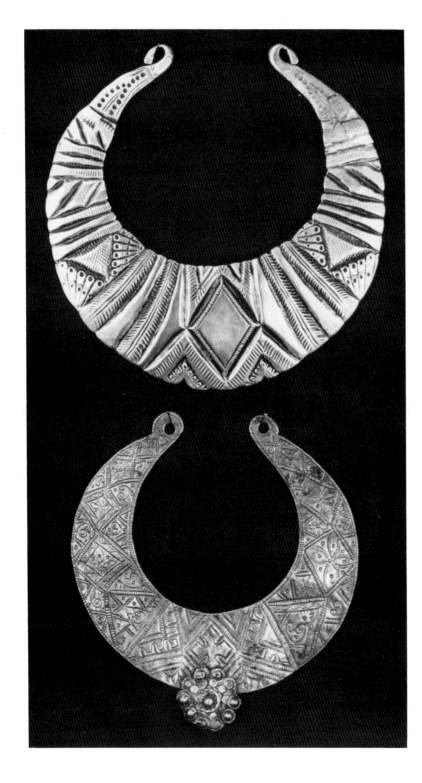

131. Above: wrought silver neck ring with engraved and punched geometric decoration. Below: design in brass for poorer families. Silk cords were attached to the rosette in the centre. Linden-Museum.

132 and 133. Variants of the above type. Private collection, Karlsruhe.

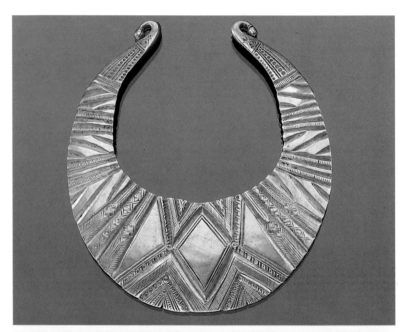

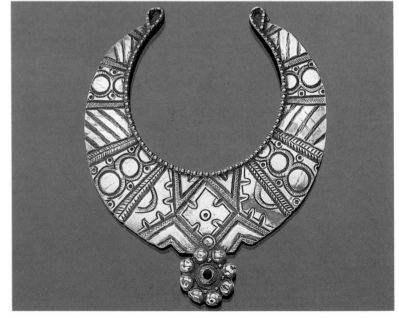

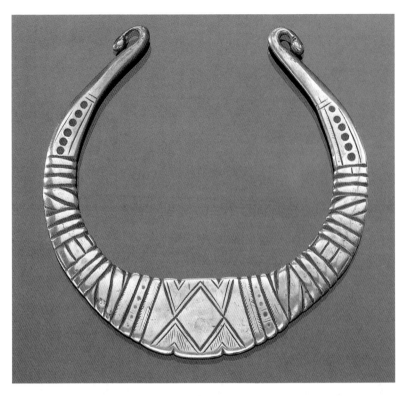

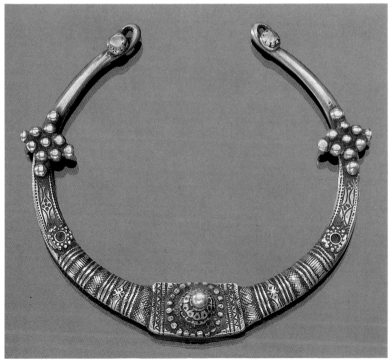

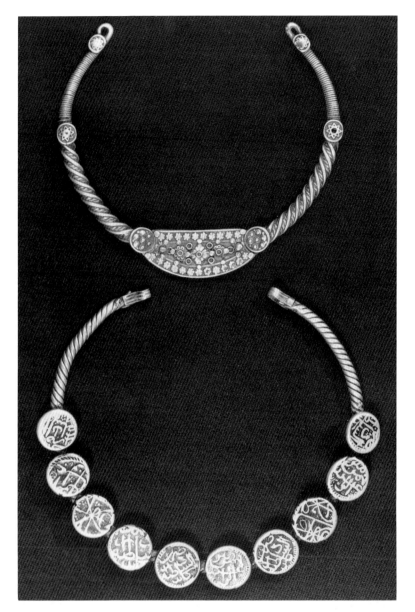

134. Round neck ring with strong, flattened central part, punched and engraved. Private collection, Karlsruhe.

135. Neck ring with engraved decoration and appliqué elements beaten in Anken. Private collection, Karlsruhe.

136. Above; twisted neck ring with wrought appliqué work. Below: the same with applied silver coins. Private collection, Karlsruhe.

99

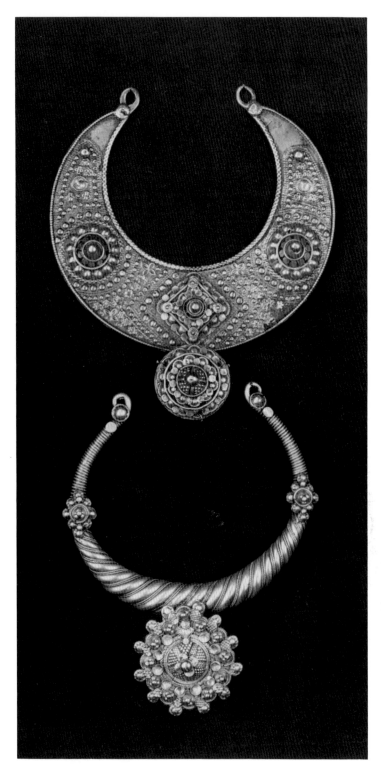

137. Neck rings. Above: brass with openwork and intricate appliqué work and pendant rosette; below: heavy silver cast with spiral seam and rosette. Linden-Museum.

138. Silver neck rings for young girls. Linden-Museum.

139. Unusually heavy, plaited neck ring. Private collection, London.

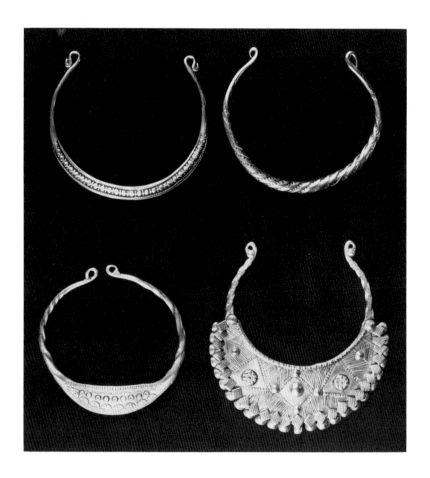

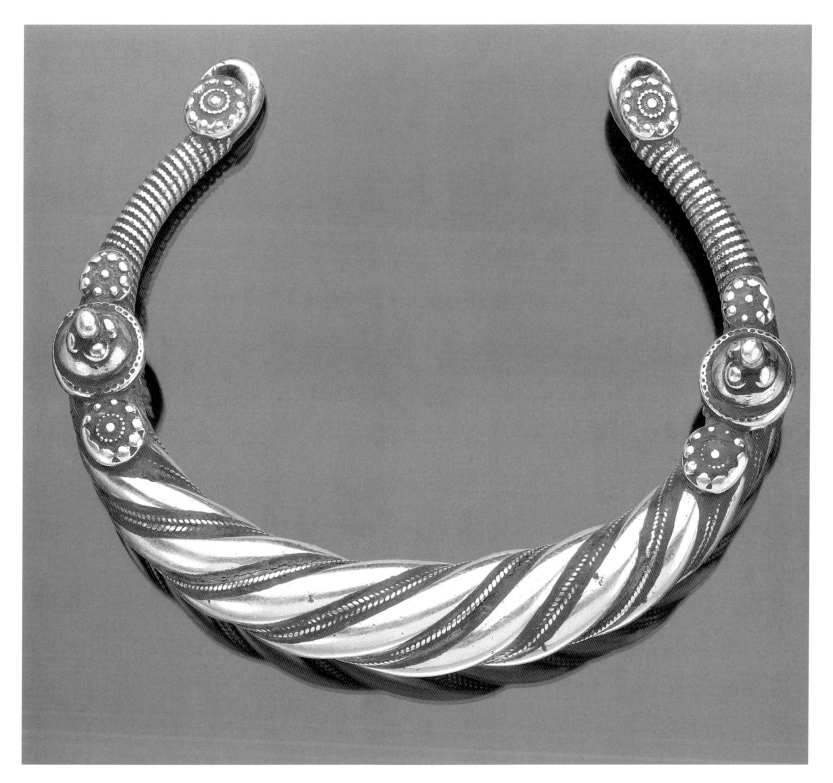

101

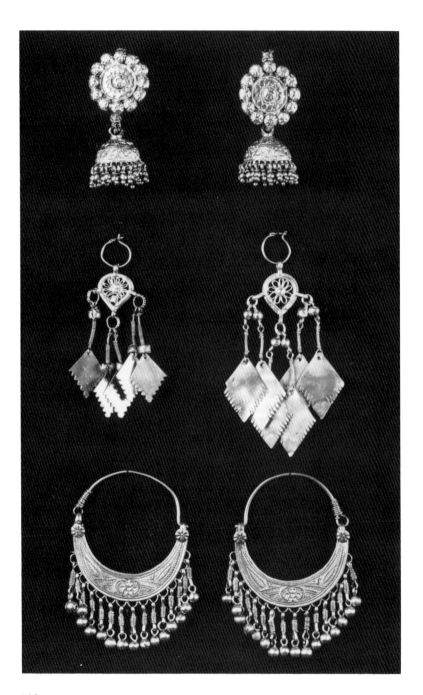

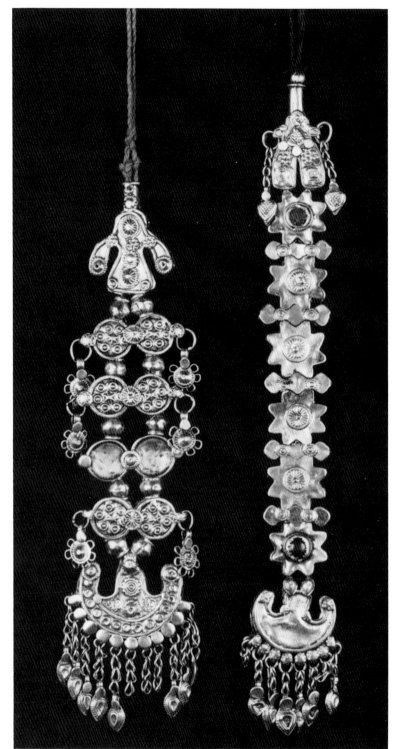

140. Earrings. Above: rosettes with hemispherical pendants. Centre: silver filigree work with serrated leaf pendants. Below: crescent earrings with engraved decoration. Linden-Museum.

141. Pectoral ornament (cf fig. 130). Beaten work with appliqué deocaration. Linden-Museum.

142. Pair of decorative shoulder straps for a highranking bridegroom. Beaten silver parts mounted on cotton with silk cords. Linden-Museum.

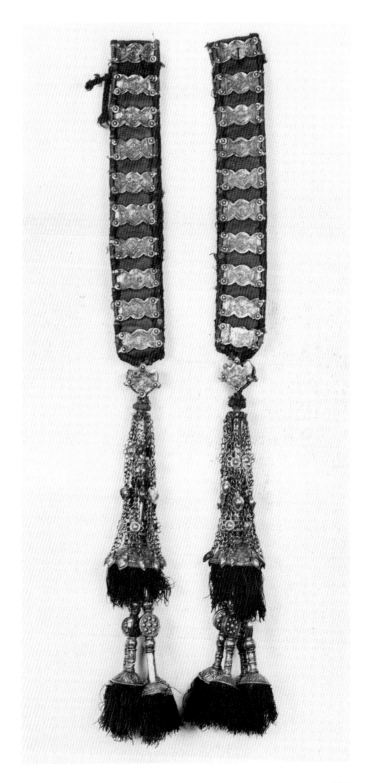

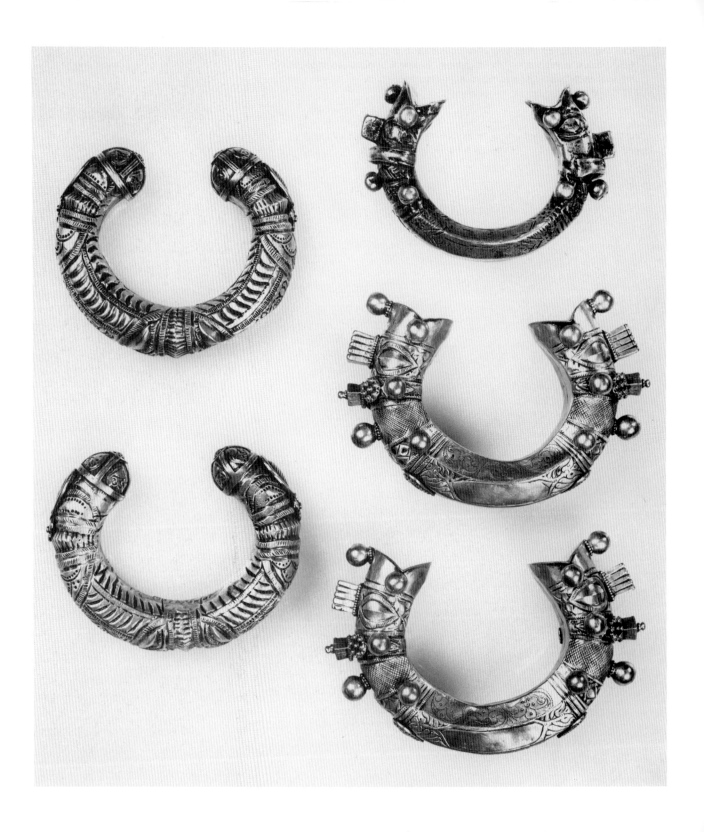

143. Arm ring. Left: pair with engraved deocaration and appliqué. Below right: beaten silver work with engravings, massive applied silver balls and snakehead ends. Above right: a similar piece made of brass. Linden-Museum.

144. Armring with engraved and appliqué decoration. In the centre a strip with a forceful wave pattern. Private collection, London.

145. A pair of foot rings made of silver sheeting bent and soldered. Engraved and punched decoration. Hinged clasp with appliqué work. Linden-Museum.

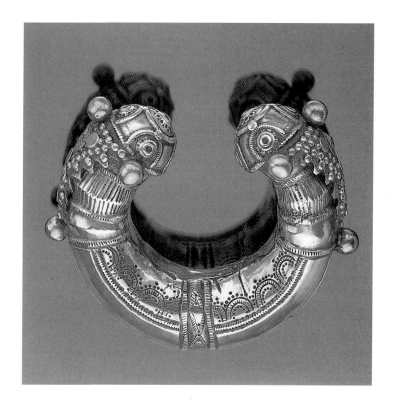

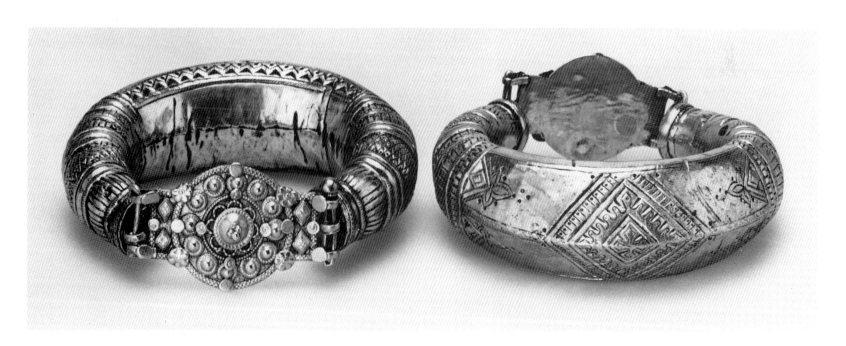

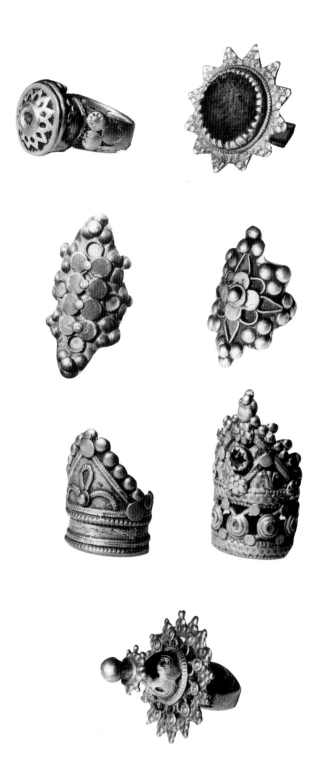

146. Finger rings. One of the centres of production was Khwazakhela.
The matrices for the production of the applied decoration (e. g. of the
ring, top left) were imported into Swat from Multan. A clearly defined
local development appears to be the production of complicated, cast
decoration such as that of the rings in the second and bottom row.
Linden-Museum.

# The Woodworkers

Organization of work – raw materials – tools and working
methods

Generally in the Islamic world craftsmen are not particularly
respected. Normally the textile craftsmen are at the head,
followed by gold and silver smiths, coppersmiths and potters.
A glance at the table of "castes" in Swat society shows that while
the woodworkers come after the gold and silver smiths and tailors,
they come before other crafts, which means that they occupy a
respectable middle position in the hierarchical society.

Unlike their counterparts in all neighbouring regions the
woodworkers in Swat are always full-time craftsmen. They were
paid by the Pakhtuns and are paid today by the landowners by a
the allocation of a piece of land which is worked by members of
the woodworker's family, or with 1/40 of the harvest of the
Pakhtun group. When a woodworker was tied contractually to a
large landowner he followed him in the periodic redistributions of
land and was paid with a quantity of corn agreed by contract.
Nowadays there are also woodworkers who work on commission
and are paid for each piece produced.

According to von der Lühe (p. 172) a certain division of labour
has also developed: "Within the 'qoum' and the 'tarkarn' there are
specialists who concentrate on the coarser work, e.g. the
production of beams, boards, tools and joinery. Another group
turns the legs of beds, chairs, tables etc. and wooden vessels, and
a third group does the carving. If, for instance, one wants to have
a small table made, one goes first to a 'tarkarn' and has the four
legs turned, then to a second craftsmen who cuts out the
framework and panels, gives them tongueandgroove joints and
mortises and chisels holes in the legs. A third craftsman carves
the framework and panels, then the second slots them all together
and wedges the framework with the legs in the mortise holes.
While the 'tarkarn' of the first and second groups can be found in
everywhere, in any 'kandai' and in the newly created bazaars,
because his products are needed for agricultural productions, the
carver is becoming increasingly rare. All the skilled carvers I ever
met have been old men. However, perhaps under the influence of
tourism there may be a new development in this field too".

Such was von der Lühe's report in 1980. His assumption that
tourism could lead to a revival of the old craft traditions, in
particular woodcarving, has not been fulfilled.

The few old men who he said were skilful carvers at the end
of the 1970s have since probably stopped working or have died. In
any case in 1988 there were no carvers in the villages we visited
who still produced work in the traditional style. There are a few

147. Mohamed Shirin, a woodcarver in Daral.

148. A woodcarver's tool box.

craftsmen – very inept ones, to judge from their work – who repair damaged traditional furniture for the resident "antique dealers", or carve the backs of old chairs, for example, which originally had no carved decoration. This type of restoration and "improvement" is easily detectable even by nonexperts because of its clumsy execution. Furniture makers who still do carving, do it for customers among the Pakistani tourists or the upper strata of the population of the region in a flattened version of the style of Kashmiri woodcarvings. Chests of drawers with mirrors, for instance, are particularly popular. Architectural woodworking has lost much of its importance because of the spread of concrete construction. Supports or doors, even if they are still made of wood, are no longer carved. The poorer people now simply buy cheap westernstyle furniture which is either produced by woodworkers in Swat or is imported from the plain. Turned wooden plates and bowls have been replaced by tin and plastic. The traditional craft of the "tarkarn" is dead.

Von der Lühe's dissertation is the only work to have dealt in detail with the material culture of Swat. Today any questions about this material culture which he left unanswered can only be answered, if at all, by examining the collections in museums.

## Raw materials

The favourite material for architectural elements. furniture and tools is the wood of the Himalayan cedar because of its resilience, strength and pleasant aroma. For the turned legs of beds and chairs, and turned vessels the harder wood of the evergreen oak and olive are also used. Von der Lühe's statement that "the 'modern' furniture made to suit the taste of Pakistani tourists is also made in walnut which is easier to work" must be qualified by the observation that many of the turned bowls and plates which formed an important part of the traditional household equipment are also of walnut. This may be explained by the fact that cedars were used for architectural elements and furniture because of their strength, and the trunks of the oaks and olives available were not thick enough to turn plates and bowls with an average diameter of 70 cm and more.

## Tools and working methods

The tools depend on the importance of the piece of work and the variety of working methods employed on it. Saws seem to have been in use in Swat for a very long period. They are used to cut the tree trunks or boards to the correct length. Boards were traditionally produced by splitting the trunks with wedges. Then the surfaces were smoothed with an adze, as can be seen for the marks (see photograph). The use of saws for cutting boards seems to have come about only towards the middle of this century.

Besides the smoothing plane of European type moulding planes are also used, as well as drawn planes with two handles cut into the sides of the box.

As well as handforged hammers of various weights there are wooden mallets or sledgehammers with smoothed curved handles and barrelshaped heads. The chisels and moulding chisels still produced in Swat often have hollow handles. For boring handles and also for decorating surfaces drills with heavy stone weights may be used. Fine ornament is carved with relatively short and very sharp knives and is sometimes just scratched. The most important instrument for carving is the chisel as can be seen from the marks.

Apart from work done on modern lathes I have never observed any turnery in Swat. Von der Lühe describes it as follows: "In Swat turning is done in two ways. Either the object is attached to a spindle between two bearings, the spindle is moved by pulling on a cord wound several times around it, while a blade is held to the object to carve it or hollow it out, or else the object itself is attached to the bearing, set in motion with the cord and carved. The first method is used for bowls, the second for the corner posts or legs of furniture. Because of the diameter of the bearings the turned legs of very different pieces of furniture all have a similar sturdy girth. Today the lathes are driven by electric motors where there is electricity. This advance has led to specialization within the 'qoum' or 'tarkarn'."

Joinery is done according to the methods employed in the oldest craft traditions of European joiners and cabinetmakers. Glue is not used, and nails and hinges only very recently.

The most important techniques in furniture production are the mortise-and-tenon and tongue-and-groove joints. Dowelled joints, often strengthened with a peg, are also used between door frames and their setting, and between roof supports and consoles.

For the framework of walls and ceilings with wooden beams the joints are usually made by simple or cross halving. For securing walls and also joining the plough to the yoke, pegged joints are also used. All these joints allow for the wood to warp, which is essential in view of the great variations in humidity. Pegged joints and halving in the structural elements of a house

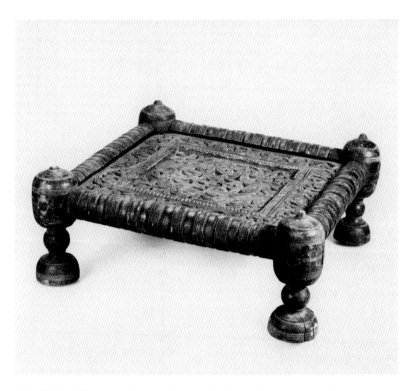

149. Table. The frame is attached to the feet with mortise and tenon
joints, the carved top is fitted by tongue and groove.
Linden-Museum.

allow for so much movement that the building is also protected
against earthquakes.

The carving techniques used in the surface decoration of the
wood are described by von der Lühe (see p.176):

"1. Grooved with knives (e.g. for outlines or the simplest
geometric ornament);
2. Notched with double-sided chisels or knives, the notches may
be V-shaped if cut only on two sides, or cubic if cut on three
sides, they can be cut parallel to the surface or obliquely, if the
relief is modelled (as in most of the ornament);
3. Cut through with the chisel (e.g. in decorative borders on
chairs or chests);
4. Dotted with a drill (e.g. for a dotted pattern)
5. Striated with a moulding plane or chisel (e.g. for supports,
halfcolumns, corner posts, and framing boards)."

## Wood joints.

mortise    tenon    pegged    tongue and groove.
                    simple

                    double

150.

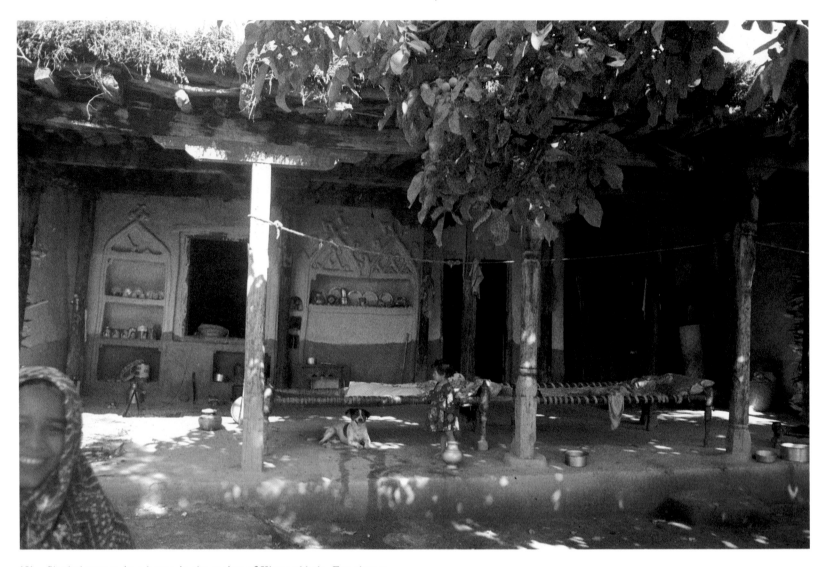

151. Shaded terrace in a house in the region of Khwazakhela. For almost
the whole year this is the centre of life in the house. The enclosed
rooms are used only in the cold season or as shelter from the rare but
severe monsoon rains.

# Furniture

## Chairs and beds

The principles of construction are the same in all cases: four turned legs, which narrow in the middle, are attached to four cylindrical or rectangular wooden rails by means of dowelled or wedged joints.

The simplest seats are stools with leather webbing woven in various geometric patterns (chequerboard, herringbone, zigzag). Their average height is 15 cm and the area of the seat usually measures between 40 × 40 and 50 × 50 cm.

For chairs the back legs are lengthened to between 65 and 100 cm. They are sometimes square but are usually cylindrical, and continue above the seat terminating in egg-shaped or pointed knobs. The back board usually begins 6–15 cm above the seat and is fitted into strong grooves in the back posts. Its lower edge is usually straight while the upper edge may be straight, semicircular, pyramidal, stepped, curved or serrated. The upper ends of the back legs are normally stabilized by means of a brace made of hide, gut or leather. Frequently the lower ends of the back are joined to the frame by means of a sort of decorative central column which has a decorative as well as a stabilizing function, and may take the typical form of a Swat capital.

In rare instances the chair back may have no decoration. As a rule it is decorated on both sides or, more rarely, on the front only. The decoration of the two sides is never the same, but they seem to harmonize with each other. Openwork backs of chairs are extremely rare.

Occasionally one finds seats for two or three persons, or "sofas", with backs. These are constructed in the same way as the stools or chairs. The number of places on the "sofas" can be judged by the number fields of ornament separated by borders on the back. It was not possible to discover whether these multiple seats were made in imitation of western models or were intended for special persons or purposes.

In 1978 I found chairs in all Swat households. Their number and quality depended on the status and wealth of the owner of the house. They were used by men and by older women. Younger women sat on beds or used stools. I have no information that the use of chairs was reserved for particular persons or that they could be a sign of the rank of their owner, as was the case with Kalash and Kafirs.

Von der Lühe has this to say about the producers of the leather webbing (p.199): "The tendons and the woven leather thongs are not prepared by the 'tarkarn' but by members of the 'kashol' 'qoum', the cord and sieve-makers who are at the bottom

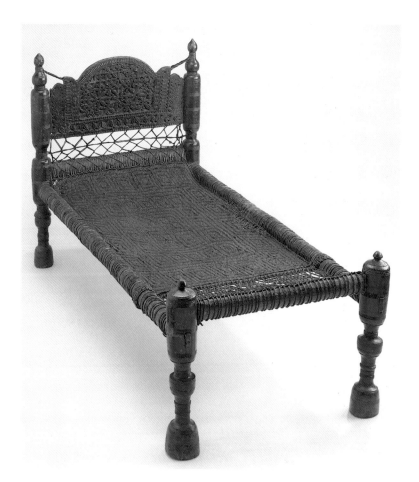

152. Throughout Swat leather-strung beds of a type also found elsewhere in northern India were usual. Only in rare instances do they have a carved headboard as in our example.
Private collection, Karlsruhe.

end of the hierarchy in Swat because of the 'uncleanness' of their trade. There are only a few men today who carry on this work and the knowledge of the complicated woven patterns seems already to have been lost. All the more recent chairs, and the old chairs which have had their webbing replaced, have a coarse mesh of thick leather strips, or else cords made of twisted maize straw are used – as in the beds made today. This webbing is no longer made by a particular group of craftsmen; often it is made by a member of the family who is good at it and copies another example. In the same way animal tendons have been replaced by cords."

Beds are constructed along the same lines as stools. During the day they are used in the covered area of the courtyard, or as seats in the "hujra". Apart from their leather or gut webbing they do not differ from the usual type found in rural areas throughout the Indian subcontinent. Their average height is 50–60 cm and the surface area measures 80–120 × 190 (maximum) cm. Very occasionally there is a carved head board set between the two upper posts which in this case are lengthened. The carved decoration of these boards is like that of a chair back extended lengthwise.

The extraordinarily varied carved decoration on chairs, "sofas" and beds is discussed in greater detail in the chapter on ornament and symbols. Unlike the chests, which seem to be basically divided into different types both of construction and ornament for the various lesser valleys as well as for particular regions in the main valley, the chairs – at least as regards carved decoration – and beds seem to conform to a single type which is so widely dispersed throughout the whole of the old Swat State that I consider it impossible to categorize particular ornamental styles according to particular regions. I have been able to examine more than 100 photographs, and although they do not constitute sufficient evidence for a final assessment, it seems to me that a chronological categorization is more probable. In view of the lack of care in the treatment of furniture and the considerable fluctuations in humidity which are detrimental to woodwork in the virtually unheated houses, I would estimate that the maximum age of the furniture is 150–180 years. The most recent chairs with "typical" Swat decoration still in the traditional style must be about 40 years old. The same is true of the chests, but not of the architectural elements.

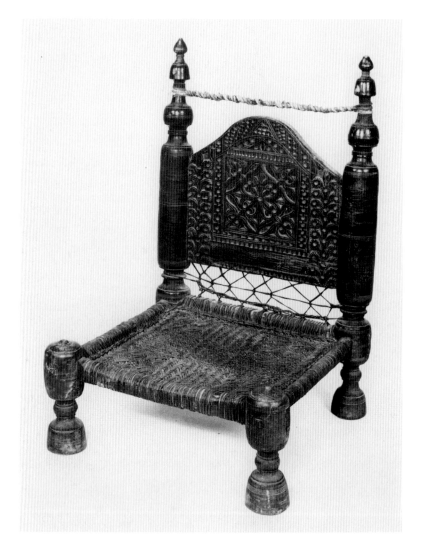

153. Chair. The pattern shaped like the points of the compass in the centre of the carved back is flanked by two very stylized trees; above the centre is a mountain motif of triangular shape. Linden-Museum.

154. Chair at the cooking hearth. Khwazakhela.

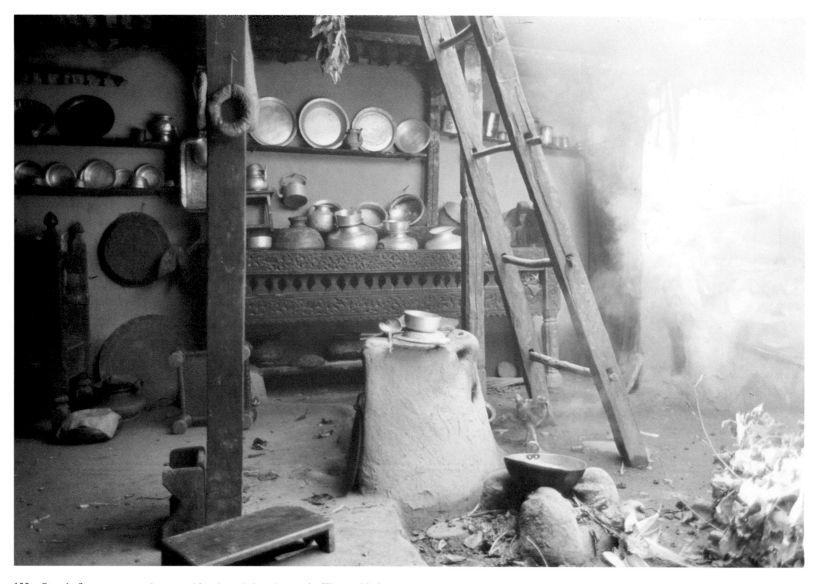

155. Stands for water pots by a cooking hearth in a house in Khwazakhela.

156. Verandah with painted ceiling beams in Taj Mahal's house, Madyan.

## Chests

Every household has several chests. They are used for storing jewellery, clothes, food of all kinds, the bride's dowry and stocks of grain. Depending on their function they range in length, breadth and depth from c. 30 cm to more than the height of a man and a breadth of c. 300 cm.

The construction of Swat chests is very uniform. Four corner posts, usually square, extend below and above the actual body of the chest by about a quarter or an eighth of the total height. The lower ends of the posts are usually grooved and carved, the upper ends may be turned like the chair posts, or carved into pyramids or balls and given relief decoration. The boards forming the frieze framework of the chest are slotted into mortises chiselled into the posts. The boards forming the sides and back of old chests are smoothed with an adze, or with a plane in the case of more recent chests, and a fitted by means of a tapering tongue into into a groove on the corner posts. About 80 per cent of the chests I have seen have lids with rounded tenons which turn in mortises in the back corner posts. Very occasionally the lidded chests have an additional opening with a sliding door usually placed on the right. The second most common type of opening is by means of a sliding door at the side, again usually placed on the right. Less common are chests which are opened by means of sliding doors which are pulled upwards, or by means of a removable panel at the back. It these cases the front is usually divided into three parts, and the opening is placed on the right or in the centre. Chests with fronts that open on hinges are probably an innovation of the last few decades.

Depending on their size grain storage chests have one or two openings in the lid for filling which are closed with a lid and round outlets in the lower quarter of the front which are closed with a wooden bung.

The fronts and front posts of chests are often carved, and the front frame and panels almost always so. For structural reasons the fronts of the chests are usually subdivided. Most frequent is a usually symmetrical lateral division in two (about 80 per cent of all chests). And in this case in about 80 per cent of all examples the decoration of the two panels is so different that one is tempted to think that the chest has a "masculine" and "feminine" half. As well as this there are divisions into 3 to 8 fields. The ornament may differ from field to field or be arranged with mirror symmetry. Division of the backs of chests – or the fronts in the case of very small chests – into two or three ornamental friezes of equal width is very rare.

In Swat-Kohistan, and probably in the neighbouring regions of Chitral, there is another type of "self-supporting" chest. The floor and lid are made from a strong board and stand out c. 8–15 cm

115

from the body of the chest. The boords forming the body of the
chest are fitted into grooves in the lid and floor. In the lid they
are also attached by mortise and tenon. The stability of these
chests is achieved mainly through the weight of the lid
(see fig. 159). Some chests from Chitral, and possibly also from
Swat-Kohistan, have floor, back and front panels attached by
tongue and groove to strong side panels which also serve as feet.
The lids are fitted by means of mortise and tenon to the side
panels (fig. 165). Chests from the high mountain regions are
distinguished from those in the Pathan-inhabited area of the
Lower and Upper Swat by their greater strength and the use of
larger boards which are usually worked with an adze.

Richly carved toolboxes have grooved sliding lids or solid
"roofs" which cover only two thirds of the body of the box.

In the whole region there are wooden food storage chests with
mud coating which serve as refrigerators.

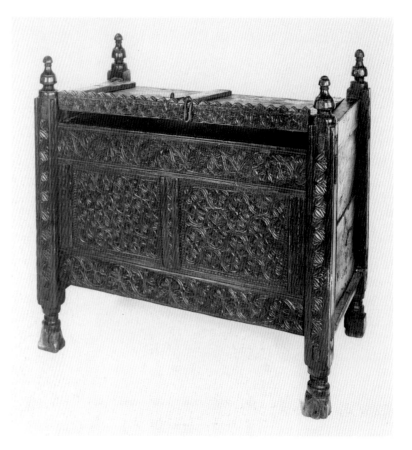

157. Chest with hinged lid, Swat. Basing his design on the classical leaf
scroll the carver has carved a delicate leafscroll pattern on the chest.
Linden-Museum.

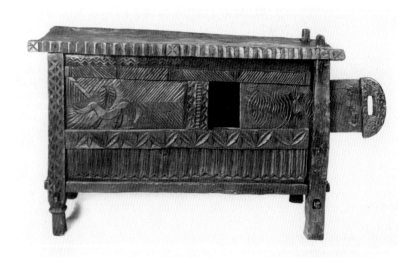

158. Chest with sliding panel on the side. Sparing use of unconventional
decoration, with a rare 'animal representation' on the righthand panel
in the front.

116

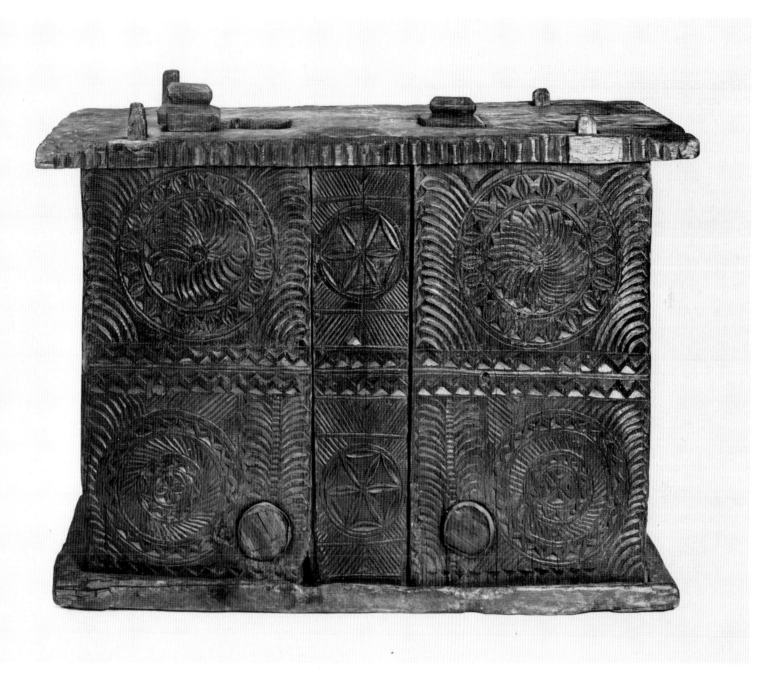

159. Massive corn chest from Swat-Kohistan or Chitral. The somewhat
    more powerfully carved rosette decoration is comparable with carvings
    of the Kalash as well as in Nuristan and among the Pashai in the
    central Hindukush. The chest has two openings on the top and two
    outlets at the bottom of the front panels.
    Linden-Museum.

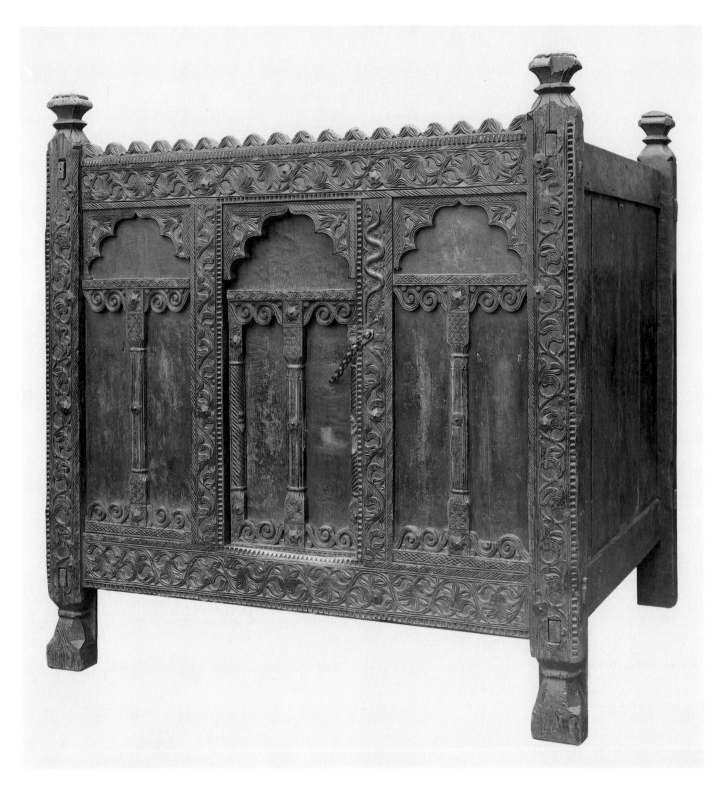

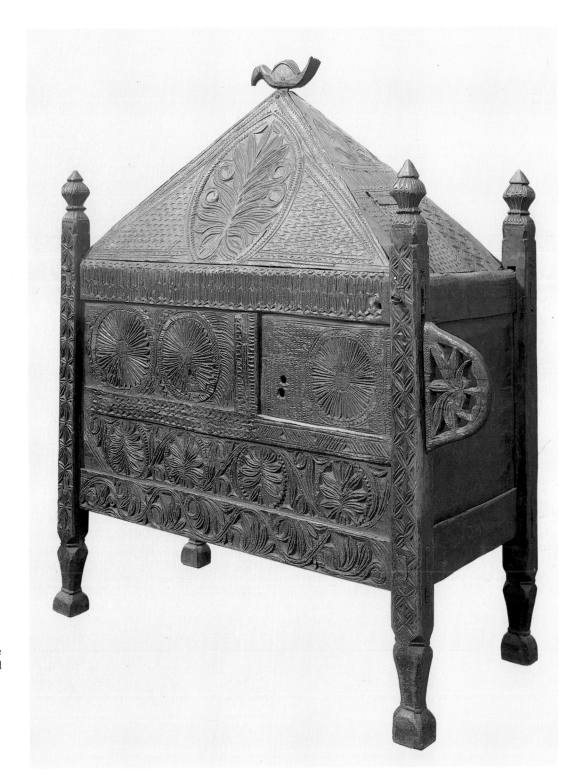

160. Storage chest of a textile dealer from the Shangla Pass region. The front is formed of three panels with column motifs and cusped arches. To the right, next to the removable middle panel, is the representation of a snake.

161. Chest with pyramidal roof and sliding door, from a valley in Upper Swat.

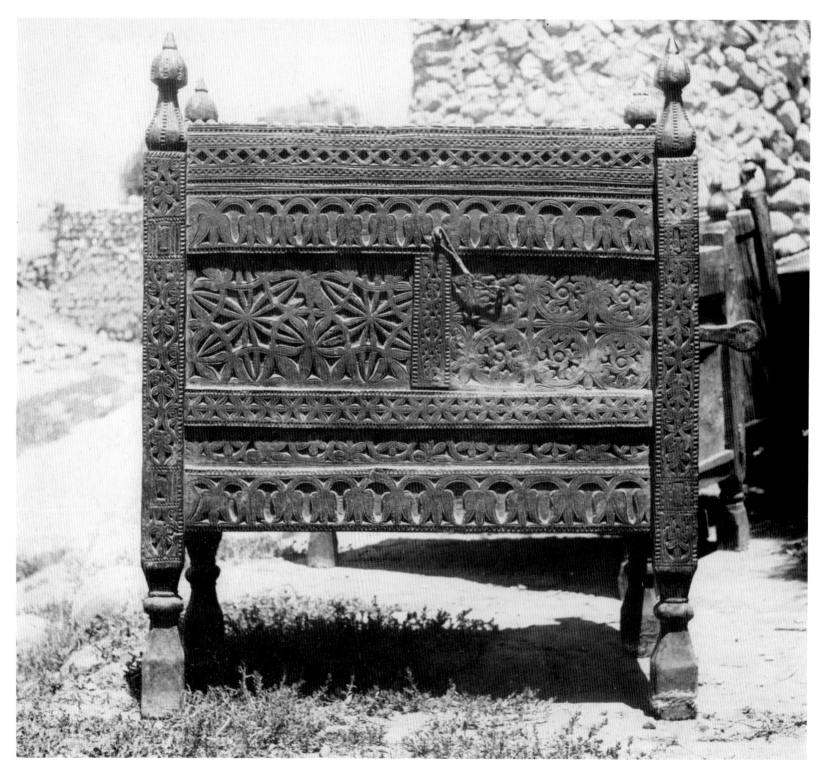

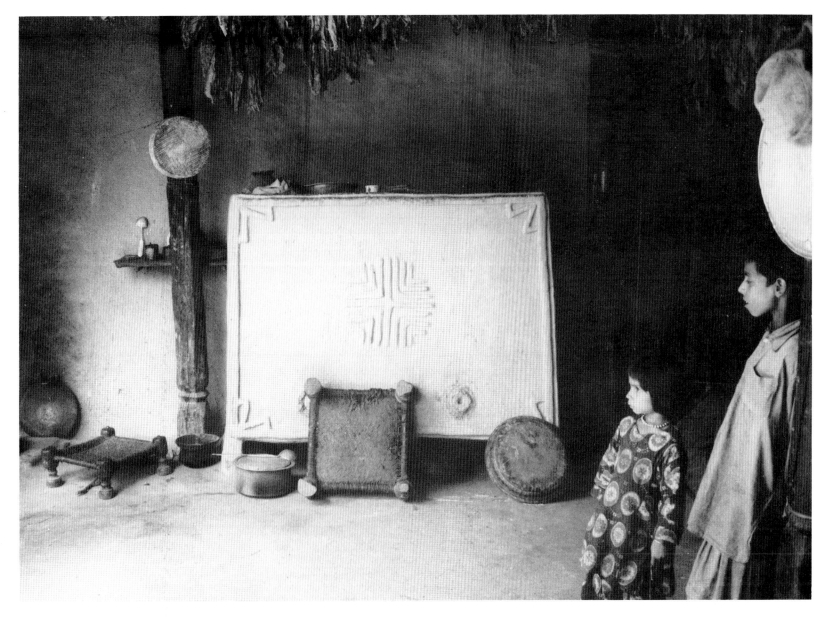

163.  Storage chest with mud cladding. The geometric central motif is
      found in a similar form in embroideries. The mud decoration is done
      by women. Kwazakhela.

162.  Chest with sliding panel on the side, Swat. The particularly fine
      decoration of the chest is impressive for its composition: the
      differently treated halves of the front are framed by an elegant leaf
      scroll. The decoration of the upper border is reminiscent of tile
      ornament so that the whole gives the impression of a faade.
      Photographed in Madyan.

Pages 122/123:

164.  Chest with front divided into compartments. Besides the variety of
      floral decoration, the geometric panel in the lower right is strikingly
      reminiscent of the ornamentation of Moghul carvings. The chest is
      opened by removing one of the front panels.  Alai-Kohistan.
      Linden-Museum.

165.  Chest with lid, Swat or Indus-Kohistan. The geometric decoration,
      like the animal depiction, is very similar to motifs on the Chaukandi
      tombs in Sind. Linden-Museum.

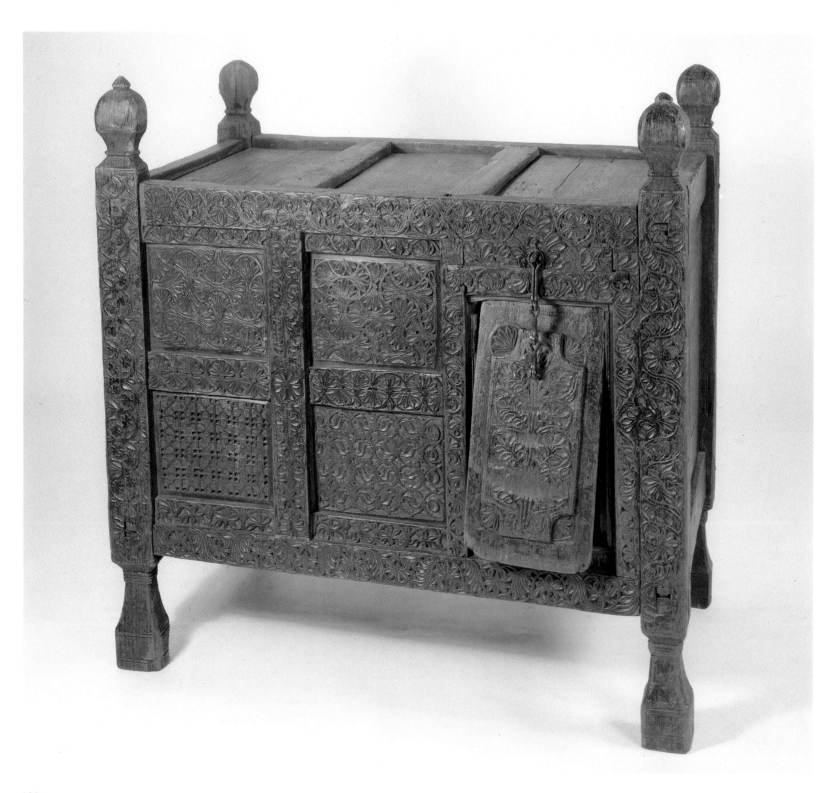

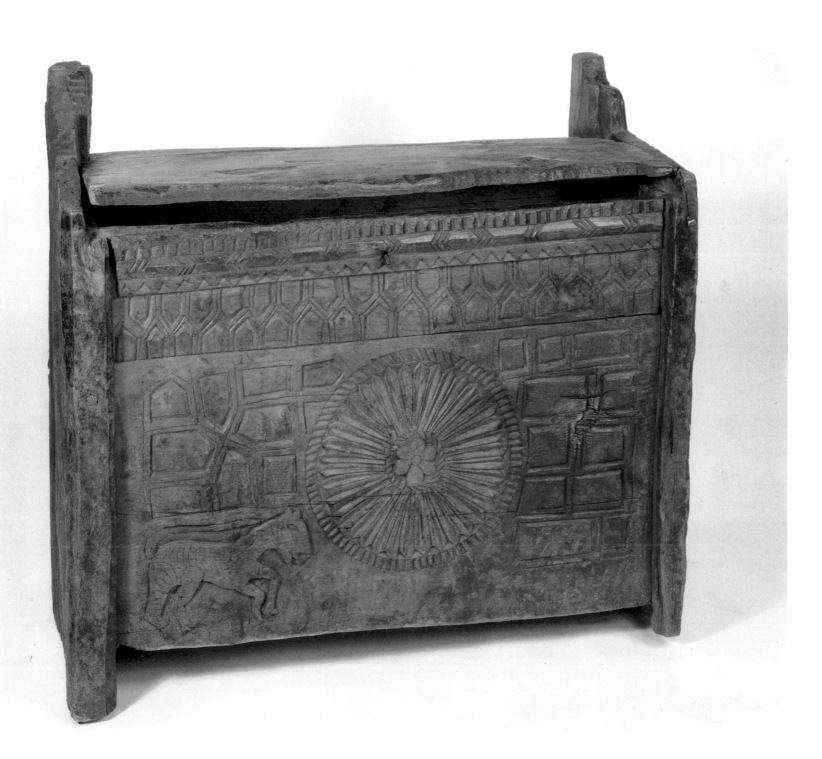

## Wallcupboards and cupboards

Von der Lühe does not mention any cupboards. I myself have seen only one in use in Swat, though in recent years I have come across about twenty such pieces on the market in Europe.

The wall niches which are part of Islamic building tradition have builtin shelves modelled in clay or made of wood and are usually either left open or else provided with curtains which are often carefully embroidered and are found throughout the Islamic world. In Swat they are also found with carved double doors.

Besides these wall cupboards there are cupboards made entirely of wood. The back and base are usually set into the clay. The cupboards have two or three carved doors which are normally closed with a wooden bolt which can be turned by means of an attachment on the top. Porcelain knobs like those once common in European kitchens are used as handles. If they are based on European models the influence must have taken place in the last century. The sparse carved decoration or the compartmented panels of the doors is almost reminiscent of central Asian felts. The ornament, the quality of execution and the state of preservation of the cupboards known to me suggest a date at the beginning of the present century or earlier.

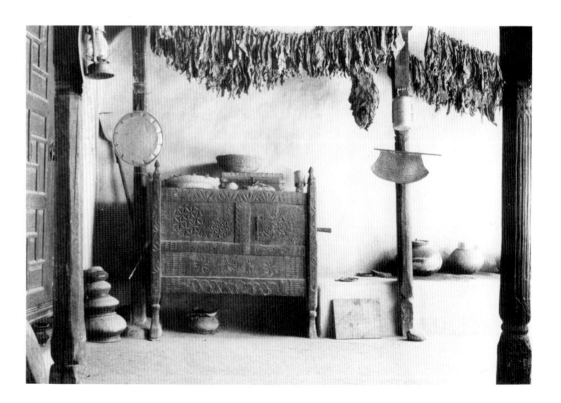

166. Furniture in a house in Khwazakhela.
Tobacco leaves are hanging from the ceiling to dry.

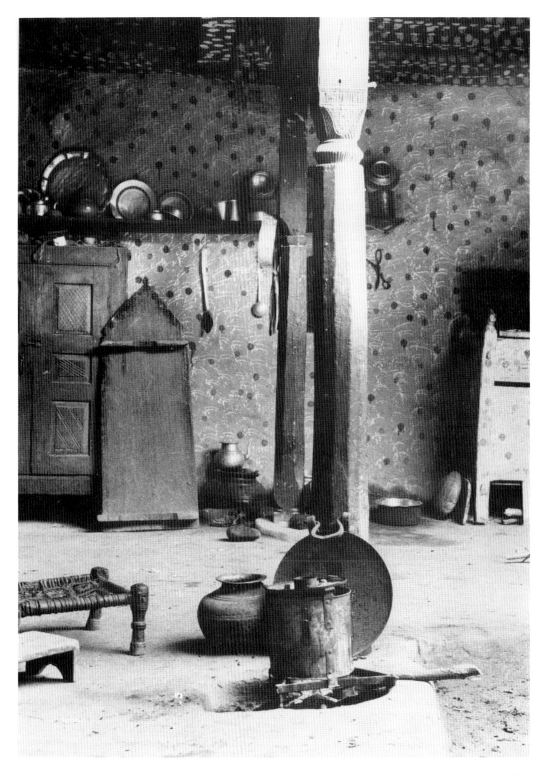

167. House in Khwazakhela. The prayer board is
leaning against the wall cupboard.

## Tables and potstands

Tables are extraordinarily rare. In construction they resemble the stools described above, but instead of the leather webbing a carved board is set in grooves in the square frame. The decoration is usually based on a central rosette.

There are two distinct types of potstands. For three or four water storage pots, if they do not stand in a wallniche, a stand with long legs is used. A ladder-like shelf is set between the four carved and grooved legs. The two back posts extend about 25—35 cm above the surface. A carved panel is placed between the back posts which stabilizes the stand and can also serve to support the round-bottomed posts as well as flat tins and pans. The most common decoration is a very stylized trefoil or fork-shaped floral branch.

Immediately beside the cooking place there are often low table-like pot-stands of triangular, square or hexagonal shape with simple notched decoration.

168.   Pot stand. Linden-Museum.

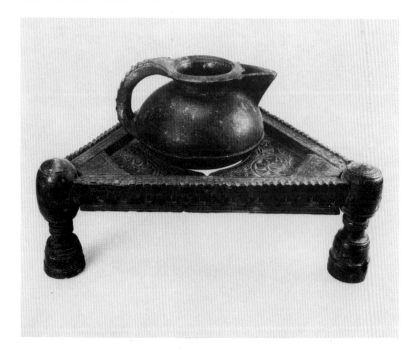

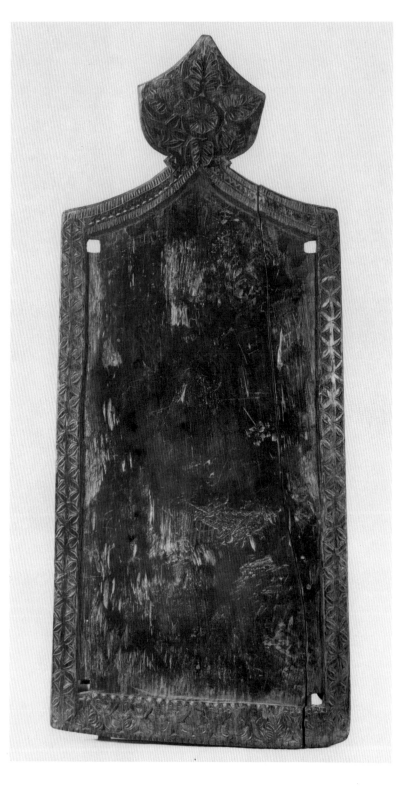

## Prayer boards

In Swat prayer boards replace the prayer carpets and mats which are usual elsewhere. Several of them are found in every household and are to be used mainly by women. Outside the times of prayer they are leant upright against the wall. The most widespread type consists of a large rectangular cedarwood board with a pointed end terminating in a circular shape which looks as if it is added on. It rests either on four short legs attached by tenons through the board, or on two planks attached by tongueandgroove joints. The shape of the board approximates to the prayerniche shape often suggested by prayer rugs. Prayer boards are on average 15—25 cm high, 4—8 cm thick, 65—80 cm wide and about 150—170 cm long. The inner area is always left uncarved. It is enclosed by a border about 6-14 cm wide usually with floral decoration. The carved ornament of the circular termination of the upper end is almost always based on a rosette or quatrefoil. In very rare instances boards have a pointed or voluteshaped termination. I know of only two boards with carved decoration within the pointed end. In one case the motif is reminiscent of a mosque lamp and in the other of a neck ring combined with a tree of life.

The second type of prayer board which is considerably less common is reminiscent of a child's bed. The sparsely carved border is attached to four posts and a panel is set into this frame by means of a tongue-and-groove joint. The triangular or curved headboard set between the upper posts is more richly carved and may be in openwork.

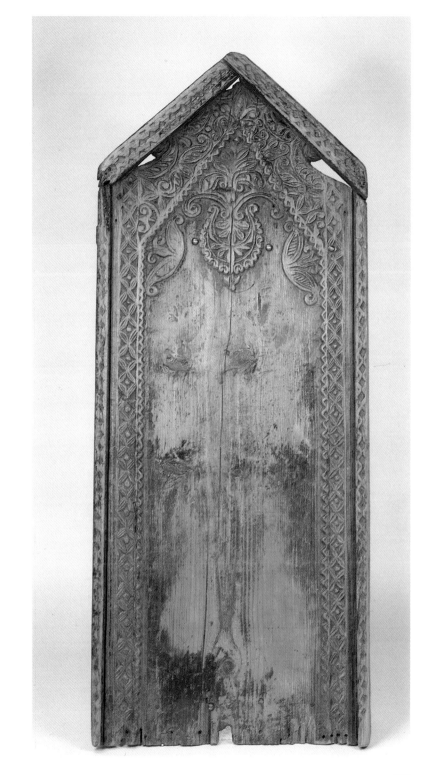

169. Prayer board. Linden-Museum.

170. Prayer board. Within a triangular field is a neck ring out of which grows a tree motif. Linden-Museum.

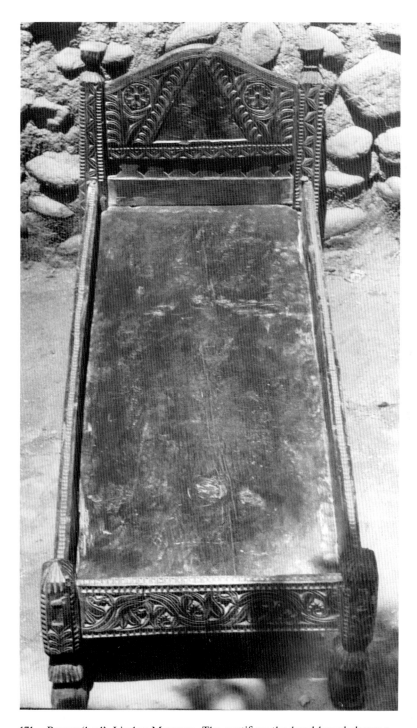

## Koran stands

I have only ever seen Koran stands in use in mosques. However, the frequency with which they appear on the market indicates that they must also be found in private houses. They are carved from a single piece of wood which is divided in two with a halving joint so that it can be opened out to an angle of about 60 degrees. Although von der Lühe says otherwise (p. 200) in fact the surface on which the Koran is laid is always left smooth, the outer surfaces are carved, and the feet have openwork carving or are cut to a niche shape. The carved decoration is like that of chests and chairs. Our collection contains two very unusual examples. A stand with openwork also in the part that supports the book: vineleaves with incised leafveins and fruit in the classical Late Antique style. I would agree with my colleague B. Brentjes (Halle) in dating the other example to the 14th/15th centuries (i.e. to the period of the Pashtun conquest of the Swat valley) on the grounds of its patina as well as its deposits and remains of paintwork. The foot of this iron stand is cut to the shape of a cusped arch niche. The foot and bookrest have a geometric openwork decoration and engraved floral ornament. I know of no pieces comparable with these two stands.

171.  Prayer 'bed'. Linden-Museum. The motif on the head board shows a mountain between two trees.

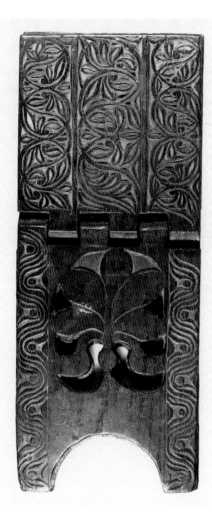

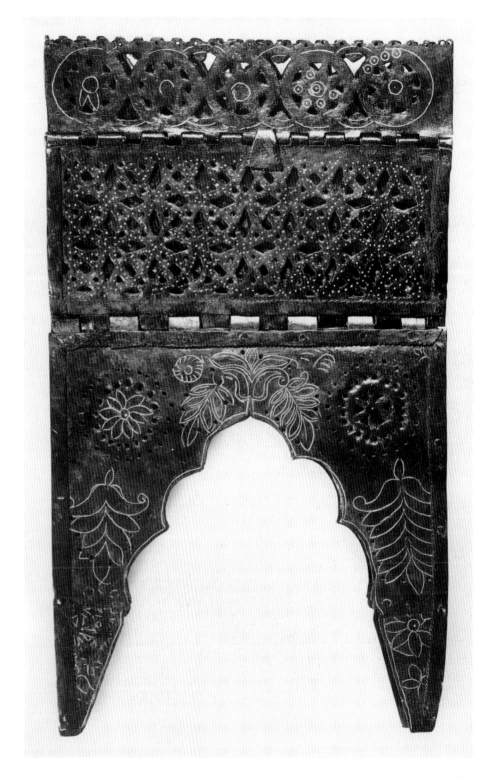

172. Folded Koran stand. The boards are joined
by halving. In the foot is an openwork
palmette, powerful decoration of interwoven
foliage. Linden-Museum.

173. Koran stand, iron, openwork and engraving.
The foot shaped like an Indian arch
surmounted by a tree. The engravings on the
border were not completed. Swat, 14th/15th
century. Linden-Museum.

174. Cooking area in Agram Shah's house in Shagram. The hearth
containing the tripod stand is surrounded by mud plaster decoration
like that found on embroidered bread cloths. Women who do the
embroidery and mud decoration inside the house have developed
some of their own traditions in motifs. Agram Shah is a landowner
and sayyid. As a religious dignitary he has the important role of
arbiter when there are conflicts, here particularly between the
Yusufzai and Torwali.

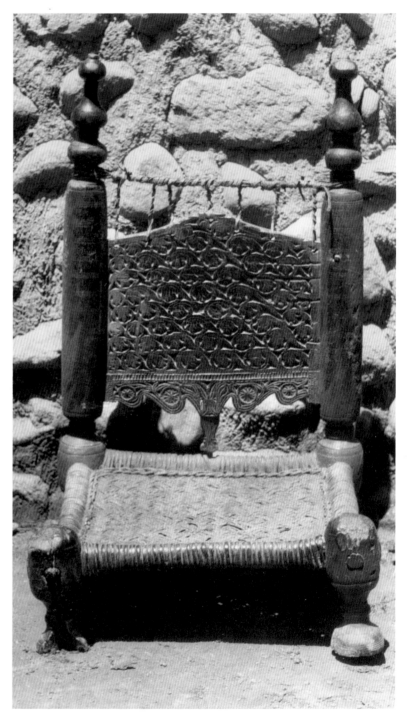

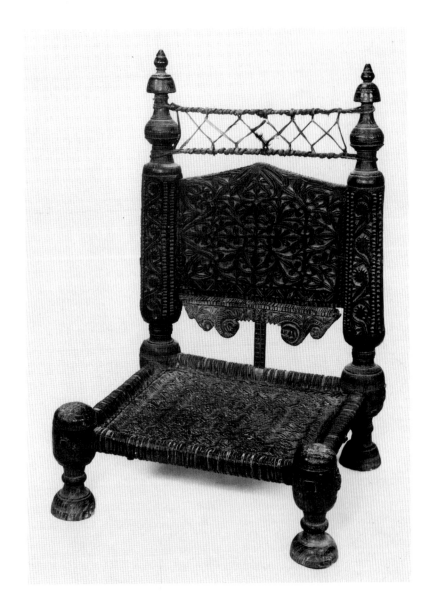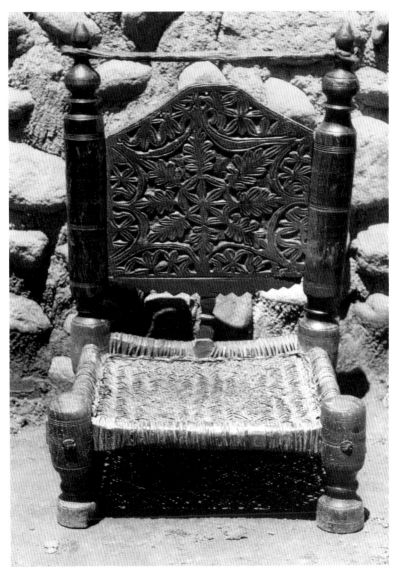

175.—177. The backs of these chairs are in the form of trees supported by columns joined to the seat. As in architectural features, the fusion of the motifs of worldtree and worldpillar is evident.
175. and 177. photographed in Madyan;
176. Linden-Museum.
177. clearly shows the oakleaf decoration typical of Swat.

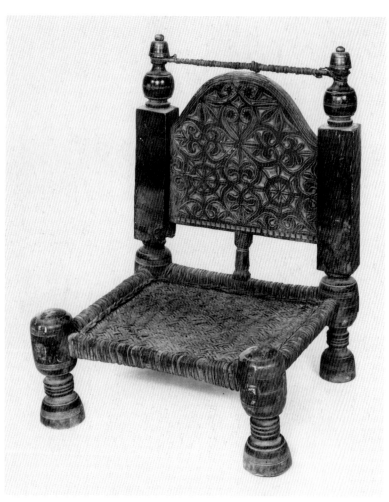

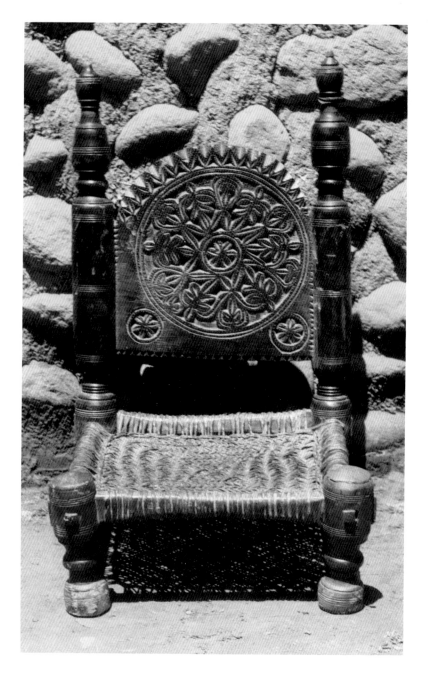

178.–179. The strongly stylized decoration of the chair backs shows their transition from floral to geometric motifs such as appear on felts of the Pamir Kirgizes. Felt production is supposed to have been initiated in Swat by Kirgizes.
178. Linden-Museum; 179. photographed in Madyan.

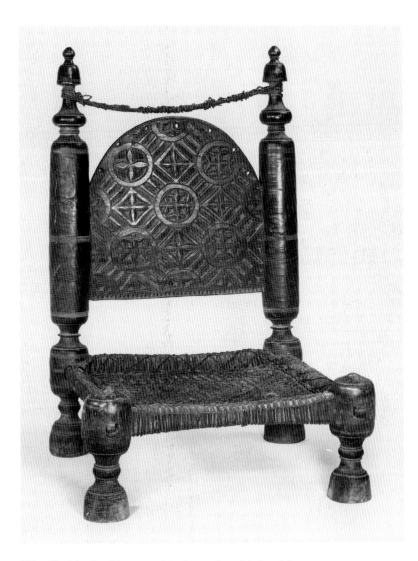

180.  Chairback with geometric decoration. Linden-Museum.

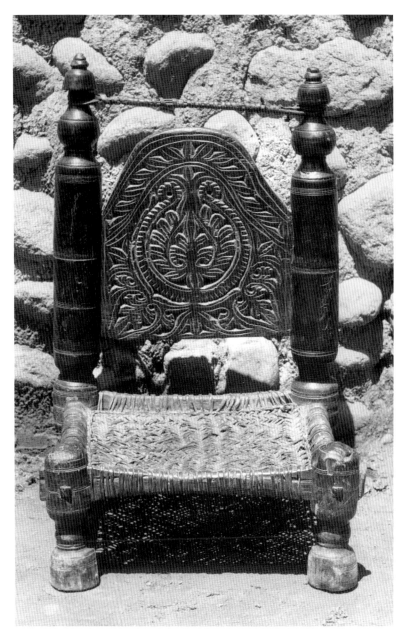

181.  Chairback showing a particularly fine example of the silver neck ring as motif, surrounded by floral ornament. Photographed in Madyan.

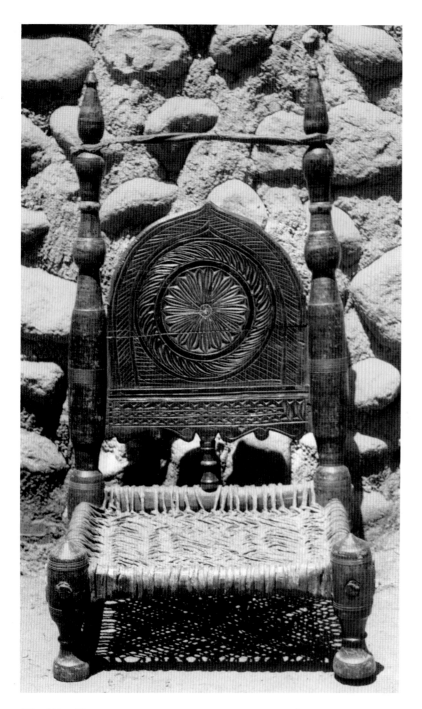

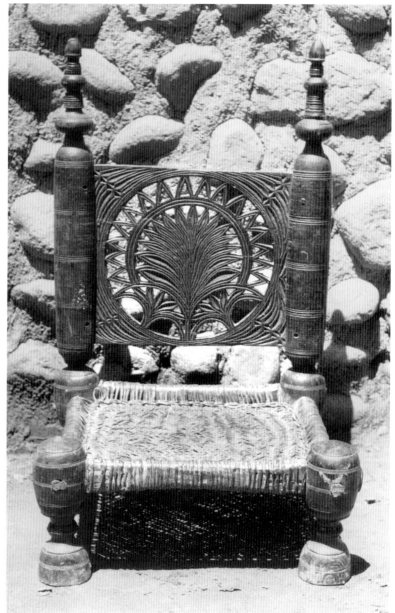

182.–183.  The rosette and the openwork rays are motifs in the repertory of patterns in Swat which may have survived from Buddhist times. Photographed in Madyan.

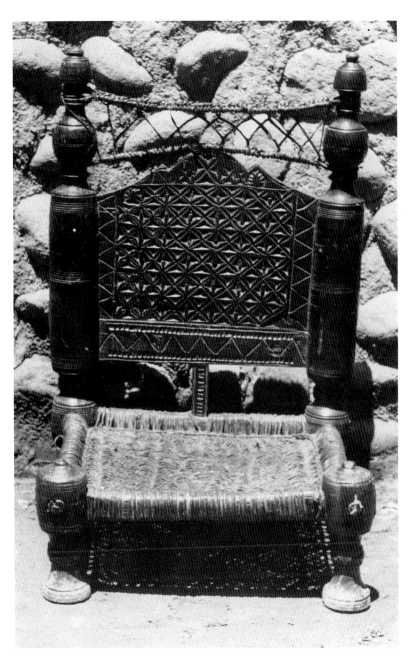

184. Chair back with severely geometric, simple notched decoration. Photographed in Madyan.

185. Chair back with cruciform flower motifs. Photographed in Madyan.

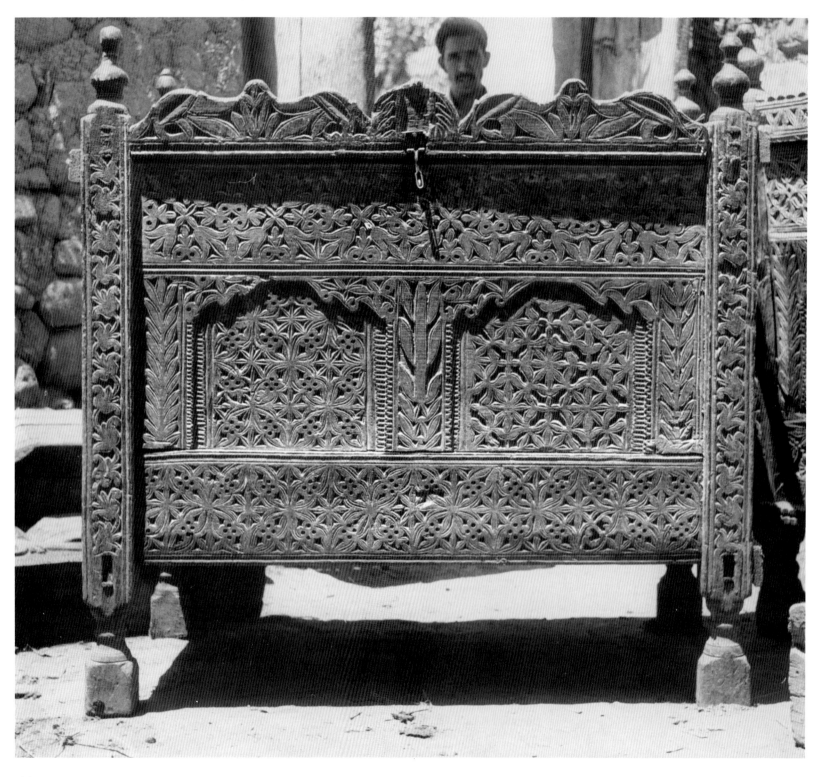

186. Chest. The front is articulated by the representation of pillars. The centre pillars in particular clearly shows the fusion of the pillar motif with the tree. The upper border is typical of chests in the Mingora region.

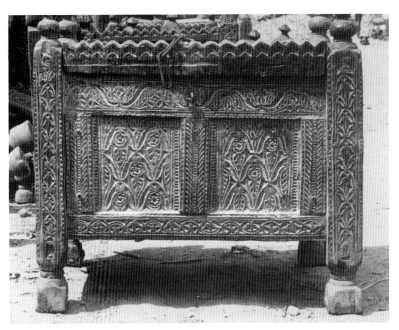

187. Detail of the façade of a tomb structure in the southern Punjab, 14h/15th century. The articulation of the façade follows the same principles of construction as that of the chest fronts (compare, for example, fig. 188).

188. The front of this chest with strongly geometric, floral motifs may be composed in a very similar way in plasterwork or as a brick faade.

189. This façade too is reminiscent of plaster decoration. The shape is found as early as the Samarra style of the 9th century.

190. Here the articulating pillars are particularly strongly emphasized. The twofold division may indicate the 'masculine' and 'feminine' halves of the chest.

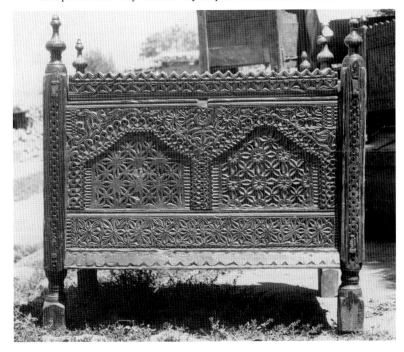

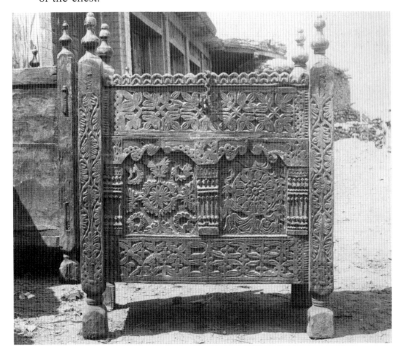

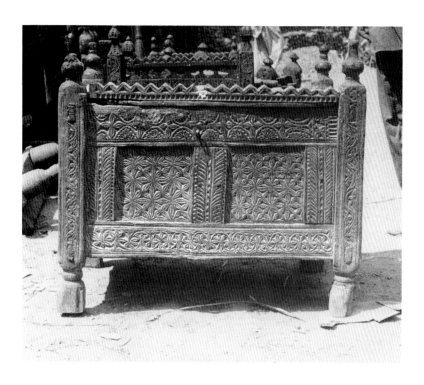

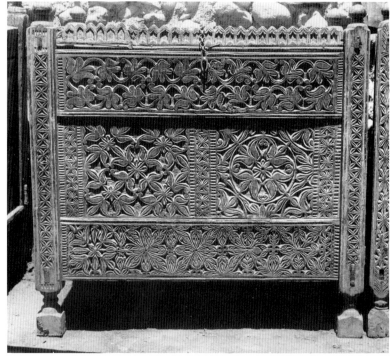

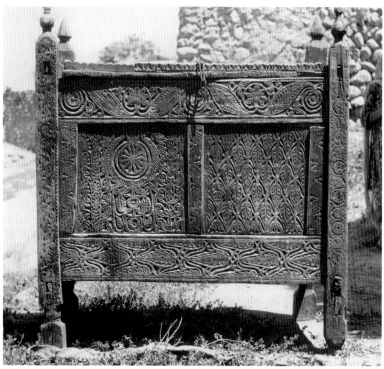

191.—193. This sequence of pictures clearly shows how the central pillar is reduced to a motif which is merely suggested and which even the carver no longer understands. A neck ring is visible in the left-hand half of 192.

# Symbol and Ornament

Reflections on the Meaning of the Motifs

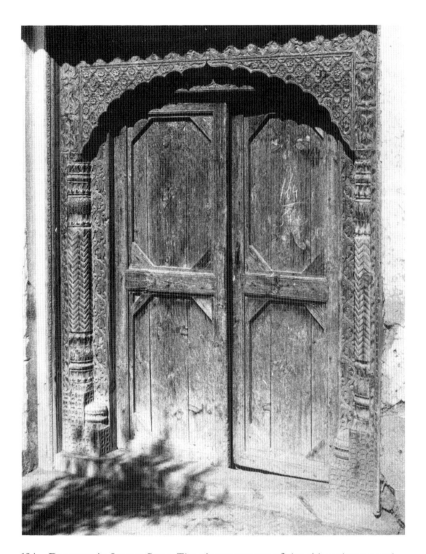

194. Doorway in Lower Swat. The zigzag pattern of the side columns and the flower-filled reticulation appear in similar form in the Moghul architecture of the 16th century.

The Grosse Brockhaus (1955 edition) gives the following definition: "Symbol (Greek), figurative image; literally what is 'thrown together'; the two halves of something which have been split but which naturally belong together (...) In this sense a symbol is an 'image of sense' (i.e. meaning), a compressed representative form of what is signified, capturing the essential without being a mere depiction, and in a higher sense elaborating it allegorically... Symbol in its strictest sense is a religious and ritual symbol, to which is attributed a magical, spellbinding power to conjure up the object..."

The definition of "Ornament" reads: "Ornament (Latin: 'adornment'), the decoration of buildings and objects of all kinds, the most basic and general form of artistic expression. Ornament may articulate and emphasize the form of the object which it adorns, but it may also have a neutral relationship to the object or obscure it. Usually it conforms to the technique and material of the object; yet in the details of its formation it obeys its own laws which do not derive from technical conditions. The formal language of ornament moves between two poles: on one hand the purely linear and abstract geometrical, and on the other a method of creation which goes back to original forms, sometimes with a pronounced naturalism. Whereas in early cultures ornament appears in very simple, clearly developed forms with a limited vocabulary of motifs, in historical times it there is an increasing enrichment, mingling and variation of motifs. These variations are not arbitrary but correspond to the expressive aims of the style predominating in the period. As early as the neolithic period distinctive systems of ornament are apparent and can be related to regional cultural groups..."

It has become usual when referring to objects which have embellishments, such as our examples from Swat, to say that these objects have ornaments on them. Without wishing to change this established usage I would suggest that we are dealing here as much with symbols as ornaments. It is certainly simpler to list the various motifs which appear as embellishments and which together form the distinctive system of ornament in the region – one has only to see a sufficiently large number of ornamented examples – than to list all the symbols concealed within this system of ornament.

Whether and to what extent the knowledge is available to interpret the ornament cannot be assessed from the present state of research. Nor can we say whether the carvers who two or three generations ago were putting ornaments on objects were still

aware of their meaning. The change in meaning from a symbol to a purely decorative ornament can take place gradually over generations. Questioning of the inhabitants of a village revealed that some still knew the meaning of a particular motif, while others saw it only as a decoration. It should also be borne in mind that when speaking to a stranger, people may possibly keep silent about pre-Islamic symbols because they want to be regarded as good Moslems.

I believe that the ornament in Swat contains a large number of motifs which are symbols with roots that can be traced back to prehistoric times.

195. Individual flower and leaf motifs.

196. Repetition of individual elements to form linear and surface ornament.

197. Combination of several elements to form surface ornament. All drawings by Dietrich von der Lühe.

140

## The Neck ring motif

One of the most interesting motifs in Swat carving, which I believe is an example of a symbol that has changed its meaning, is the woman's neck ring which appears on chairs, chests and in panels above doorways. Two comments can be made with certainty about this motif. Where it appears on articles of furniture, particularly chests, these formed part of the bride's wedding goods. Lühe (p. 255) explains the meaning of the motif as follows: "When I asked about the meaning of this piece of jewellery I was told that it represented the crescent moon as a symbol of Islam so when it is given as a wedding present or used as a sign on wedding chests or furniture, or over the entrance to a house, it indicated that the owner was an orthodox Moslem. It appears at the same time on the ornamented slate grave stones". The people Lühe questioned were explaining the neckring motif as they understood it at that time, or as they wished to explain it to the questioner for the reasons given above.

On closer exmination it emerges that at least three different types of neck ring are represented.

One type is a torque or "Wendelhalsreif" (spiral neck ring) made of thick silver wire. A. Janata (p. 104) assumes that this type was produced in the Swat valley until after 1900 and was exported from there to the Kalash in Swat-Kohistan and the Kafirs in Afghanistan. In pre-Islamic Kafiristan these rings were symbols which could be worn only by high-ranking men and their wives and daughters'. Among the Kafirs the successful "killer" achieved a high status. Swat was Islamicized by the 11th century, but it was not until the 15th century that the crescent moon first appears as a symbol of Islam in Turkey.

The second type of neck ring represented has a crosssection which is either rounded (thickening in the middle), rectangular or flat. It is found in the Punjab and Sind. Representations of this type of neck ring are found on the socalled Chaukhandi graves near Karachi dated to the 16th/17th century, where they appear together with the woman's complete collection of jewellery.

I have never seen either of these two types of neck ring worn in Swat itself. The second type may however be confused with the type still commonly worn in Swat consisting of two thick plaited silver wires.

The third type which is the most easily recognized in representations consists of a flat silver or brass plate usually with a pendant rosette in the centre. This type is closest in shape to a particular sort of representation of the crescent moon.

It is common to all three neck ring types that their curved ends are reminiscent of very stylized heads of aquatic birds (ducks or geese). The motif of the neck ring is practically never found in isolation; it is almost always combined with livestock amulets or

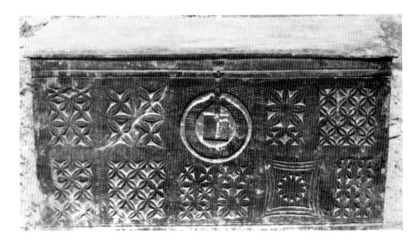

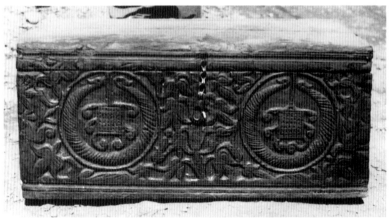

198.—200. These chest fronts have particularly clear examples of the three types of neck ring represented in Swat carvings (see p. 142).

201. Tombstone in a cemetery in Madyan. The neck ring motif appears twice, left of the centre is the 'Sword of Islam', surrounded by geometric motifs.

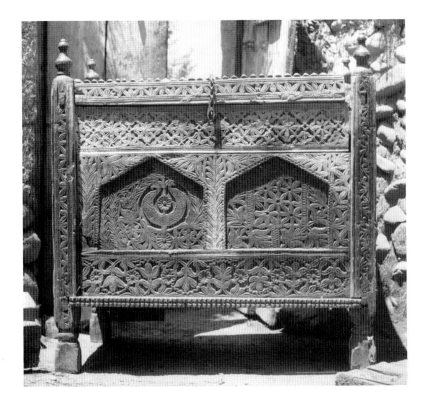

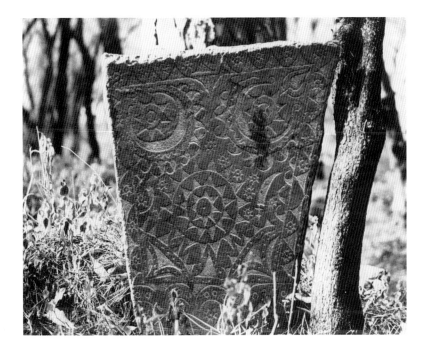

plant motifs, which I interpret as trees.

The key to the understanding of these representations of neck rings is provided, I believe, by an silver pendant, embossed in a mould, which also comes from Swat. On it too a neck ring can be seen encircling a tree in the top of which sit two birds. The most convincing interpretation of this combination of motifs is by A. Janata (p. 36 f):

"These representations are based on a world picture whose origins go back to the depths of the prehistoric age and which can only be sketched here in rough outline. The tree of life – in shamanism the world pillar – joins together the superterrestrial, terrestrial and subterrestrial spheres. Seen from the human level the top reaches into the region of the upper world which is ruled by gods, the roots into the underworld possessed by demons. The bird, a representative of the celestial, uranian principle, stands for the sun, which gives light and warmth..."

Janata argues that this representation is a visualization of a world picture and continues: "In an earlier work I attempted to allocate this complex of symbols a place in the customs of Afghanistan (Bauer and Janata 1974). I can now add some supplementary information. For a woman who has been brought up traditionally, the first time in her life when all cosmetic means and resources are used is when she is made up as a bride. It can therefore be no coincidence that it is on the implements used for her toilet, such as hairpins, cosmetic pencils, containers for cosmetics and so on, that the tree of life, bird and fish, the significance of which has been explained, are found. Furthermore, an important part of the property transaction which is part of every marriage contract, is the jewellery which the bridegroom presents to his bride as his gift. Other articles which have important functions in the wedding ceremony are also laden with the same symbols, in particular the sugar axe. This is used to cut up sugar loaves; the pieces, distributed among the people present, are supposed to lead to a speedy wedding or children (Janata 1963. 69 f). These sugar axes bring together in their decoration the tree of life, sun, bird and snake or dragon (Bauer and Janata 1974, 33, fig. 16, 17). The fertility symbolism is as evident as the context is illuminating.

There are also a number of masculine attributes which I linked together in the earlier book: powder horn, gun lever, belt hook and other equipment connected with the ammunition belt, all decorated with bird heads – usually depicted in three-dimensional form. They are almost always the heads of ganders..."

"The Afghan, following the example of the Pashtun, is duty-bound to protect his wife and land with all means at his disposal. This duty is laid on him expressly by one of the basic requirements of his value system, the Pashtunwali: 'namus satal'. The word 'namus' means not only the 'female part of the family'

but also 'chastity, conscience, basic principles, honour, reputation and dignity'. The 'namus satal' requirement demands of the Pashtun not only the protection of his wife but also of his household hearth, his agricultural land and the pastures".

The use of this extremely complex combination of motifs on bridal goods and over the entrance to a house, must, I believe, mean far more than the interpretation of the neck ring as a crescent moon symbol suggests. The fact that the representations of birds are no longer visible to the "European eye" is irrelevant; it does not mean that they are not present. The names of motifs from Swat have unfortunately not been recorded. In central and northern Asia there are many ornamental representations of animals which would never be recognized as such without the help of the names given to them.

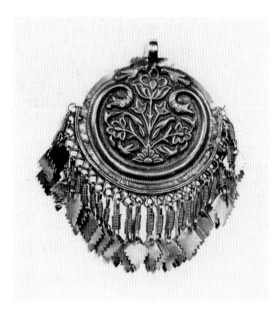

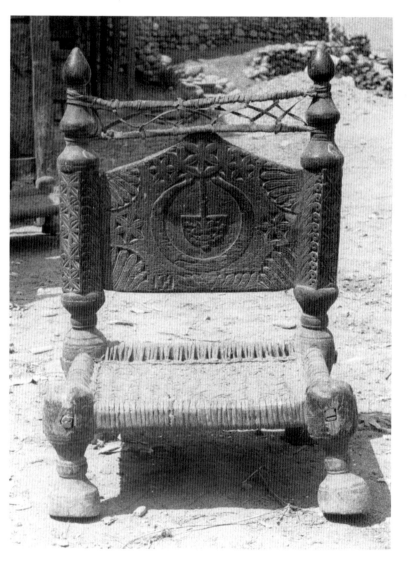

202. Pendant, wrought silver. A world snake is curled round the world mountain on which stands the world tree, in the top of which birds are visible. Private collection, Stuttgart.

203. Chair. On the back is a flat neck ring motif with animal amulet and floral decoration. Photographed in Madyan.

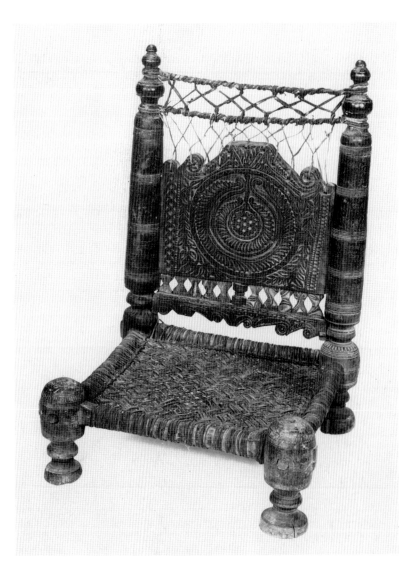

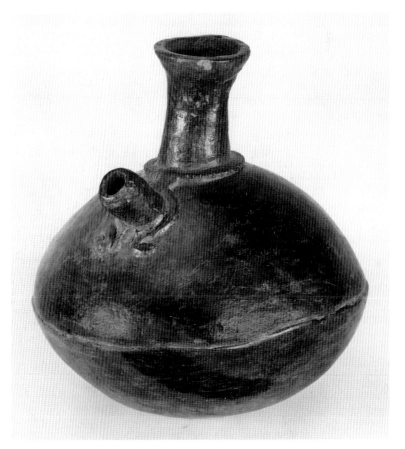

204. Chair decorated with a spiral neck ring and animal amulet.
Linden-Museum.

205. Washing jug, ceramic. The spout is surrounded by a neck ring motif.
Linden-Museum.

## The symbolism of the centre

### Pillar of the world or world pillar – world tree – cosmic mountain

Pillar, tree and mountain are symbols connected with a world picture which sees the world in three great storeys – heaven, earth and underworld. These storeys are linked together by a central axis which can be a pillar, tree or mountain. "And this axis serves as an 'opening' or 'hole'; through this hole the gods descend to the earth and the dead to the subterranean realms; through this hole the soul of a shaman in ecstasy can fly up or go down as he requires on his journeys to heaven or the underworld" (Eliade pp. 251 ff).

This originally "shamanistic" image of the world is most widespread among the Arctic and north Asiatic peoples, but was also found among others such as the Germani, Finns, Ests, Mongols and – in close proximity to Swat – the Kirgiz, according to Eliade in what is probably the most thorough study of the phenomenon. Jettmar has pointed out (in connection with the Hindukush) that ideas of the central pillar are found among the Kafirs of Nuristan and the Kalash of Chitral who are also very close by. Eliade (p. 253) also remarks "The symbolism of the world pillar is also known in more developed cultures (Egypt, India, e.g. Rig Veda X, 89, 4 etc.), China, Greece and Mesopotamia." And in another passage: "The symbolism of the world tree is complementary to the central mountain. Sometimes the two symbolisms overlap; in general they supplement each other. But both of them are nothing more than better elaborated mythic forms of the cosmic axis (world pillar etc.)."

Eliade (p. 251) describes how this cosmological concept is reflected in the material culture: "The cosmology, as expected, is reflected exactly in the microcosm of mankind. The world axis has its concrete representation in the pillars which support the house..."

We can sum up. The evidence of the cultures directly neighbouring Swat shows that the concept of the world pillar and the world tree was known in Swat before the Islamic conquest. It is also true that the architecture in Swat at the time of the Islamic conquest already had the form still current today. The Pathan conquerors, the descendents of nomads, who first settled in Swat, had no carpenters or woodworkers of their own; they made the local craftsmen their clients who then continued to work for the new masters in the traditional style.

There is no basic difference between the architecture of private houses and mosques. In both the most important and most richly decorated elements, the pillars, symbolize a widespread, ageold, pre-Islamic world picture.

206. Detail from the base of a pillar, world snake around a geometric rosette. Linden-Museum.

207. Palmette-like tree motif on the base of a pillar. Linden-Museum.

208. Detail from a pillar with neck ring, pomegranate, foliage scrolls and geometric patterns. Linden-Museum.

209. Entrance to the winter prayer hall of the Great Mosque of Madyan. Right and left of the door are half-tree motifs, niches surrounded by rams' horns and surmounted by mountain motifs.

210. Painted faade of a house in Swat-Kohistan. Beside naively stylized geometric patterns is the combined tree and vase motif.

211. Carved pillar from Chitral. One face has a forked foliage design, while the face on the right shows cypresses on mountains. 18th century. Linden-Museum.

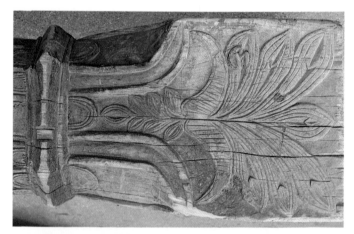

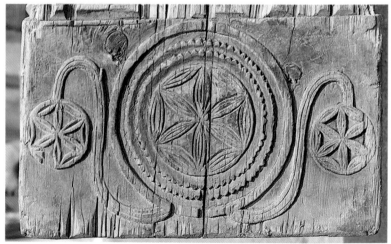

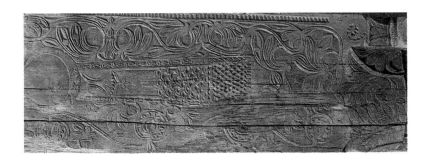

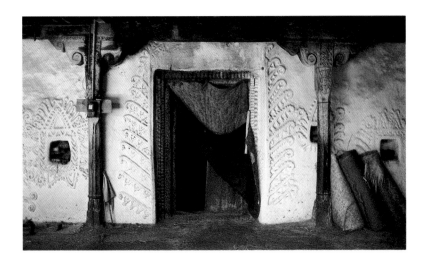

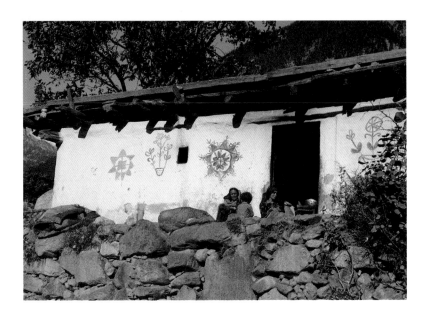

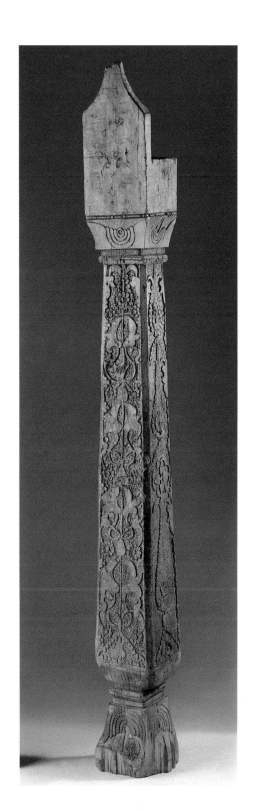

Thus, as in other places the symbols of the world tree and the world mountain were overlaid, so in Swat too the motifs of world pillar or world tree were overlaid and fused. I am convinced that the pillar in the typical Swat house or mosque is in fact the world pillar or world tree. In this connection the Khwazakhela carver's remark (which seems rather obscure and difficult to interpret) quoted at the beginning of this book – "I want to turn wood back into a tree again" – takes on a new meaning. It is an expression of a last vague memory of a pre-Islamic cosmology. To complete this argument it should be noted that among various peoples of the Hindukush the Himalayan cedar is considered to be a "pure tree" (see Jettmar, 1975, p. 254) which grows in the "pure highmountain regions where man is closer to the gods". The preferred material for the pillars is the wood of the Himalayan cedar.

Only this interpretation of the pillars can explain why the pillar motif is – with the neck ring – the most common element of decoration in Swat carvings. Columns appear as an articulating element on the fronts of chests, in one case a tree even appears as the decoration of a pillar itself. Pillars are represented in friezes above doors, and are also shown on the doors themselves. Pillars often form the link between the chair seat frame and the chair back. Only there do they have a structural function, though this could be equally well served by any other sort of wooden link.

Another symbol of the centre, the cosmic mountain, is very rarely represented in carvings. Nevertheless we have found chairs, prayer beds and chests with mountain motifs. These motifs are frequently found in mud plasterwork above wall niches and in embroidery, often in combination with the tree motif.

It has been shown that all representations of objects – neck ring, pillar, tree and mountain – found as motifs in Swat carvings have a clear pre-Islamic origin. The only objective Islamic motif I know of (appearing in two examples, on the base of a mosque pillar and on the back of a chair) is the representation of a washing jug symbolizing ritual purity.

212. Mosque pillar with a capital representing branches and clearly showing the fusion of the motifs of pillar and tree. Private collection, Karlsruhe.

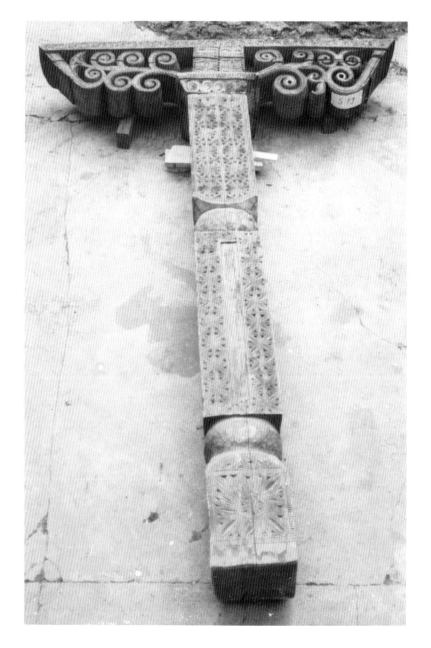

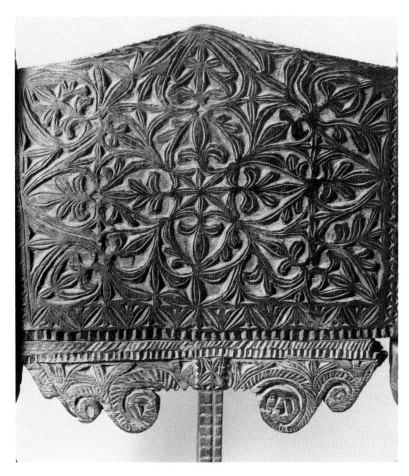

213. Detail from a chair. A pillar supports a stylized treetop.
Linden-Museum.

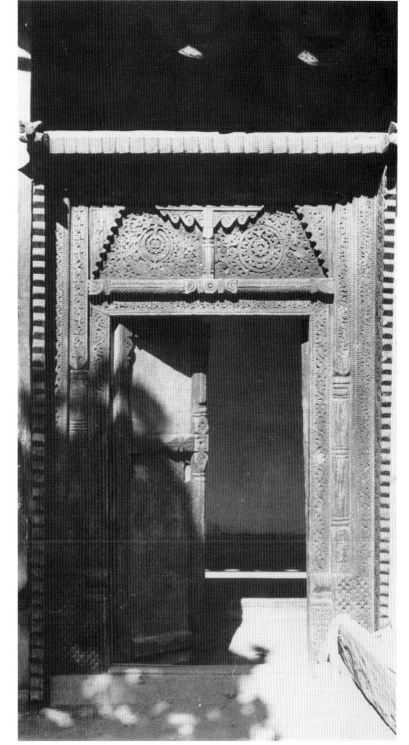

214. Main entrance of the Great Mosque of Kalam. The infill above the
door is divided in two by a pillar with a neck ring motif on either
side.

215.—218. Tree motifs in various materials. Wall painting and door of terraced houses in Swat-Kohistan. Jug with applied tree ornament. Linden-Museum.

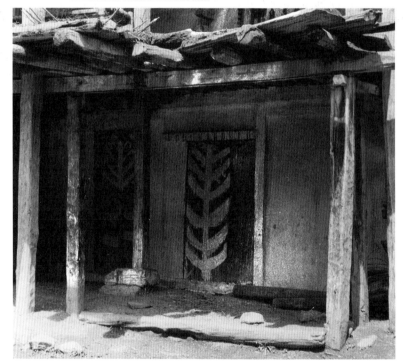

219. and 220.   Worldtree motifs on the back of chairs. Left, private
collection, Karlsruhe; right, photographed in Madyan.

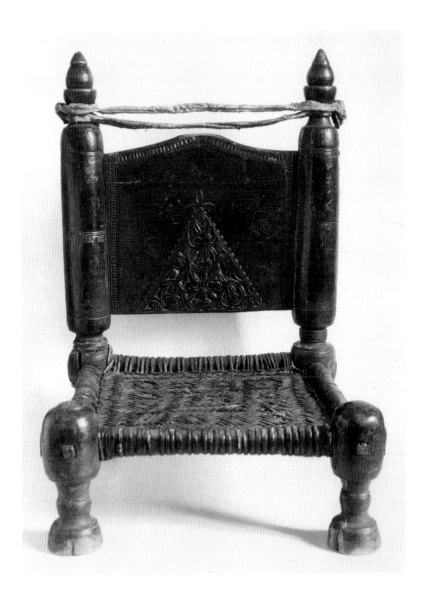
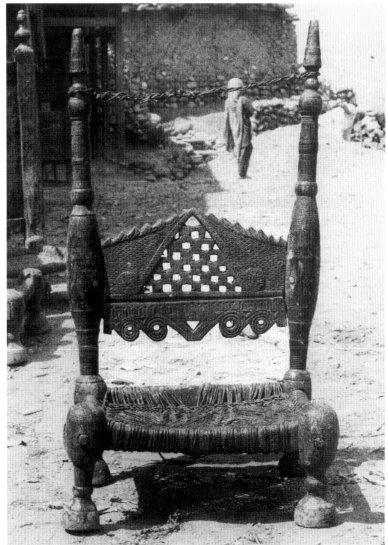

## Other motifs

There is a complete absence of recognizable representations of animals or people in Swat carving, probably as a result of rigorous Islamic ideas (not religious regulations as is often claimed). The only exceptions I know are the representation of an aquatic bird (sunbird? on the back of a chair and that of a snake on a chest.

As a symbol of an animal there occasionally appears, as in the folk art of central Asia and also of Nuristan, a very stylized ram's or ibex's horn, a symbol of magic apotropaic power and fertility.

Sceratto (East and West, 1983, p. 21 ff.) has recently discussed a symbol that is extremely difficult to interpret and which appears on a pillar of the mosque of Utrot (since destroyed) as well as elsewhere. His intepretation of a labyrinth as a symbol of initiation into the mystic secrets of a dervish order deserved a more detailed investigation.

Strongly stylized rosette-like sun motifs belong, as comparison with material from Kalash (Chitral) and Pashai and Kafirs (Afghan Hindukush) demonstrates, together with the bands with interlace which occasionally appear in the Dardic canon of forms.

I assume that various other geometric motifs also had symbolic significance, though this is naturally more difficult to identify than the meaning of motifs the representation of which itself provides indications of possible context of meanings.

I have often found the swastika, adopted from the Indian repertory of motifs, painted on wooden architectural elements but never as a motif in carving.

Dietrich von der Lühe provided a short inventory of Swat ornament which attempts of systematize the individual motifs and is still a valuable aid. His representation of the addition of one or several elements to lines or surfaces is supported by the way he looks at the material through the abstraction of his drawings, but it by no means does justice to the wealth of imaginative combinations of motifs. Only the enumeration of the various foliage rinceau borders with two, three or four leaves, leaf and flower rinceaux, interlaced foliage rinceaux, give some ideas of the multiplicity of possible forms.

The rinceau motifs have one thing in common: they are in the tradition of classical Islamic ornament. This is true of all the plant and floral ornaments, despite various echoes of late antique traditions, Sogdian central Asian motifs of the 5th – 7th centuries AD, some similarities with finds from the Indus valley culture of the 3rd and 2nd millennia BC and finds from Bactria of the 3rd millennium BC up to the Graeco-Bactrian Empire around the beginning of our era.

In all speculations which the rich material from Swat gives rise to, it should not be forgotten that "Islamic ornament" was not a new development after the rise of Islam but drew from these

221. Koran stand with circular decoration similar to that found in Bactrian metalwork as early as the 3rd century BC. Linden-Museum.

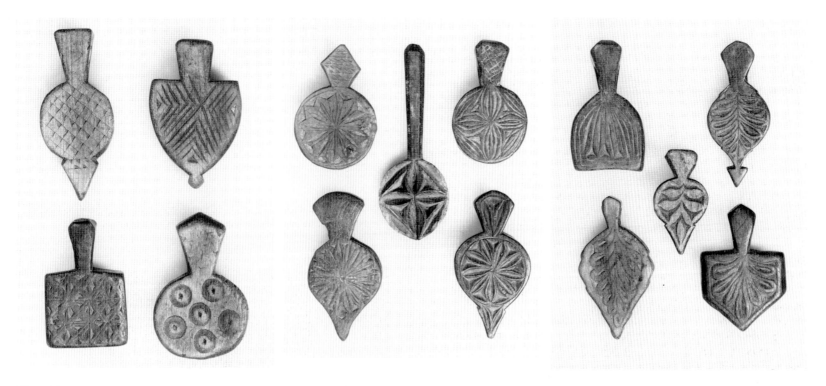

222.–224.  Animal amulets with geometric and simple plant motifs. Since branching is not practised in Swat, these also serve to identify the owners of the livestock. Linden-Museum.

225. Carved chest lid with sparing rosette decoration in the style of Kirgiz felts. Linden-Museum.

226. Detail from an opening to a mill. A tree growing out of powerful stylized ram's horns. Linden-Museum.

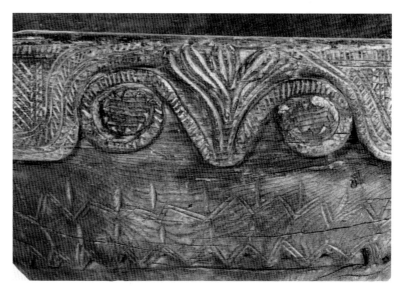

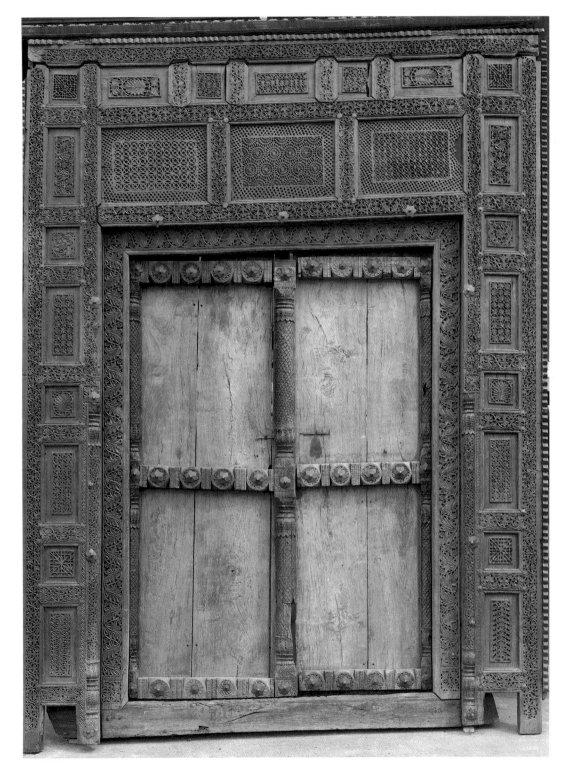

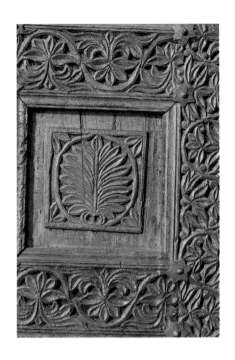

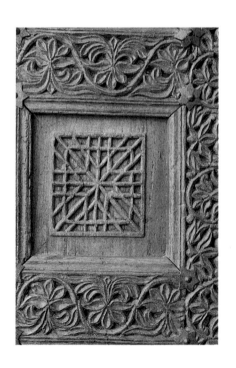

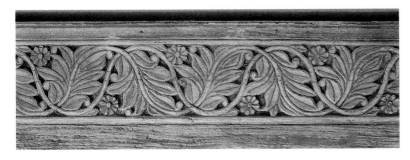

227. Entrance to a landlord's house from Lower Swat. The panelled door frame is in the classic Islamic woodcarving tradition. Linden-Museum.

228. Detail from the door showing palmette motif.

229. Detail showing geometric star motif.

230. Leaf scroll ornament from the door.

231. Small box with sliding lid. The foliage decoration is unusually deeply carved. Linden-Museum.

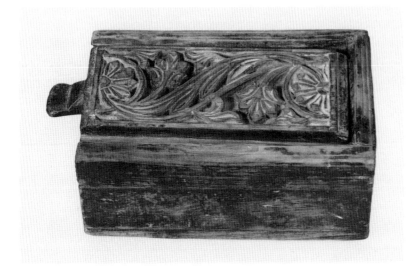

sources in differing degrees.

It therefore seems more sensible to me to go into individual elements or stylistic tendencies which are related to neighbouring cultures or have direct chronological predecessors, using detailed picture captions. Thus there is, for example, a group of chairs in which the design seems to me very close to Kirgiz felts. Other pieces of furniture (chests, chairs), but above all door frames show direct parallels with Moghul architecture in Punjabi centres.

I shall pick only two more examples to demonstrate how easily interpretations can be onesided if one does not have a precise knowledge of the context.

Frequently on animal amulets and spoons, and more rarely on chests and chairs there is a type of circular ornament which also appears on finds from Bactria from the 3rd millennium, as well as on others from the Indus valley (2nd millennium), but the closest connections chronologically are to be found in metalwork of the late Ghasnavidic and Ghoridic periods (12th/13th centuries AD) from Multan and Lahore. The material with circular ornament from Bactria and the Indus valley culture is considerably better known to scholars working on the region than is the 12th/13th century metalwork. Therefore if an external influence has to be found for an orament, which could also have originated locally, the most probable supposition is an influence from the neighbouring Punjab at the time of the Pathan settlement of Swat.

Another example is the vineleaf and grape motif on a Koran stand. Anyone familiar with the discussion concerning the relationship of folk art to to the late antique art of the Gandhara empire naturally thinks of late antique models. In my opinion it is at least worth considering that vines were cultivated by the neighbouring Kafirs until the 19th century and that we have reports of ritual to do with the vine.

Another fact worth noting is that the ornamental surface is almost always square, even when the object offers other possibilities. Does this perhaps indicate that the original inhabitants of Swat had a concept of a square universe like the Scythians 2500 years ago?

I am aware that I have raised many more questions than I have answered. In my choice of texts and images I have tried to outline the historical depth that must be taken into account, as well as the context of geography and the history of ideas where further is necessary.

232. Chair. The back has a representation of a washing jug as a symbol of purity. Private collection, Karlsruhe.

233. Painted roof beam with geometric motifs. Swat-Kohistan.

234. Chair. The back with flower-filled reticulated pattern in the Moghul tradition. Photographed in Madyan.

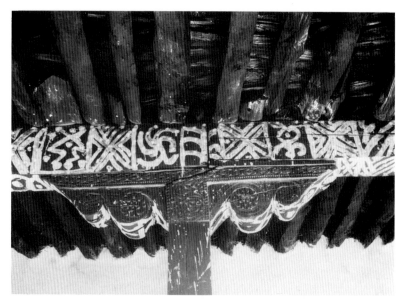

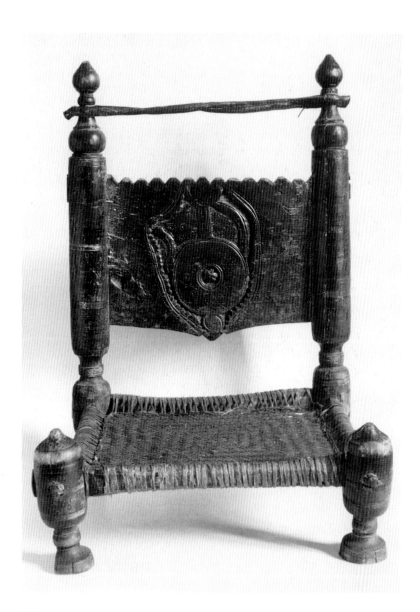

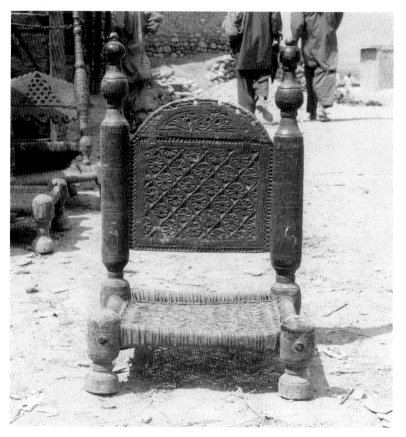

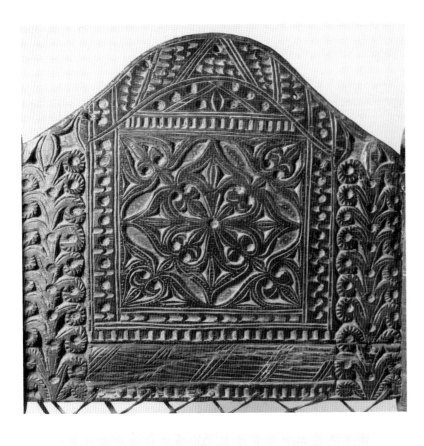

235. Detail of a chair back. Geometric rosette in the 'Kirgiz style' flanked by two trees and surmounted by a mountain. Linden-Museum.

236. Square table with a rosette surrounded by a foliage border. Linden-Museum.

237. Koran stand with openwork motifs of vine leaves and bunches of grapes. Linden-Museum.

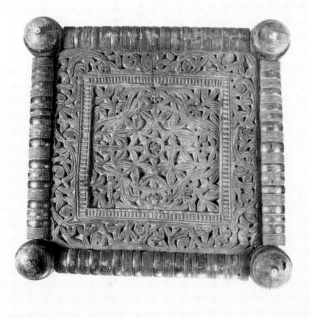

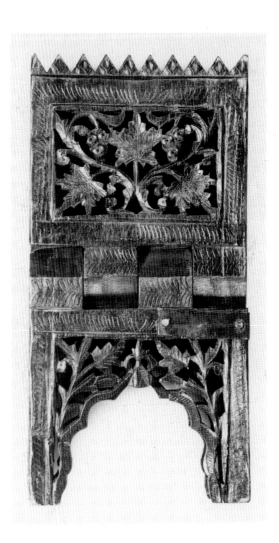

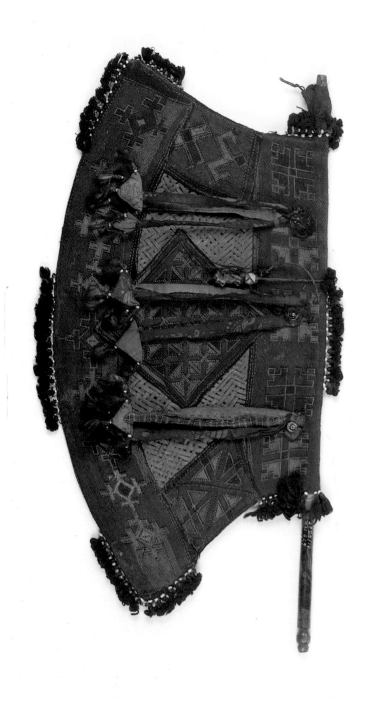

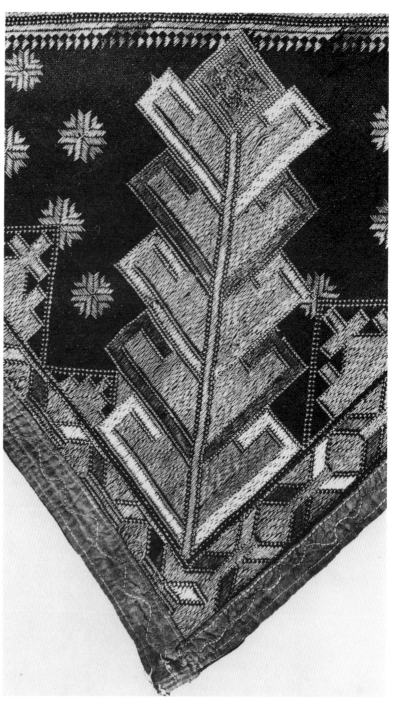

238. Firefan with silk embroidery. The composition of the ornament is described in the caption to the illustrations of the bread cloths (figs. 96 and 97).

239. Detail from a bread cloth, tree motif.

240. Bread cloth, silk embroidery on cotton (cf figs. 96 and 97). Private collection, Karlsruhe.

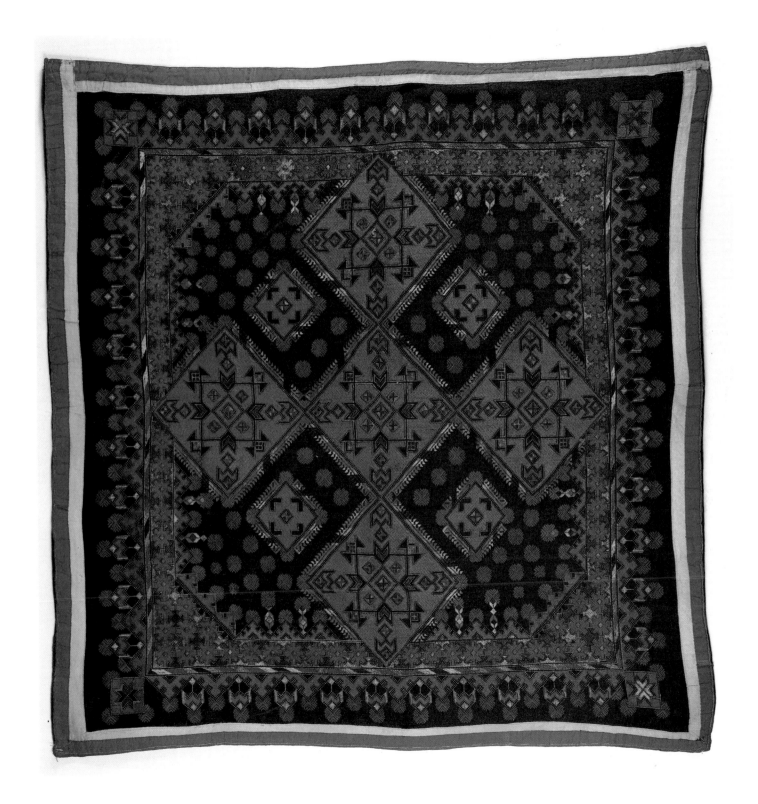

159

# The History of the Swat Valley

Dietrich von der Lühe

## The pre-Islamic period

It is very difficult to obtain a deeper understanding of the material products of a culture without taking into consideration the development of that culture. However, not much is known about the history of the Swat valley up to the beginning of the present century. The few written sources, ruins, archaeological finds and burial objects or coins, which have been found either by chance or through systematic archaeological investigation cast light only on particular periods. This summary of our knowledge of the history of the region has not been written to create a false impression of continuity from our fragmented information[1]), but to provide material for a theory of substrata which has yet to be elaborated[2]).

"At this point in time we cannot say how far such clearcut differences between the periods are due to our fragmentary knowledge (which is still inadequate for the clarification of the intermediate phases of development) or whether they are due to the unsettled nature of the dominant groups of peoples and the sudden changes and overthrows which result from this. We can be sure, however, that in no other region of the Indo-Pakistani subcontinent has such as starkly constrasted sequence of cultural horizons within a period of c. 2000 years so far been recorded." [G. Stacul, East and West XVI (Rome) p.86][3])

This instability is due to the geographical situation. Despite its relative remoteness this extremely fertile valley has been exposed to a multiplicity of influences because it is near to the main passes between the subcontinent and central Asia, as well as to the most important trade routes between West and East.

By the analysis and comparison of archaeological finds in Swat it is possible to differentiate various periods between 2400 and 50 BC.[4]) Hand formed ceramics are evidence for the first phase of the early historic civilization in northwest India. According to radiocarbon tests this can be dated to period between 2400 and 2100 BC and shows strong affinities with archaeological finds in Iran (e.g. Tepe Hisar) as well as in Turkmenistan.

A second period has similarities with neolithic finds in Beluchistan and with the Harappa culture of the Indus valley. In this period the potter's wheel is in use. It begins around 1810 BC and from c.1500 BC, about the same time as the beginning of the decline of the Indus valley culture, it gave way to – or was eclipsed by – other periods, some of which lasted only a short time, and again showed strong connections with Iran and central

Asia. Ceramics, tools, remains of skeletons, burial rites etc. indicate a very changeful history during the following centuries. Although the finds extend over the Bronze and Iron Ages, they show no continuous development but a changing supremacy of various local farming peoples who were connected to a greater or lesser degree with the southern plains, an nomadic tribes from Iran or central Asia with an economy based on livestock.

"The complexity of these periods and the generally scanty archaeological evidence make it difficult even to summarize the events which were presumably connected with the spread of the Aryan ethnic groups in the regions of the Indo-Pakistani subcontinent"[5])

The Achaemenid Empire, probably beginning with Cyrus (553–529 BC) and continuing under Darius I, spread eastwards in the direction of the Ganges, and the area between Jallalabad on the Kabul river and the Indus became incorporated into the empire as the twentieth satrapy with the name Gandhara.[6]) Although the Swat valley is not thought to have been part of this satrapy, from the 6th century onwards it was within the political and cultural sphere of influence of the Achaemenids. When they were succeeded by Alexander the sovereignty over these eastern provinces seemed threatened especially from the mountainous regions to the north. This explains why he led one part of his army through these mountainous regions while the other marched straight through the Peshawar basin in order to secure the crossing over the Indus. According to Aurel Stein's reconstruction of this campaign, based on Greek sources (e.g. Arrian's Anabasis), Alexander conquered Lower Swat early in 327 BC after successful sieges of Ora (now Udegram) and Bazira (now Barikot), and subdued the Assakenoi people living there, and in 326 he crossed the Indus. In spite of these victories and the subjection of the local rulers his plans of further conquest floundered because the exhausted Greek troops mutinied, and the difficult retreat began.

This campaign marks the first wave of Hellenistic influence in northwest India. After Alexander's death only the regions north of the Hindukush remained under the Greek rule of the Seleucids. The southern regions, including Gandhara, were conquered by the Indian Maurya dynasty. Around the middle of the third century Bactria became an independent kingdom which through its prosperity and conquests extended further and further and around 183 BC reached the Ganges. After the collapse of this Greco-Bactrian empire Menander formed an Indo-Greek kingdom out of its southern parts, including Gandhara and Punjab.

Greek power and influence appeared once again. First the Irano-Scythian Shakas conquered the Indo-Greek lands (c.75 BC), then the Parthians (between 19 and 49 BC), and introduced new cultural and ethnic elements, before they were supplanted by the Yüehchi. They originally came from the border regions of the

160

Chinese Kansu province, conquered Ferghana and Bactria, then abandoned their nomadic life and under Kadphises founded the dynasty of the Kushan. Their most important ruler was Kanishka whose empire extended during the first half of the second century from Bactria to Sind in the south, Benares in the east, and presumably beyond the Pamir to the north. Gandhara became the centre of an empire which experienced a unique flowering which lasted until the middle of the third century, traded with Rome and China, and brought together all kinds of influences under the rule of Buddhism to create Gandhara culture.

In the course of the third century the power of the Kushan dynasty slowly collapsed. They were increasingly beleaguered by the burgeoning Sasanids to the north and west, and by the Gupta dynasty to the east. There was also pressure from the nomadic tribes of central Asia who were forcing one another to move beyond the Oxus and the Hindukush. The Kidarites followed the Chionites and in turn were followed by the Hephtalites or White Huns who conquered the whole of the Indus valley towards the end of the fifth century and settled there until they were forced to give way to an alliance of the Sasanids under Chosroes I and the T'uchueh Turks. The latter then settled in Gandhara and, while continuing to foster Buddhism, influenced the art and culture to such a degree than from then on it is possible to speak of an 'Irano-Buddhist" style.[8])

From the eighth century onwards the Arabs exerted pressure from the west on the Irano-Afghan area and converted the population to Islam.

The extent to which the Swat valley was directly affected by all this has still not been investigated. It is certain that as Uddiyana it belonged to Gandhara and enjoyed the same cultural flowering[9]), as is shown by the many ruins, rock paintings and archaeological finds, as well as the reports of Chinese and Tibetan pilgrims. At an early stage Swat was a centre of Hinayana Buddhism and of the Mahayana school that developed from it. Tucci considers that there was no more suitable place in the subcontinent for the development of this school.

'In this place Buddhism became as it were westernized and at the same time translated into an artistic and dogmatic form which is universally comprehensible without losing the basic inspiration of the Master."[10]) [G. Tucci, East and West IX, 4, p.281]'

If the geographical situation was an advantage for this development, then for the Vajrayana School what mattered were the "original ideas, rites, superstitions and practices which Buddhism founded" [G. Tucci, East and West IX, 4, p.281] and which had never completely died out. They also favoured the development of Swat as a centre of Tantrism, although even during the later period of the dominance of these esoteric schools there was already a hint of decadence. Both the Buddhist and the

Hindu traditions regard Swat as a centre of esoteric teachings "a place of magic spells and love potions, witchcraft, sorcerers and fairies."[12]) [G. Tucci, East and West IX, 4, p.280].

The Chinese pilgrim Fa Hsien, who visited the valley around AD 403, mentions more than 500 monasteries, and after him Sung Yün praises the richness of the region and the respect in which Buddhism is held. Two hundred years later (c.630) Hsüan Tsang laments the decline. Of the 1400 monasteries that had supposedly been there most were in ruins or had disbanded, the monks still quoted from the scriptures, but no longer understood them, though they were still experts in magic exorcism. There were still grapes in abundance but cultivation of the fields was sparse.[13])

The origins of this economic and cultural regression are not known. Besides the constant invaders, who in fact preferred to carry off the movable wealth, it seems that earthquakes and the ensuing floods were the cause rather than destructive aggression, and there is evidence for this in the ruins.

However the great legacy left by this era, which lasted more than a thousand years, is evident in the more recent material culture.

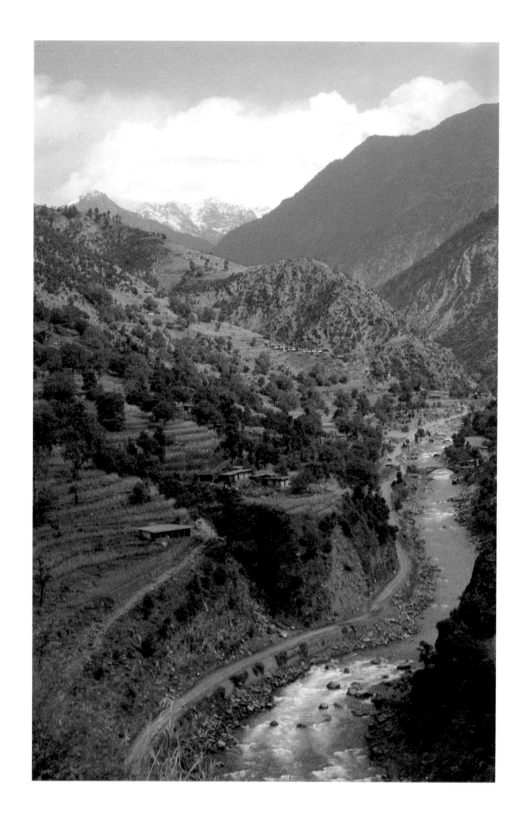

241. View of the deep Swat valley with the main road above Madyan.

242. Nomadic shepherds passing through Madyan (traditional transport).

## From the Pathan invasion to the present

After the decline of Buddhism the history of Swat disappears into obscurity emerging only rarely in the accounts of historians.

The conquest of the Peshawar basin by Mahmud of Ghazni in 1001 marks the beginning of the Islamic invasion of India. In the course of this campaign Pathan tribes joined Mahmud in penetrating the Swat valley, conquered the local "rajas" and drove the part of the population which did not convert to Islam into the mountains.[14] Dilazak and Swati Pathans took over the land and settled there, but in about 1024 the Dilazak were driven out by the Swatis and moved back to the plain.

From about 1485 after bloody confrontations with Ulugh Beg, the Chaghatai Turk ruler in Kabul and uncle of Babur, the future founder of the Moghul dynasty in India, the Pathan Yusufzai moved to the basin of Peshawar and Mardan and drove beyond the Indus the Dilazak people who were settled there. Soon they were penetrating into the Swat valley. But it was not until after twelve years of bitter fighting that they succeeded in defeating the Swatis under their sultan, Awais. The Swatis, too, were forced to cross the Indus and settled in Hazara, where in the Black Mountains there are still villages which call themselves Swati. Shortly afterwards the Yusufzai also conquered Dir and Buner.

Under their leader Malik Ahmed and Sheikh Mali the land was occupied and divided among the clans of the Yusufzai. The Mandars received Mardan and Swabi, the Nolizais Buner, the Malizais Dir and the Akozais the Swat valley. At the same time Sheikh Mali introduced the Wesh system, a periodic reallocation of land among the groups of descendants in the individual clans, a system which survived in Swat until the first quarter of the present century.[15]

Once again there was conflict with Babur, but since he wanted peace on his northern flank because of his war in India, a peaceful solution was found. The Yusufzai were guaranteed rights over the lands occupied by them and paid tribute for them. The treaty was confirmed by the marriage of Babur to the daughter of Sheikh Mansur, an improtant Yusufzai leader. However, under Humayun, Babur's successor on the Indian Moghul throne, the Yusufzai gained their independence, which they kept until the incorporation of Swat into the state of Pakistan.

In 1586 Akbar failed in his attempt to make Swat return to paying tribute. The plains of Peshawar and Mardan were incorporated into the Moghul Empire, and it was there that the fighting took place which followed the collapse of the Moghul Empire, with the attempts to unite all the Pathan tribes under the suzerainty of the throne of Kabul, the conflicts between the Sikhs and the Afghans and finally the British occupation of the whole of India as far the Durand Line. Meanwhile Swat remained unaffected and independent.

However, continual battles seem to have taken place there. The population "have a bad reputation because of thier jealousy and malice. No value is attached to human life and murders are commited for trifles: a quarrel between two indivisuals over som petty matter could quickly develop int a confrontation between two factions or even two ethnic groups, which might end in a bloodbath".[16]

Even Khushkal Khan, who praises the beauty of the Swat valley and describes the ways of life possible there, is strongly critical of the Swatis saying that they are "worse than the Hindus", that their customs and habits were like those of the "Kafirs", and that through filthiness and neglect they had turned the land into a desert.[17]

In 1835 Abdul Gaffur, who was probably born around 1795 in Upper Swat, returned to Swat "after years of wandering and sufi meditation".[18] His piety had earned him the epithet of an "Akhund of Swat", and after his arrival his reputation as a holy man increased so that he soon became the leading figure in the valley. He settled in Saidu which then became the centre of political life in Swat. Because of his influence over the people he succeeded in forcing the rival Yusufzai clans to unity. They accepted the appointment of Sayyed Akbar Shah as King of Swat and the establishment of a standing army of 800 horsemen, 3000 foot soldiers and five or six cannon[19], the first prerequisites for a centralized state power. But the king died in 1857 and neither his descendents nor those of the Akhund succeeded in having themselves appointed or elected king.

In 1849 the British destroyed the Sikh Empire, conquering the Punjab and occupying Peshawar. They attempted to "pacify" the unruly Pathans along their noew border. An attempt to gain control of Swat – called the Ambela campaign – failed in 1863 when the clans resisted. The participation of the Akhund in these struggles made him a symbol of resistance and increased his reputation.[20]

When he died in 1877, Swat again declined into a long period of struggles for supremacy. The changing coalitions and the legitimacy of the persons who claimed the political inheritance of the King or the Akhund, are difficult to unravel, especially since external powers were now also involved, such as the Nawab of Amb to the southeast and the Nawab of Dir to the west. The latter seems to have had the support of the British in his attempts at annexation, since they expected him to unite and pacify the region.[21]

In 1895 the British created the Political Agency of Malakand at the most important pass linking the Swat valley with the southern plains, in order to protect their interests in Dir and Swat as well as the connection to Chitral which ran through Dir. In 1901 when

243.–245. The earliest travellers' descriptions of Swat are by Buddhist pilgrims in the first half of the 1st century AD. Because of the inhospitable nature of the mountains traffic has always used the few passable valleys and fords. Camels represent a new means of transport now used to carry potatoes which are grown on the uplands (up to about 3300 m). The bridge (fig. 244) still cannot be crossed by lorry.

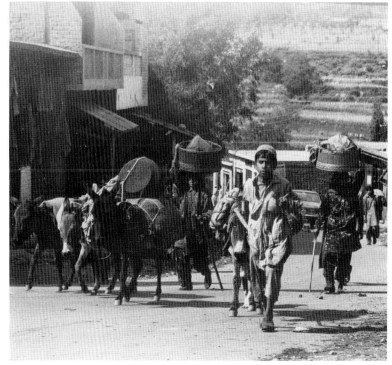

246. This finely carved lorry driver's cab from Mingora demonstrates both change and continuity.

247. Jaffer Shah's house gives an idea of the rate of change in Swat. Side by side are a prayer board, a television, an electric iron and a poster for St. Moritz.

248. The work is as skilful as in the past, but the traditional webbing of beds is now woven from plastic cords instead of leather thongs.

the North West Frontier Province was founded, Swat together with other Tribal Areas became part of British India, although it still could not be brought under British control. In fact there were uprisings both before and after, such as the one led by Mastan Mullah on the border between Swat and Malakand.

Throughout this perid the internal turmoil in Swat continued. Finally in 1917 Miangul Abdul Wadud, a grandson of the Akhund, succeeded in being elected "Badshah" (king) by the assembly of the Yusufzai clans, after he had killed or driven into exile many of his rivals. According to Ahmed this election was the result not only of his charismatic personality but also of a favourable wider historical, social and religious situation similar to the one that had enabled the Akhund to exert his influence, and the "Badshah" could appeal to the Akhund's legacy.[22] The increasing pressure from non-Islamic powers, first from the Sikhs and then from the British, there was a revival of Islam which ensured that there was renewed interest in the person and sermons of the Akhund and of his heir. The Akhund and his heir were not khans and hence symbolized "the millennarian hope and expression of the dispossessed and impoverished country people who formed the majority in Swat".[23] The spiritual and economic authority of the Akhund created a family charisma which his descendents could appeal to. His grave in Saidu became a centre of pilgrimage. The village retained its political and religious importance as the centre of the country. It received the epithet "Sharif" (noble). Its ownership strengthened the appearance of legitimacy. Finally Swat was directly and decisively drawn into the wider politics of the North West Frontier, and even the khans had to make concessions if they wished to keep the whole of their territory from the powers that threatened them. Miangul Abdul Wadud consolidated his power with great energy and in a short time had created an autocratic state based on his person and personality. He formed a standing army, built about 80 forts at all strategically important points in the country from which a small garrison could control all the surrounding territory, built new roads, created a telephone network, and founded the first schools and hospitals.

Externally he not only secured the previous frontiers, but also annexed parts of Dir and Amb, and continually extended the border northwards into Swat- and Indus-Kohistan. These military operations also served to pacify the rebellious clans.

In a short time he succeeded in Pathanizing the Swat valley by declaring Pakhtu the official language, and above all by abolishing the Wesh system. Most of population were now no longer merely tied to the land, subject to a Pathan clan which first exploited the land but after a short time changed again, but as land became purchasable they became personal dependants of the owner. They were identified with him and identified themselves as belonging to him or his descendants. At the same time within the State there

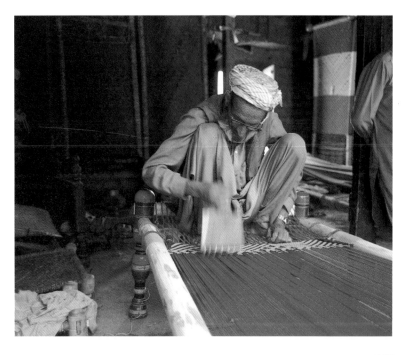

developed a sense of ethnic identity among the "Swatis", based less on an actual ethnic unity than on identification with the geographical and political territory of the "Swat State".

One can agree with Ahmed (though he never states it explicitly) in speaking of an enlightened oriental despotism[24]), in which he sees the element of "enlightenment" both in the nature of the ruler – his personal qualities – and that of the ruled.

Hay speaks for example of the "basically... democratic people"[25]) which the Pathans represent, and doubts whether under them "an individual ever possessed such absolute power over any part of their land as the present leader of Swat".[26])

The British formally recognized him and his state in 1926 and gave him the title of "Wali (Prince) of Swat". From that time onwards accounts of Swat are full of praise for the progress which the country had made or was making "under the strict yet benevolent rule of the 'Wali'".

Until 1947 it remained one of the more than 500 princedoms of British India, and was then the first to join independent Pakistan after the partition. The Pakistani government was responsible only for the postal service, the currency and defence, although Swat retained its own army and police for its internal security. Pakistani law only applied in so far as it was accepted and adopted by the ruler. Otherwise there was a code of law based on the "Pashtunwali", the Pathans' system of values, rules and sanctions.

In 1949 Miangul Abdul Wadud abdicated in favour of his son the "Waliahad" (heir apparent) Miangul Jahan Zeb. In 1969 the "State of Swat" was finally and completely dissolved and has since been administered as a District of the North-West Frontier privince in accordance with the Pakistani administrative structure. Saidu Sharif is now the seat of the Deputy Commissioner. The reasons for this development is probably to be found in the close relationship between the "Wali" and the military dictatorship of Ayub Khan – both literally by marriage and politically – and the new regime of Yahya Khan, while denying far-reaching reforms to the masses, felt that it had to hold out this administrative act as a sort of "sop to democracy". It is true that there had been political opposition, at least latently, to the "Wali" and his family, but his election to the national assembly shows "that the loyalty to the 'Wali' and his family is based on more factors than mere authority and state patronage".[28])

The population of Swat were able to participate again in the development of opinion in Pakistan until their freedom was again taken from them by the military coup d'état in 1977.

249. Tomb steles in the cemetery in Mir-Qasim-Baba, Swat-Kohistan. Graves will soon be the last remaining evidence of the traditional culture of Swat, and even here prefabricated stone slabs are increasingly supplanting the traditional wooden steles and wooden borders to the graves. Soon these will have rotted away.

Notes

[1] I believe that Bedford, op.cit., 80 f, uses such a shortcircuited argument when she not only compares the border ornament on the woollen rugs of Swat with Harappa ceramics, but claims that this is their derivation.

[2] The above mentioned attempt by Erika Schmitt, op. cit., is unsatisfactory for two reasons. Firstly, she expressly investigates only the connections between Gandhara art and modern folk art, and secondly she does not take into account the extensive collections from Swat.

[3] Stacul, G., Excavation near Ghaligai... , 86.

[4] See Silvi Antonini, C., Preliminary Notes on the Excavations...; idem, Swat and Central Asia; Stacul, Preliminary Report on the Pre-Buddhist Necropolises...; idem, Excavation near Ghaligai...; Jettmar, K, "The Middle Asiatic Heritage of Dardistan", East and West, vol 17 nos. 1–2, Rome March-June 1967, 59–82.

[5] Stacul, Excavation near Chaligari..., 87.

[6] See Halade, M., Indien. Gandhara. Begegnung zwischen Orient und Okzident, Fribourg, 1968, 20 ff; Khan, F.A., Architecture and Art Treasures in Pakistan, Karachi, 1969, 69 ff; Tarn, W.W., The Greeks in Bactria and India, Cambridge, 1951.

[7] Stein, On Alexander's Track..., 41 ff.

[8] Hallade, op. cit., 69.

[9] See Facenna, A Guide to the Excavations in Swat...; and Tucci, Preliminary Report on an Archaeological Survey in Swat.

[10] Tucci, op.cit., 281.

[11] Ibid.

[12] Ibid., 280; 'dakini' are the keepers of the secret knowledge who live in the air.

[13] See op.cit., 325.

[14] See Wadud, op. cit., XXIII ff; and Bellew, A General Report on the Yusufzais, 59 ff.

[15] See the chapter on social structure.

[16] Wadud, op. cit., XL.

[17] Quoted in Raverty, op.cit., 280.

[18] Ahmed, Millennium and Charisma..., XVI.

[19] See Wylly, H.C., From the Black Mountains to Waziristan, London, 1912, 125.

[20] So, for example, the biography of the later Wali (Wadud, op.cit.) can be used with caution as the most important source for this period, since it depicts the legitimacy and consistency of his seizure of power in a highly subjective manner.

[21] See Webb, B.M., "The Ancient State of Swat", Canadian Geographical Journal, vol. 70, Ottawa, February 1965, 70.

[22] Ahmed, op. cit., 96 ff.

[23] Ibid., 98.

[24] Ahmed, op. cit., 126, refers expressly to Wittfogel, K., Oriental Despotism: a Comparative Study in Total Power, Cambridge, 1957, who sees this highly centralized system of rulership on the basis of an irrigation economy, which requires organized population and a burocracy to organize it, which to some extent applies to Swat.

[25] Hay, W.R., "The Jusufzai State of Swat", Geographical Journal, vol. 84, no. 3, London 1935, 234.

[26] Ibid.

[27] Ibid., 246; see e.g. B. Webb, op.cit., 70; or Rawson, D.L., "Swat – where yesterday walks side by side with tomorrow", Natural History, vol. 66, Washington, Sept. 1957, 354.

[28] See Ahmed, op. cit., 129.

250. Cemetery in Madyan with the sparse trees typical of the moderately high areas.

251. Cemetery near Kalam, Swat-Kohistan, with wooden grave border.

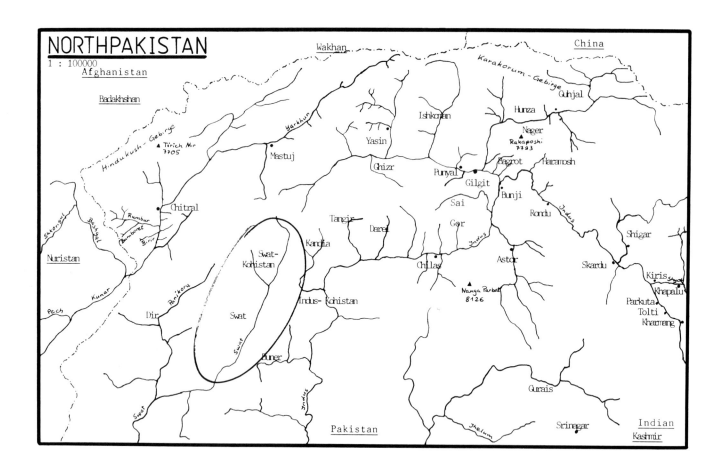

NORTHPAKISTAN

1 : 100000

Afghanistan

China

Wakhan

Karakorum - Gebirge

Badakhshan

Guhjal

Ishkoman

Hunza

Hindukush - Gebirge

Yarkhun

Nager

Rakaposhi
7793

Tirich Mir
7705

Mastuj

Yasin

Ghizr

Punyal

Bagrot

Haramosh

Chitral

Rumbur

Bumboret

Birir

Tangir

Darel

Sai

Gor

Indus

Gilgit

Bunji

Rondu

Shigar

Bashgal

Shatorigal

Swat-
Kohistan

Kandia

Chilas

Astor

Skardu

Kiris

Shyok

Nuristan

Kunar

Panjkora

Indus- Kohistan

Nanga Parbat
8126

Khapalu

Parkuta

Tolti

Pech

Dir

Swat

Swat

Buner

Kharmang

Gurais

Indus

Srinagar

Indian

Swat

Pakistan

Jhelum

Kashmir

170

# Mountain Peoples in North Pakistan

Jürgen W. Frembgen

The north of Pakistan is geographically part of the Hindukush, Karakorum and the north-west Himalaya. There is probably no other place with so many high mountains in such a limited area. The landscape of Chitral, which adjoins Afghan Nuristan to the west, belongs, like Kohistan, to the Hindukush. The region around Nanga Parbat on the other hand is counted as part of the Himalaya. In the north the Gilgit-Karakorum joins the western Karakorum main range. The Karakorum range is the most glaciated area outside the polar regions, with some of the tallest peaks in the world. Together with other chains it forms part of the Transhimalaya system, the watershed between the Indo-Pakistani subcontinent and central Asia.

The exploration of the Hindukush, Karakorum, Pamir and the northwest Himalaya, which formed the area known as the "great Scharung zone", was begun during the 19th century, mostly by the British. The motives were primarily the safeguarding of the northern frontier of the Anglo-Indian colonial empire and the opening up of trade routes.

Building on the pioneering works of John Biddulph, D.L.R. Lorimer and others, systematic ethnological investigations were conducted from the 1950s onwards. Karl Jettmar's many expeditions, the linguistic work of the indologists Georg Buddruss and Hermann Berger, as well as stationary field research, e.g. in Hunza (Irmtraut Stellrecht) and Nager (Jürgen Frembgen), should be mentioned.

The mountain valleys in the southern flanks of the Hindukush and Karakorum are the home of a large number of ethnic groups. Since the end of the last century these mountain peoples have been called "Dardans" by ethnologists and others, a term taken from ancient sources, and the region where they live has been called Dardistan. They are remnants of peoples and splinter groups, some of whom have preserved archaic cultural traits and elements into modern times, particularly in the sphere of religious ideas and customs. Because of their similar way of life the peasant cultures of these mountain peoples of what is now Pakistan form a single coherent cultural area.

## 1. Population groups and languages

Because of its relative remoteness North Pakistan is a retreat for ethnic groups who use the residual ancient Indo-Aryan language. The linguistic divisions form the basis for the differen-tiation of the individual ethnic groups. This differentiation is also based on the findings of physical anthropology involving the study of facial and physical features of heads and bodies, skin patterns, pigmentation etc.

Among the main groups in North Pakistan are the Shina speakers, Kohistani, Kho, Burusho and the non-Dardic Balti who speak an archaic Tibetan dialect. Shinam, the largest Dardic language, extends from Gupis/Punyal in the west, through Gilgit, Chilas, Tangir and Darel as far as Baltistan in the east. On the eastern bank of the Indus Shina is spoken as far south as near the Alai valley. West of it is the area consisting of Indus-, Swat- and Dir-Kohistan inhabited by the Kohistani, who use various dialects. The Khowar-speaking Kho form the most important element of the population of Chitral and also inhabit in the western part of the Gilgit valley, especially Ghizar and Yasin. Burushaski represents an isolated residual language in Karakorum, belonging to no existing linguistic group, and is spread throughout the politico-geographical regions of Nager, Hunza and Yasin, as well as by emigrants in the region of Gilgit. On the grounds of ethnological similarities the Burusho are included among the Dardic peoples.

The ethnic patchwork of north Pakistan also includes the remains of a number of Dardic groups mainly living in the southern border area of the Hindukush. In southern Nuristan the Dardic languages Pashai, Shumashti, Ningalami-Grangali and Gawar-Bati are found; in south Chitral Dameli, Phalura and Kalasha; in the Upper Swat region Torwali and Bashkarik; and lastly in Indus-Kohistan Chiliss, Gowro and Batervi. The ethnographic map of north Pakistan is completed by several other ethnic groups who migrated there later. Dumaki-speaking Dom came as smiths and musicians, probably together with the Dards who were penetrating into Karakorum from the south. Another specialized group of craftsmen were the Kashmiri who worked as gold and silversmiths. Since the nineteenth century the mountain Tajiks (Wakhi- and Yidga-speakers) have migrated from the north into the valleys of Hunza, Ishkoman and Yasin as to north Chitral. In the Hindukush and Karakorum there are Gujar groups who use the estates in the smaller valleys for rearing livestock or as tenant farmers. Depending on the altitude they keep buffalo and cattle, or goats and sheep. In Gilgit, the traditional centre of the Shina-speakers there were other migrants from the North-West Frontier Province and the Punjab.

Until recent times the various vernacular languages of North Pakistan preserved a rich oral tradition of stories. Besides myths, sagas (e.g. the Kesar Saga), legends and historical accounts there are an unusual number of stories about people meeting fairies, witches, demons and other spirits, as well as fairy tales, songs, shaman songs, proverbs, riddles etc. However, for 20–30 years the

tradition of story telling has declined as a result of a comprehensive cultural transformation. In parallel with this Khowar, Shina and Balti have developed into literary languages, and scripts for them have been devised.

## Environment

Until the construction of the Karakorum Highway access to north Pakistan was difficult, cut off as it was by a mountain massif. Most of the paths and passes in the mountains are extremely difficult and dangerous, for a long time rivers had to be crossed with the aid of rope-bridges or beam-bridges, inflatable rafts, or swimming. Not until a few years ago were modern bridges built with Chinese aid across the Indus and Hunza River.

In general the way of life of the mountain people is in close accord with the hard mountain environment. This is also true of the expression of their physical behaviour: their stamina and sureness of footing in difficult terrain, and their lightfootedness in crossing loose stones are remarkable.

In Kohistan and the western Himalaya, which have the advantage of the monsoon rains, evergreen oak forests grow and forests of spruce, pine and cedar; beyond this mountain front begins a dry zone with almost no vegetation with real desert steppes in the valley bottom. Near the settlements there are artemisia steppes, but meadows with grass and herbage only occur at heights above 3000 m. Because of the great summer heat in the deep valleys and canyons of Indus-Kohistan and along the course of the Indus parts of the population move to higher, climatically pleasant regions in this season, returning in autumn to their winter villages at a lower level.

Further north, in the broad, partly U-shaped valleys of the Hindukush and Karakorum are the settled oases with alluvial levels and rubble terraces. Since the rainfall is not sufficient for the cultivation of the fields and orchards and river valleys are deep and canyonlike, a complicated system of artificial irrigation is necessary. The water is diverted by channels from mountain streams and conducted onto the terraced fields, because it is only in the areas at the summit or near glaciation that there is enough precipitation: in northwest Karakorum the annual rainfall is c.2000 mm. The movement of glaciers often destroys the 'head' of the irrigation channels, which provides a water supply for one or more villages. Mudflows make regular repairs to the main and subsidiary channels necessary.

Villages and houses of some groups of relatives are situated by tradition on barren land which cannot be used for cultivation in the most easily defensible position, for instance, on moraine or at the entrances to deep tributary valleys.

## Economy

In the valleys south of Gilgit-Karakorum and in Kohistan goatfarming plays an important role. It is done intensively since the evergreen oak forests there provide sufficient fodder. In the monsoon belt of Kohistan cereals are cultivated using the rainfall, sometimes helped by irrigation whenever the streams are full enough. Here - as elsewhere in north Pakistan - the area given over to maize cultivation is constantly being increased. In some places, especially at the southern edge of Kohistan, in Chitral and even in the Gilgit valley, rice is grown. Hunting and fishing occasionally supplement the diet. The use of forests (timber, pasturage) is of importance throughout the Hindukush and its effect is of overexploitation.

Further north in Karakorum and Chitral there is intensive agrarian farming and fruit cultivation. The keeping of livestock with the use of mountain pastures plays a less important part there than in the south. As has already been mentioned the extreme aridity calls for a very clever system of irrigation. The natural conditions vary from village to village, but the mountain farmers always seek to make the best possible adaptation and exploitation of their resources. The cereals wheat, barley, maize, millet and buckwheat are grown, and especially pulses such as lentils, peas and beans. Besides a wide variety of green vegetables there are potatoes, tomatoes, cucumbers, turnips, pumpkins etc. Shortage of water may mean that the crops of the first planting (wheat, barley) take longer to ripen and so delay the second planting. Then instead of maize or millet at least buckwheat can be planted which can be used in combination with other crops. Fruit is important in the diet as well as bread and vegetables, and in dried fruit, particularly apricots, are used for winter provisions. There are more than thirty varieties of apricot found for example in Nager and it it is known that many of them were introduced from Baltistan. Some varieties are named after the people who imported them. In gardens and the edges of fields grow apples, pears, peaches, cherries, pomegranates, grapes, various sorts of soft fruit, as well as walnuts and almonds. Some of these fruit - for instance melons - need favourable climatic conditions which are not found everywhere in north Pakistan.

In the summer the herdsmen take goats and sheep to the high pastures. A small breed of cattle is kept mainly by the Burusho in their villages. There are yaks in the region of the main mountain ranges of the Hindukush and Karakorum (especially in Baltistan). Besides milk products livestock also provide the essential fertilizer for the fields, as well as meat, wool, hair, leather and skins. Keeping the herds on the mountain pastures is the job of the men. The women are responsible for cultivating the fields. This division of labour is understandable particularly in the valleys

inhabited by Shina-speakers between the Indus and the Gilgit rivers because the high meadows are situated near the passes and conflicts between individual valleys mostly take place in this region. Among the less warlike Wakhi and other mountain Tajiks the roles are usually reversed women look after the mountain pastures and men cultivate the fields.

In the past raids provided an important additional means by which luxury goods, for example, could reach the mountain valleys. The Hunzukuts were famous for their raids on caravans. Like the inhabitants of Chitral who were also conveniently situated on trade routes they were also involved in slave trading. Trade relations in which food and craft products were exchanged existed between individual kingdoms, valley republics and villages. Since the end of the 1930s money has been increasingly used as currency and simple bartering has become less common today. Market centres such as Gilgit, Chitral, Skardu and villages with bazaars along the Karakorum Highway now play an important part in supplying North Pakistan.

## 4. House and Settlement

The characterist house in north Pakistan is the oneroomed dwelling with attached storerooms and occasionally a cowshed and porch. Often a veranda is attached and this can also be used in the summer for living in. On the roof there are sometimes additional storage rooms. The houses usually have one storey; buildings with two or more storeys are only found in particularly densely built areas (e.g in mountain towns). In Nager only members of the royal dynasty or high officials are entitled to houses with more than one storey.

Traditional building materials are stones, tree trunks and mud. The walls of houses are usually made of stones with or without layers of wooden beams and mortar. This type of "cabin construction" is particularly typical of defensive towers which extend from Indus-Kohistan to Karakorum. The flat roof is usually constructed from tree trunks (poplar, walnut, cedar) and a layer of mud or earth. Depending on the region it is also insulated, as for example in Astor, with willow branches, bark and birch fibre. The living room is almost square and is divided up by pillars around a central fireplace (e.g four-pillar house in Chitral, Hunza and Nager, eightpillar house in Yasin); the smoke-hole is often constructed as a "lantern roof". The various regional house types can be recognized from the location of the seating and sleeping platforms, the cupboards and storage containers as well as by the proportions of the ground plan which are related to a particular system of symbols (e.g. in Hunza, Nager, Gilgit).

The northern regions of Pakistan are in a seismic active zone; in the recent past there have been repeated fairly strong earthquakes (e.g. in Hamran in 1972, Patan in 1974, and Darel in 1981 and 1984), which cost many lives and destroyed a large part of the buildings. Stone houses of the sort described could withstand smaller earthquakes with their mixed construction, especially the roof and the pillar construction independent of the walls are potentially earthquakeproof, but they are often built on dangerous, unprotected sites. This is also true of the new houses often built of unsuitable materials (brick, corrugated iron roofs), which have been built since e.g. the severe earthquake in Kohistan (1974). The migration of experienced carpenters to the cities in Pakistan is also having a detrimental effect on this region.

Because of frequent wars and feuds settlements throughout north Pakistan used to be built as fortified mountain villages. The houses form to this day a closely packed closed complex of buildings since the surface available for building is also often restricted because of the geography of the region. In many cases open scattered settlements could not be built until after the pacification of the northern territories by the British. A defensible village in Nager, Bagrot or other Karakorum valleys would once have been divided into separate sectors which were inhabited by particular kinship groups. Today this system has largely disappeared. The villages in the north are characterized by dwellings which are shielded from the streets by mud or stone walls, by water channels, basins and drinking water cisterns; in some there are also public baths and latrines. In the centre – often in the shade of tall trees – are the mosque, assembly place and dance floor, polo ground and sometimes a guesthouse. The walled fortified village was formerly protected by towers and gates. In Nager the defence towers and houses erected for the purpose, called "bazm ha", were used as rooms for the young men who practised dancing, sang songs, passed the time with games of skill and engaged in sporting competitions with other groups of young men. Among the most important duties of the 18–25 year olds is keeping watch for the village.

## History

Light has been thrown on the early history of north Pakistan by recent discoveries of rock paintings and inscriptions, archaeological monuments and literary sources (1000 BC – AD 1000), which give a picture of the religious and political circumstances. During the long Buddhist period the kingdom of Bolor existed in the second half of the 1st century AD with centres at Gilgit and Skardu. This state protected trade on the branch of the Silk Road that runs through the mountains and it controlled the passes. In the 8th century, however, despite Chinese support, Bolor fell

under the rulership of Tibet. After a Hindu period came the expansion of Islam in the 13th/14th centuries.

The historic events and developments up to the British colonial period are dealt with in a number of local historical works. These include, for example, the history of Jammu and Kashmir (Hasmatullah Khan), Chitral (Wazir Ali Shah), Gilgit (Shah Rais Khan), Hunza (Qudratullah Beg) and Kalam (Abdul-Haq Mankiralay). They provide important supplementary material to the scientific work on the ethnology and history of North Pakistan. In this way the history of the ruling dynasties in the various kingdoms can be documented. After about the middle of the 19th century when a prince of the Trakhanating dynasty from Gilgit called on the Governor of Kashmir for help in asserting his rightful claim to the throne the Gilgit region fell under lasting foreign rule. It was occupied and obliged to pay tribute to Kashmir which was supported by the British colonial power. In 1889 the British themselves founded the Gilgit Agency in order to give more effective protection to the northern Frontier of India against Russian expansion. After a liberation movement against the Kashmiri Dogra regime in 1947/48 the region was finally joined to the newly founded state of Pakistan.

Apart from what has been revealed by the important archaeological finds the history of north Pakistan before 1800 seems uncertain and has some legendary features. For some periods and some regions there is only scanty and doubtful information. But light can be shed on the cultural history up to the 15th/16th centuries by careful recording of oral traditions and local written sources. For the last 200 years there is relatively reliable evidence. As may be shown by the example of the small state of Nager it is possible in this way to reconstruct the history of the settlement, the social and political institutions as well as the local historical events. In the centralized states and in the valley republics this is a bloody history of struggles for the throne, murders, intrigues and military campaigns. It is particularly among the population of the kingdoms that a clear sense of history can be found and this was apparently further intensified following Islamicization. There is evidence of an interest in the past in genealogies, lists of names, tales about historical events, praise songs, anecdotes etc. Some traditions about kinship groups and residence groups also relate them of the royal dynasty, so that the two traditions help to shed light on each other and make it possible to reconstruct the history of settlement and the locality in various periods.

## 6. Social organization

The largest ethnic group in north Pakistan, the Shina speakers, is divided into four population groups similar to castes: the Shin, Yeshkun, Kamin and Dom. The agricultural and livestockrearing Shin and Yeshkun form the principal part. The Shin claim a higher social status and dissociate themselves from the other groups by avoiding cattle and dairy products. They are immigrants from the south and have overlaid the long established population of the Gilgit region. These earlier inhabitants were the Burusho who have now settled further north in Hunza, Nager and Yasin, or around Yeshkun. It has not yet been proved that the Yeshkun should be regarded as descendants of an earlier Burushaskispeaking population in the Gilgit region. The Kamin often work as craftsmen and also partly as agricultural workers. The Dom smiths and musicians are particularly despised; some of their women take up prostitution. The social structure of the Shina speakers like that of the other ethnic groups is supplemented by the presence of the privileged Sayid (descendants of the Prophet), members of the royal dynasties and various groups of immigrants of lesser status.

In Indus-Kohistan the population is divided into an upper class of landowners and a group of dependant agricultural labourers, herdsmen and craftsmen. Among the Kho the members of the native ruling dynasty are at the summit of the social pyramid followed by an aristocratic class graded by rank and status, and broad lower stratum to which the previous inhabitants, such as the Kalash, belong. In the small states of Nager and Hunza the traditional system of social stratification presents the following picture: the narrow upper stratum consists of the king, members of the local dynasty and aristocracy. From among the aristocracy (in Burushaski called "Uyoko" or 'the great') are recruited the "wazirisho" (minister) and trangphating (village representative). The middle and lower strata include "shadarisho" (servants) and "baldakuyo" (carriers). As these indigenous terms indicate the peasant population is divided up into different "occupational strata" according to various services provided for the ruler and aristocracy. The services correspond as it were to status levels. Wealth, success in war, polo or other sports competitions, an exemplary way of life and giving of feasts ensure the social status and guarantee of privileges. Social rise and decline are possible in this system under certain conditions. A member of the lower class may for example be freed by the king from taxes and work duties in gratitude for particular services, or receive a piece of land as a gift, or rise to a higher official position. Not until the abolition of kingship in 1972 (Nager) and 1974 (Hunza) did this system of social obligations, which existed in a similar form in Chitral and other states, come to a end. In some social strata the organization outlined here has survived.

The strictly patriarchal "extended family" forms the basic economic and social unit, families are combined into kinship groups (clans and lineages), which have a certain independence as

regards law and religion. Conflicts in law, communal work and other matters of larger significance are regulated, however, at village level or by the state authorities.

## 7. Forms of political organization

The traditional political structures of North Pakistan were influenced by the mountain geography of the region. In the south, in Kohistan and the Shinaki region (around the transverse course of the Indus), there were until recently segmentary societies without a central authority which can be termed valley republics (Gor, Tangir, Darel, Kandia, Harban, Jalkot, Palas etc.). The isolation of these inaccessible ranges of mountains and the economic conditions hindered the development of lasting states with a central power. Since the steeply sloping land is barely passible for horses this was an area where wars were fought on foot. The valley republics of Indus-Kohistan were comprised of units of one or two valleys with tributary valleys, which were frequently involved in internal feuds and wars but which would come together against external enemies if need be. In each of these territories there was a council of the heads of families to make political decisions. In the broader valleys of the northern area, with an oasis economy, distant trading links and easier access through passes and roads the conditions for the creation of states were far more favourable. This was also a region with mounted fighters and accordingly the horse was exceptionally highly prized. The south was more of a free tribal region similar to the "Tribal Areas" of the North-West Frontier Province, it was even called "Yaghestan" – "land of the free". Before this there existed states and valley republics intermittently in both regions, in the south and in the north; kingdoms emerged suited to the local village and clan organization, which were then reorganized into a society without any central authority. An example of this is the small state founded by the tyrannical Raja Wali Khan in Tangir and Darel (1895–1917).

In the northern part of the mountain area formed by the Hindukush, Karakorum and the northwestern Himalaya there were numerous kingdoms in the second half of the 2nd millennium AD – sixteen in all, including small "satellite states". Among the largest and most important political units were Chitral, Gilgit, Hunza, Nager and Skardu. The dynasties who ruled there were often of foreign origin. For example, Chitral was ruled from the 14th century by the Rais dynasty which had been founded by Shah Nader Rais who came from Turkestan; they were followed after 1595 by the Timurid Kator. Princes of the Trakhanating dynasty of Gilgit finally conquered Nager and Hunza and created small states there with a strong central power. In Nager there then developed an ethnic stratification as the kings accorded a higher status to immigrant groups, and the indigenous population clearly occupied an underprivileged position. The ruling dynasty of the Moghlotkuts (a branch of the Trakhanating) established a system of services which the people had to provide for the court. In this way the inhabitants of Nager were strictly divided up according to a hierarchy of status, rank and official position. The palace in the capital Uyum Nager with officials, servants, including falconers and praisesingers, bodyguard, the keeping of slaves etc. is typical of an oriental royal court. From this centre of power the king governed the 28 villages of his state with the help of a staff of officials. Here law was pronounced, campaigns planned, and trade controlled. The political power of the king was limited, however, bloody struggles and rivalries for the throne were the order of the day in Nager and other states and the lifespan of a the ruler depended very much on how skilfully he manoeuvred between the power blocks composed mainly of members of the aristocracy, and how he worked together with them. The king used various "instruments" to regulate the political relations with the family groups. Most important were the awarding of official posts, ties of adoption, marriage alliances, gifts of land and the protection of particular privileges. The participation of family groups in political power characterizes Nager as what is called a segmentary state. Similar conditions existed in the other kingdoms of the north. The legitimacy of the rulers grew from their relations with powerful guardian fairies who belong to the group of purest superhuman beings. As a guarantee of fertility the king took a leading part in the seasonal farming festivals (sowing, harvest), to ensure the luck and welfare of the population.

After union with Pakistan (1947/48) and the loss of independent statehood (1972) the territories of the former states and the valley republics now belong administratively to the "Northern Areas" and the "North-West Frontier Province".

## 8. Islam and popular beliefs

According to oral traditions North Pakistan was superficially Islamicized from about the 12th century, but the successful conversion of the population began only later. It was undertaken by various religious tendencies in Islam which entered the mountain area from various directions. Under the ruler Taj Moghul the Ismailiya, supposedly from the 14th century onwards, extended from Badakhshan into north Chitral, the Gilgit valley and its northern tributary valleys, as well as into Hunza. Under the Balti ruler Ali Sher Khan the Shia was introduced towards the end of the 16th century. Today the inhabitans of Baltistan, Haramosh, Bagrot, Nager and parts of Astor and Gilgit are Shi'ite.

From the area where the Pathans settled to the south there then followed a Sunni conversion of the Kohistani, Shinaspeakers etc. In the course of this missionizing the Sunni clergy also spread the "wesh" system of periodically reallocating land with the result that the indigenous mountain farmers regarded this way of exchanging land as Islamic in origin and adopted it with the new religion. Previously there had been tolerance between the various religions of North Pakistan, even allowing mixed marriages, for example; but since the 1970s increasingly militant Shia-Sunni conflicts have become apparent. An aggressive Sunni missionary movement is now putting growing pressure on the Shia. In July 1988 there were clashes in Gilgit and surrounding area in which almost 8000 people were killed.

As well as orthodox Islam and the widespread veneration of saints there also exists – sometimes intermingled with these – a folk religion which is characterized by shamanism, belief in fairies and witchcraft. Only a few such phenomena can be mentioned here. Since Islam was only accepted in some areas at a late stage, memories have survived particularly among the Shinaspeakers or male and above all female deities. Ceremonies in which priests sacrificed goats at the shrines of these higher beings were still being practised in the 19th century.

In the folk beliefs of the Shina-speakers, Bursho and other groups particular importance is attached to a world picture based on mountain nature in which distinctions are made between various zones of purity and impurity arranged vertically. Spiritual beings, people, animals and plants each have a particular place depending on their characteristics. Peaks, mountain lakes and high meadows are regarded as the epitome of purity, they are the abode of fairies and other superhuman beings. Ibexes and wild goats which live in the alpine regions are regarded as holy animals. The domestic goat, incidently, is seen as a descendant of the wild goat living in the area inhabited by humans. Juniper trees and lichen Lethariella cladonioides, called "gulgul" in Hunza, are surrounded by an aura of purity and holiness. Plants used for incense are prized above all for their aroma. Only certain people, for example, shamans and hunters are able to expose themselves to the bewitching scent of the flowers blooming in the "fairy gardens", since they have prepared themselves for a confrontation with fairies by obeying certain purity regulations. Fairies are usually described as beautiful girls with shining wings, though their eyes are set perpendicular and their feet often turn backwards. Backward feet are also supposed to be found occasionally on witches and shamans. From an orthopaedic point of view this is what is known as the "paw position", a syndrome which can occur through convulsions and very quick breathing. Other spirits, which have the features of witches, giants, goblins and nature spirits, dwell in the zone inhabited by humans or in

deeper regions. Deep rivers and the mouths of valleys are considered impure.

## 9. Folk art and material culture

Crafts are often practised as a secondary activity or as a cottage industry; members of lowly regarded groups mostly work as specialized blacksmiths, gold- and silversmiths, leather workers, weavers and so on in the larger villages.

The region of Pamir, Hindukush, Karakorum and the northeastern Himalaya represent an area with a common culture from the point of view of material culture too. At first sight the peasant cultures there appear barren; but besides simple agricultural tools, household utensils (e.g. stone pots, vessels and wooden spoons) and evidence of weaving and basketwork, there are, however, objects of folk art and material culture which for their richness in forms, quality or uniqueness demand particular attention. Only a few selected fields can be briefly discussed here.

Artistic woodcarvings are found above all in mosques and as architectural elements in royal palaces in Baltistan, Hunza etc. Influences from Kashmir can be clearly recognized. In Nager the tradition of carving is being continued by young craftsmen who decorate the wooden doors of the Shi'ite meeting houses with very expressive, colourfully painted relief decoration, and decorate the interiors with a new type of wooden mosaic work. Further south, in Tangir, Darel and Kohistan, there are carvings which include elements from Gandhara art (e.g clematis, rosette, acanthus) as well as ornaments from local traditions. These are highquality carvings on mosques, private houses and above all carved borders and posts of graves. Besides floral ornaments and others which can be interpreted as cosmic symbols, strongly stylized figurative motifs are also apparent.

A multiplicity of interesting motifs are also found on women's caps from Hunza, Nager, the villages in the Gilgit valley and from Chitral. The caps are made of cotton and embroidered in bright colours in silk or cotton thread. This type of head covering was adopted in the course of the 19th century from Turkestan and developed its own names for the individual patterns and ornaments. Previously women wore a sort of bonnet made of dark material with appliqu work. It is noticeable that height of the rim of the caps varies between each region. Thus caps from Hunza, Nager and Chitral are on average 6–9 cm high, while those from Gupis and Ghizar (upper Gilgit valley) measure 12–17 cm. In some districts home-produced silk is used for the embroidery (e.g. Ghulmet in Nager, Punyal). Silk embroidery is used for decorating not only caps but also women's clothes, coats, small bags, bridal veils, trimming on shirts etc. Another special type of embroidery

is found in the textile art of Dir-, Swat- and Indus-Kohistan.

To conclude with a note on the local gold- and silversmiths' work. Here too, as in the case of the carving of Karakorum, Kashmiri influences are apparent, and some elements of the bridal jewellery resemble the repertory of jewellery in Turkestan. The main metal used is silver and the precious stones include rubies, aquamarine, turquoise and cornelian. The royal crowns of Nager represent a special case. These emblems of authority were made around the beginning of the 20th century by Kashmiri craftsmen. They are full crowns with specific shapes and symbols which show evidence of the influence of Iranian and, to some extent, European models.

## 10. Modern change

After a long period of relative isolation large areas of the Hindukush and Karakorum have been opened up to the outside world by the Karakorum Highway, built in 1964–1978 to link Pakistan and China. Apart from the geostrategic transformation brought about by the construction of this asphalted all-weather road, it has opened up North Pakistan and thus led to a change in the economy.

A wealth of new consumer goods and technologies (e.g. cars, hydroelectric power stations, machines) have been imported from the plains of Pakistan. Much of this is associated with Sunni Islam which has meant the further decline of the indigenous system of belief. Because of the overpopulation of the northern regions the import of grain has now become necessary. Since many men in the mountains can no longer make a living from farming they seek seasonal employment in the Punjab, in Karachi or in the Gulf States. Trade between Pakistan and China (Sinkiang), which has been made possible by the Karakorum Highway, is limited and creates only a few new jobs. The traditional economy of the mountain peoples is changing: the farmers are increasingly orientated towards the market centres (Gilgit, Skardu, Chitral) and therefore grow cash crops (e.g. fruit). Because of this economic change trade between individual villages has become almost insignificant, pasture farming has declined sharply and many objects of the local material culture have been replaced by new industrial products.

The building of the Karakorum Highway is a decisive factor for change in the local cultures of North Pakistan, however modern changes have been in evidence since the British colonial period, and later after the abolition of kingship. In the meantime not only the economic sector but also wide areas of culture are open to a great variety of foreign influences. Above all the Sunni missionary movements (particularly tabighijamaat) have suppressed as obscure shamanism, local customs and calendar systems. Tourism has contributed considerably to the emptying of meaning of these phenomena. Kalash and Hunzukuts in particular have felt the damaging effects of ethnotourism. Among the Kalhas who have long been exposed to massive pressure and attempts at conversion from their Muslim neighbours, the first steps have now been made to start a Christian mission too. The introduction of the Pakistani school system has spread the national language of Urdu and even English. Residual languages such as Burushaki, which have never developed into literary languages, are threatened with extinction.

### Suggested reading

Because this paper is intended to give only a general ethnographical overview and the individual themes have been dealt with in a correspondingly compressed form, detailed notes on the literature have not been given. From the extensive scholarly and popular literature on the cultural history of North Pakistan the following important monographs and introductory works are recommended. They also contain more detailed bibliographies.

Barth, Fredrik 1956   Indus and Swat Kohistan. An Ethnographic Survey Oslo.

Biddulph, John 1880   Tribes of the Hindoo Koosh Calcutta (Repr. Graz 1971).

Frembgen, Jürgen 1985   Zentrale Gewalt in Nager (Karakoum) Politische Organisationsformen, ideologische Begründungen des Königtums und Veränderungen in der Moderne Stuttgart.

Jettmar, Karl 1975   Die Religionen des Hindukusch Stuttgart.

Keay, John 1977   When Men and Mountains Meet The Explorers of the Western Himalayas 1820–75 London.

1979   The Gilgit Game. The Explorers of the Western Himalayas 1865–95 London.

Müller-Stellrecht, Irmtraud 1973   Feste in Dardistan. Darstellung und kulturgeschichtliche Analyse Wiesbaden.

1979   Materialien zur Ethnographie von Dardistan (Pakistan) Aus den nachgelassenen Aufzeichnungen von D. L. R. Lorimer Teil I. Hunza Graz.

1980   Teil II. Gilgit, Teil III. Chitral und Yasin Graz.

Nayyar, Adam 1986   Astor: Eine Ethnographie Stuttgart.

Snoy, Peter 1975   Bagrot. Eine Dardische Talschaft im Karakorum Graz.

Staley, John 1982   Words for my Brother Travels Between the Hindu Kush and the Himalayas Karachi.

# Bibliography (general)

| | |
|---|---|
| Ahmad, K.S | **A Geography of Pakistan**, London, 1972 |
| Ahmed, A. | **Millennium and Charisma among Pathans. A critical essay in social anthropology**, London, Henley, Boston, 1976 |
| Ahmed, U. | **Bibliographie des Deutschen Pakistan-Schrifttums bis 1974**, Hamburg (Deutsch-Pakistanisches Forum), 1975 |
| Albrecht, H. | **Lebensverhältnisse ländlicher Familien in Westpakistan: Sozialkonomische Schriften zur Agrarentwicklung**, Saarbrücken, 1971 |
| Ali, Amjad | 'The Folk Arts of Swat', **Pakistan Quarterly** (Karachi), vol. X (1961), no. 3 |
| Asad, T. | 'Market Model, Class Structure and Consent: A Rreconsideration of Swat Political Organisation', **Man**, vol. 7 (1972), no. 1 |
| Asmi, S. | 'Swat – A Many Splendoured Valley', **Focus on Pakistan** (Karachi), vol. 4 (1977), no. 2 |
| Barth, F. | 'Ecologic Relationship of Ethnic Groups in Swat, North Pakistan', **American Anthropologist**, LVIII (1956) |
| Barth, F. | **Political Leadership among Swat Pathans**, London, 1965 |
| Bedford, M.C. | **Pit Loom Weaving: Islampur and Fatepur, Swat, West Pakistan**, MA thesis, Department of Art California State University, Fresno, 1974 |
| Bellew, H.W. | **A General Report on the Yusufzais** (1864), reprint, Lahore, 1977 |
| Biddulph, J. | **Tribes of the Hindoo Koosh** (Calcutta, 1880), reprint, Karachi, 1973 |
| Caroe, O. | **The Pathans, 550 BC-AD 1957** (London, 1958), reprint, Karachi, 1973 |
| Dani, A.H. | **Peshawar, Historic City of the Frontier**, Peshawar, 1969 |
| Dani, A.H. | 'Indus and Swat Kohistan. An Ethnographic Survey', **Studies Honouring the Centennial of Universitets Etnografske Museum, Oslo**, vol. II, Oslo, 1956 |
| Dani, A.H. | **Political Leadership among Swat-Pathans**, London, 1959 |
| Dani, A.H. | 'The System of Social Stratification in Swat, North Pakistan', **Aspects of Caste in South India, Ceylon and North-West Pakistan**, ed. E.R. Leach, Cambridge, 1971 |
| Dani, A.H. | 'The Traditional Architecture of Nuristan and its Preservation', **Cultures of the Hindukush**, ed. K. Jettmar, Wiesbaden, 1974 |
| Dani, A.H. | 'Preliminary Report on the 1963 Excavations Campaign of Barama – I (Swat Pakistan)', **East and West** (Rome), vol. 15 (1965), nos. 1-2 |
| Dani, A.H. | 'The Cultural History of Northwest Pakistan', **Year Book of the American Philosophical Society**, Philadelphia, 1960 |
| Dani, A.H. | 'Megalithsystem nud Jagdritual bei den Dardvölkern', **Tribus**, 9 (1960) |
| Dani, A.H. | 'Schnitzwerke aus den Tälern Tangir und Darel', **Archiv für Völkerkunde** (Vienna), vol. 14 (1960) |
| Dani, A.H. | 'Die Bergvölker Westpakistan', **Bustan**, Vienna, 1961 |
| Dani, A.H. | 'The Middle Asiatic Heritage of Dardistan (Islamic Collective Tombs in Punyal and their Background)', **East and West** (Rome), n.s. vol. 17 (1967), nos. 1-2 |
| Dani, A.H. | **Die Arabeske, Sinn und Wandlung eines Ornaments**, Graz, 1977 |
| Dani, A.H. | **Bagrot. Eine dardische Talschaft im Karakorum**, Graz, 1974 |
| Dani, A.H. | 'From Swat to the Gorges of the Indus', **Geographical Journal**, vol. C (1942), no. 2 |
| Dani, A.H. | 'Archaeological Notes from the Hindukush Region', **Journal of the Royal Asiatic Sociaty of Great Britain and Ireland**, (1944), 1-2 |
| Dichter, D. and N.S. Popkin | **The North-West Frontier of West Pakistan**, Oxford, 1967 |
| Diemberger, A. | 'Kundfahrten in Swat, Dir und Chitral', **Österreichische Alpenzeitung** (Vienna), vol. 82 (1964), no. 1337 |
| Diemberger, A. | 'Swat and Central Asia', **East and West** (Rome), vol. 19 (1969), nos. 1-2 |
| Dilthey, H. | **Versammlungsplätze im Dardo-Kafirischen Raum**, Wiesbaden, 1971 |
| Dorn, B. | 'Beitrag zur Geschichte des Afghanischen Stammes der Jusufsey (1838)', **Bulletin Scientifique publi par l'Académie Impériale des Sciences de Saint Petersburg**, Leipzig, 1838 |
| Edleberg, L. | 'The Nuristani House', **Cultures of the Hindukush**, ed. K. Jettmar, Wiesbaden, 1974 |
| Eliade, M. | **Schamanismus und archaische Ekstasetechnik**, Zurich, (no date) |
| Elphinstone, M. | **An Account of the Kingdom of Caboul and its Dependencies in Persia, Tartary and India**, 2 vols., Karachi, 1972 |
| Facenna, D. | **A Guide to the Excavations in Swat (Pakistan) 1956-1963**, Rome, 1964 |

Fautz, B. **Sozialstruktur und Bodennutzung in der Kulturlandschaft des Swat (Nordwesthimalaya)**, (Giessener Geographische Schriften, 3), Giessen, 1963

Grierson, G.A. **Torwali. An Account of a Dardic Language of the Swat Kohistan**, London, 1929

Hay, W.R. 'The Yusufzai State of Swat', **Geographical Journal** (London), vol. 84 (1935), no. 3 London, 1935

Hasan, Sh.Kh. 'Stone Reliefs from Chaukhandi Tombs in Pakistan', **East and West** (Rome), vol. 34 (1984), nos. 1-3

Herrmann, F. **Symbolik in den Religionen der Naturvölker**, Stuttgart, 1961

Hirschberg, W. and A. Janata **Technologie und Ergologie in der Völkerkunde**, Mannheim, 1966

Hütteroth, W.-D. 'Zum Kenntnisstand über Verbreitung und Typen von Bergnomadismus und Halbnomadismus in den Gebirgs- und Plateaulandschaften', **Vergleichende Kulturgeographie der Hochgebirge des südlichen Asien**, ed. C. Rathjens, C. Troll and H. Uhlig, Wiesbaden, 1974

Hussam-Ul-Mulk and J. Staley 'Houses in Chitral: Traditional Design and Function', **Folklore**, vol. 79 (1963)

Jettmar, K. 'Schmiedebrauchtum im östlichen Hindukusch', **Mitteilungen der Anthropologischen Gesellschaft**, Vienna, vol. LXXXVII (1957)

Jettmar, K. **Die frühen Steppenvölker: Der Eurasiatische Tierstil, Entstehung und sozial Hintergrund**, Baden-Baden, 1964

Jones, S. **Men of Influence in Nuristan**, London, New York, 1974

Khan, F.A. **Architecture and Art Treasures in Pakistan**, Karachi, 1969

Khan, M.U.H. **Purdah and Polygamy**, Peshawar, 1972

Kirfel, W. **Symbolik des Buddhismus**, Stuttgart, 1959

Kirfel, W. **Symbolik des Hinduismus und des Jinismus**, Stuttgart, 1959

Klimburg, M. 'Male-Female Polarity Symbolism in Kafir Art and Religion. New Aspects in the Study of the Kafir Art and Religion', **East and West** (Rome), vol. 26 (1976), nos. 3-4

Kühnel, E. **Die Moschee**, Graz, 1974

Kussmaul, F. 'Siedlung und Gehöft bei den Tagiken in den Bergländern Afghanistans', **Anthropos** (Fribourg, Switzerland), vol. 60 (1965)

Lentz, W. Über einige Fragen der materiellen Kultur von Nuristan', **Zeitschrift für Ethnologie** (Braunschweig), vol. 69 (1937)

Lindholm, Ch. and Ch. 'Marriage as Warfare', **Natural History**, 88 (1979), 88

Lindholm, Ch. 'Leatherworkers and Love Potions', **American Ethnologist**, 8 (1981), 3

Löffler, R. **Soziale Stratifikation im südlichen Hindukusch**, Dissertation, Mainz, 1965

Lorenz, E. **Vesh – Eine Form des gemeinsamen Bodenbesitzes bei den Pathanen**, Phil. Dissertation, Vienna

Malik, M.U. and A. Schimmel (ed.) **Pakistan**, Tübingen, 1976

Menon, M.M. 'Swat: Some Aspects of its Geography', **Pakistan Geographical Review** (Lahore), vol. 12 (1957), no. 2

Morgenstierne, G. **Report on a Linguistic Mission to North-Western India**, Oslo, 1923, (reprint, Karachi)

Muncherji, D.H. 'Swat, the Garden of Asoka', **Pakistan Quarterly**, vol. IX (1960), no. 3

Obaid, N. 'Swat', **Focus on Pakistan** (Karachi), vol. 3 (1973), no. 2

Porada, E. **Alt-Iran. Die Kunst in vorislamischer Zeit**, Baden-Baden, 1962

Rahman, I.U. 'Folk Tales of Swat', **Reports and Memoirs** (Rome), vol. XIII (1968), 1

Raverty, H.G. 'An Account of Upper and Lower Suwat, and the Kohistan, to the source of the Suwat River, with an account of the tribes inhabiting those valleys', **Journal of the Asiatic Society of Bengal** (Calcutta), XXXI (1862)

Rawson, D.L. 'Swat – where yesterday walks side by side with tomorrow', **Natural History** (Washington), vol. 66 (1974)

Robertson, G.S. **The Káfirs of the Hindukush**, (London, 1896), reprint, Karachi, 1974

Scerrato, U. 'Labyrinths in the Wooden Mosques of North Pakistan. A Problematic Presence', **East and West** (Rome), vol. 33 (1983), nos. 1—4

Schmitt, Erika **Ornamente in der Gandharakunst und rezenten Volkskunst in Hindukusch und Karakorum**, Dissertation, Heidelberg, 1969

Silvi Antonini, C. 'Preliminary Notes on the Excavations of the Necropolises Found in Western Pakistan', **East and West** (Rome), vol. 14 (1963)

Snoy, P. 'Nuristan und Mungan', **Tribus**, 14, 1965

Stacul, G. 'Preliminary Report on the Pre-Buddhist Necropolises in Swat (W. Pakistan)', **East and West** (Rome), vol. 16 (1966)

Stein, A. **On Alexander's Track to the Indus**, (London, 1929), reprint, Karachi, 1975

| Steul, W. | **Paschtunwali. Ein Ehrenkodex und seine rechtliche Relevanz**, dissertation, Heidelberg, 1977 |
| Swinson, A. | **North-West Frontier. Peoples and Events 1839-1947**, London, 1969 |
| Tarn, W.W. | **The Greeks in Bactria and India**, Cambridge, 1951 |
| Tucci, G. | 'Preliminary Report on an Archaeological Survey in Swat', **East and West** (Rome), vol. 9 (1958), no. 4 |
| Wutt, K. | Über Zeichen und Ornamente der Kalash in Chitral', **Archiv für Völkerkunde**, vol. 30 |

## Bibliography to the chapter by Viola Förster-Lühe

| Ahmad, Khurshid | **Family Life in Islam**, published by The Islamic Foundation, Leicester, no date |
| Al-Hatung, Said Abdullah | **Women in Islam**, Lahore, 1979 |
| Erlbeck, Ruth | **Frauen in Indien**, Münster, 1978 |
| | **Frauen und 'dritte' Welt, Beiträge zur feministischen Theorie und Praxis**, published by Sozialwissenschaftliche Forschung und Praxis für Frauen, Munich, 1980 |
| Jeffrey, Patricia | **Purdah, Muslimische Frauen in Indien**, Berlin, 1985 |
| Mandudi, Abdul A'la | **Purdah and the Status of Women in Islam**, Lahore, 1972 |
| Mies, Maria | **Indische Frauen zwischen Unterdrückung und Befreiung**, Cologne, 1973 |
| Mirza, Hussain, Sarfaraz | **Muslim Women's Role in the Pakistan Movement**, Lahore, 1969 |
| Nasra Shah (ed.) | **Pakistani Women, Women in Development**, Washington, 1982 |
| Patel, Rashida | **Women and Law in Pakistan**, Karachi, 1979 |
| Siddiqui, M. Mazheruddin | **Woman in Islam**, Lahore, 1952 |
| Ul Haq Khan, Mazhar | **Purdah and Polygamy. A Study in the Social Pathology of the Muslim Society**, Peshawar, 1972 |